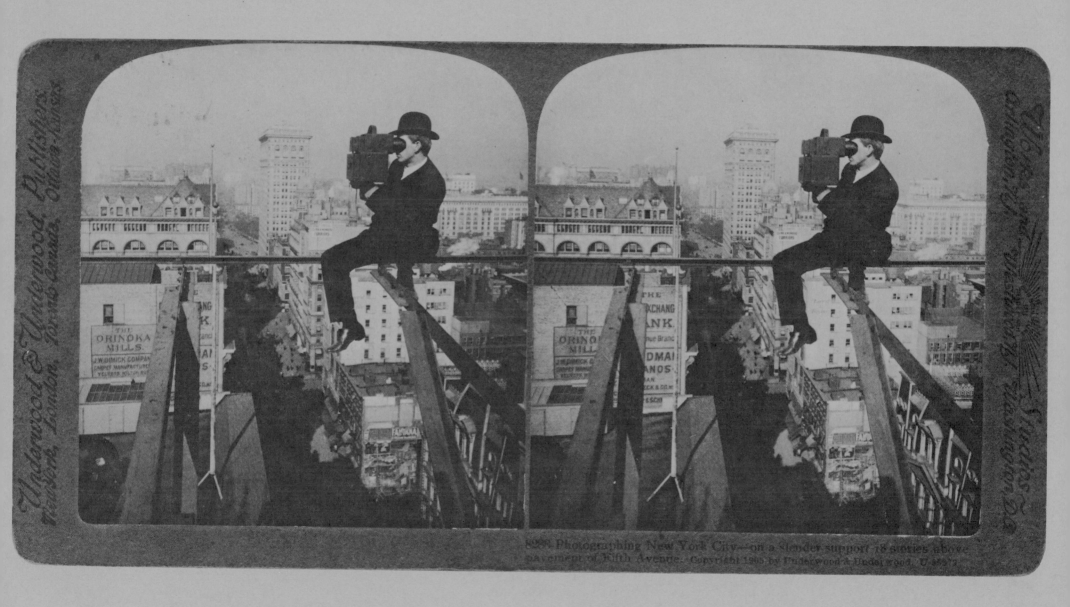

Photographing New York City—on a slender support 18 stories above pavement of Fifth Avenue. Copyright 1905 by Underwood & Underwood.

A Century of Photographs
1846 –1946

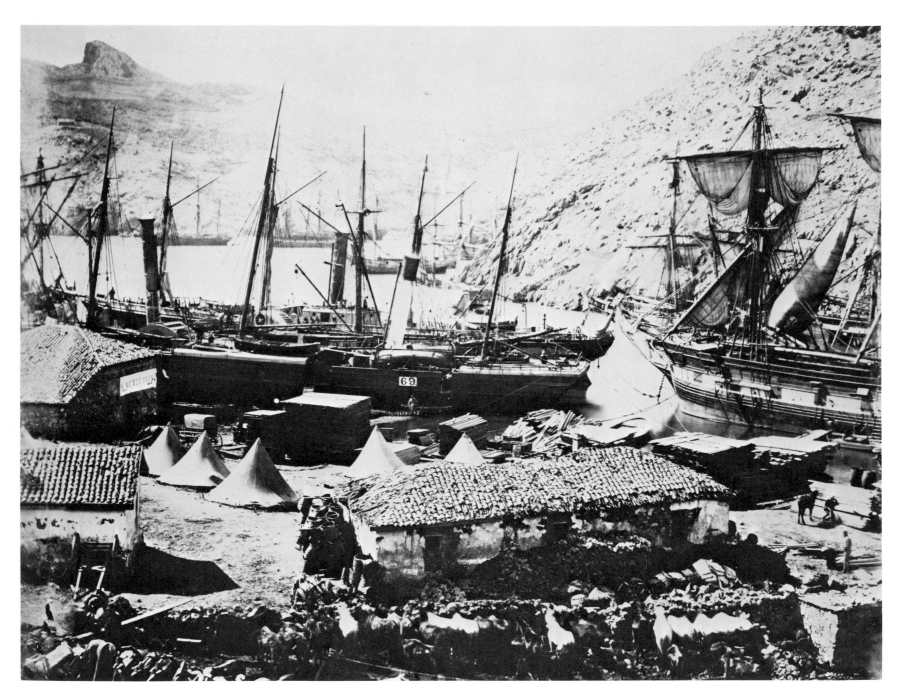

Cossack Bay, Balaklava, 1855. Photograph by Roger Fenton. LC–USZ62–2375

A Century of Photographs 1846—1946

Selected from the Collections of the Library of Congress

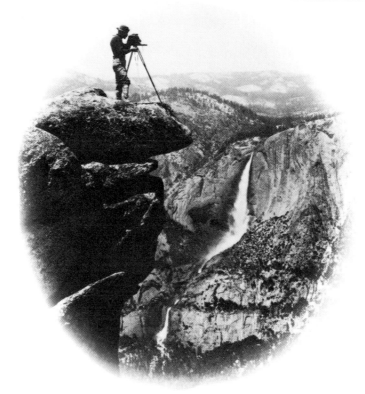

Compiled by Renata V. Shaw

Library of Congress · Washington · 1980

Library of Congress Cataloging in Publication Data
Main entry under title:

A Century of photographs, 1846–1946.

Consists of articles originally published in the
Quarterly journal of the Library of Congress that
explore the collections of the Prints and Photographs
Division.
Includes bibliographical references.
CONTENTS: The pioneers: Fern, A. and Kaplan, M.
John Plumbe, Jr., and the first architectural photo-
graphs of the Nation's Capitol.—Milhollen, H. D.
Roger Fenton, photographer of the Crimean War.—Vander-
bilt, P. Two photographs of Abraham Lincoln. [etc.]
1. United States. Library of Congress—Photograph
collections—Addresses, essays, lectures. 2. United
States. Library of Congress. Prints and Photographs
Division. I. Shaw, Renata V. II. United States.
Library of Congress. Prints and Photographs Division.
III. United States. Library of Congress. Quarterly
journal.
TR6.U62D572 779'.074'0153 79-21624
ISBN 0-8444-0295-8

Designed by William W. Chenoweth

**Endpapers: Photographing New York City, 1907.
LC–USZ62–44435 (half)**

**Title Page: Photographing Yosemite Falls from Glacier
Point, 3300 feet above the valley, Yosemite National
Park, California, 1902. LC–USZ62–26579**

For sale by the Superintendent of Documents, U.S. Government Printing Office
Washington, D. C. 20402

Contents

To Obtain Photographs

Photocopies of the photographs in this publication may be purchased from the Photoduplication Service, Library of Congress, Washington, D.C. 20540. Current prices may be obtained from the Photoduplication Service. A request should be accompanied by a full description of the photograph, including the negative number given in the caption (and beginning with the designation LC–).

Some photographs are under restriction, and these are indicated by the word *restricted* following the caption. Information about these photographs and the names and addresses of those holding the right to give copyright or other permissions are available from the Prints and Photographs Division. This book is published as a guide to the collections of photographs in the Library of Congress and does not give to any user any rights he would not otherwise have to any of the photographs reproduced here.

Foreword

For many years, photographic materials have made up the largest part of the collections in the Library's Prints and Photographs Division. There are perhaps as many as 9 million prints, negatives, transparencies, and stereographs to be found here, with images produced from almost all of the photographic technologies, old and new. With the exception of the Farm Security Administration photographs, which have been widely studied and published, public awareness of the Library's photographs has been indirect and random. This is so, even though the credit lines for illustrations in a variety of publications reveal the wide use of these photographs—they often appear in textbooks and have been used frequently in developing documentary films for television.

Of course, many people are familiar with the Library's photographs. The collections are well known to professional picture researchers, some of whom work full-time in the Prints and Photographs reading room. Other visitors to the division use the photographs as a source for basic historical research. The many images from the Civil War period provide information about uniforms and equipment, battlefields and camps. There are photographs taken at Gettysburg, for example, which show Lincoln on the speaker's stand. And the Park Service used the Civil War photographs in restoring Ford's Theater. By studying stereographic photographs of the theater taken immediately after the assassination, it was possible to reconstruct the interior with great accuracy. The photographs are also used by persons who have no special interest in photography itself but have a picture of their own they want to identify. With the aid of the Library's large portrait collection, it is often possible to identify the image and compare it with known examples of the same picture.

The collections are especially important for students of photography, since here they can work with original prints of all periods. There are examples from the first days of the medium, and pictures by members of the contemporary avant-garde. The history of photographic technology can be studied from examples ranging from daguerreotypes to collodion glass negatives, from early color transparencies to contemporary color prints.

These many uses of the collections are an indication of their accessibility. Unlike many museums and libraries, which have limited access, the Prints and Photographs division makes its photograph collections available to anyone who visits the reading room. Although, quite obviously, the visitor who comes with a specific purpose will have a more rewarding time than one whose purpose is vague.

But even these many uses do not exploit the full range and importance of the photograph collections, which afford many opportunities for research and study. The work of a particular photographer like Arnold Genthe is represented in all its aspects, from negatives to studio proofs to finished exhibition prints. Such a collection offers a unique opportunity to study several stages of photography as a means of personal expression. Using the documentary collections, it is possible to study how a particular subject, for example the city of Washington, has been seen at various times and by various persons. Or one might study the influence and uses of documentary and aesthetic photography, how they acted upon one another, and how they have affected society.

Unfortunately, a great deal of the photographic material in the Prints and Photographs Division remains uncataloged and little used. There have been some published catalogs and some checklists, but most of these have touched only a small part of the collections, or have been generalized descriptions of the whole mass, like the Library's *Viewpoints* or Oliver Jensen's *America's Yesterdays*. It is hoped that this book, along with other publications relating to the collections, will prepare the reader to make the best use of the photographs available at the Library and will better acquaint scholars and critics particularly with the material here. These articles, reprinted from the *Quarterly Journal of the Library of Congress*, reflect thirty years of collections development and a variety of curatorial approaches. Some of the images discussed, like the daguerreotypes which are the earliest known photographs of the nation's capital, are remarkable in themselves and in the information they provide. There are other daguerreotypes from the medium's earliest days, images of the Crimean and Civil Wars, and photographs from the later nineteenth century, the early twentieth century, and the present era. As the title indicates, the book contains selections from roughly a hundred years of photography, as well as from places near and far, from the city of Washington and the Middle East and Africa. The photographs and articles represent aesthetic, documentary, and interpretive viewpoints, both in a general way and as they are practiced by specific photographers.

And even at that, the articles do not cover a majority of the Library's collections: three of the largest and, in one case, the best known, are not mentioned at all. The Farm Security Administration, the Detroit Publishing Company, and *Look Magazine* Collections include massive groups of materials, making up perhaps three-quarters of the total photographic collections. But despite these omissions, *A Century of Photographs, 1846–1946* presents an excellent introduction to the major collections of photographs and reveals the Library's primary position as a great archive of documentary photography.

Jerald C. Maddox
Curator of Photography

Introduction

In 1846 the Library of Congress, along with the Smithsonian Institution, was authorized to receive as a deposit one copy of each copyrighted "book, map, chart, musical composition, print, cut, or engraving."[1] Although photographs were not explicitly mentioned, some photographs and stereographs were sent to the library between 1846 and 1859, when the copyright deposit law was repealed because it had no enforcement provision and was thus ineffective.[2]

Following a recommendation from the Librarian of Congress the copyright law was changed in 1865 so as to require that one printed copy of every copyrighted "book, pamphlet, map, chart, musical composition, print, engraving, or photograph" be deposited in the Library of Congress.[3] The gradual accumulation of visual materials and their use by library patrons was significant enough during this early period for the Librarian to propose new rules according to which "all engravings and works of art will be constantly protected and used only with special permission from the Librarian."[4]

The first photographic collection of impor-

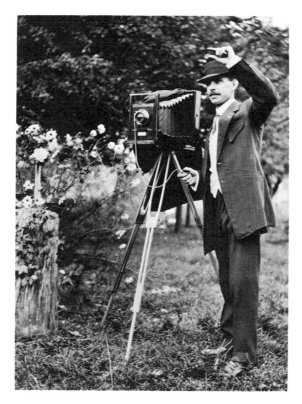

A. W. Leonard with large camera, about 1911. From the French collection. LC–USZ62–35617

tance offered to the Library of Congress for purchase was "Mr. Brady's *Historical Gallery of Portraits*." Although the Library Committee voted to recommend a $25,000 appropriation to purchase these 2,000 mounted photographs, this 1871 proposal apparently was not accepted.[5]

A reorganization of the Library of Congress into separate departments was first suggested in 1895. Two years later the Division of Prints was officially established, and a special gallery in the new Library of Congress building was reserved for exhibitions of graphic art. During the first three decades of the twentieth century, the division was mainly concerned with fine prints and reproductions of works of art which were lent to local schools and institutions. Gradually the interest in photographs as original historical source materials began to emerge. In 1920 the U.S. Army War College transferred to the division three hundred daguerreotype portraits of prominent New Yorkers and Washingtonians made by the studio of Mathew B. Brady between 1845 and 1853.

When the Carnegie Foundation endowed

1

a chair of fine arts at the Library in 1929, the Division of Prints changed its name to Division of Fine Arts. Soon thereafter the Pictorial Archives of Early American Architecture were established to facilitate the collecting of photographs and negatives of important buildings which were being destroyed. An endorsement from the American Institute of Architects brought more than ten thousand negatives to the Library. This architectural collection was soon augmented by the Historic American Buildings Survey, sponsored by the Civil Works Administration.

This project continued from 1933 until 1941, when it was interrupted by the war. Public interest in the visual records of the Historic American Buildings Survey was so great that the recording of buildings and cataloging of photographs, measured drawings, and data pages was resumed with new enthusiasm when the Library returned to peacetime activities.

The funding by the Rockefeller Foundation of the Photoduplication Service in the Library was of particular significance to the Prints and Photographs Division. This new in-house service, begun in 1938, made the work of printing negatives and copying photographs less complicated, for it became easier to control the flow of visual materials in and out of the photographic laboratory. In previous years photographic work had to be sent outside the Library to commercial photographers.

During the 1940s, the Library came to realize the importance of actively collecting photographs as records of life in America. Nine thousand negative plates and photographs by Arnold Genthe were purchased in 1943. The same year the Library also bought the Phelps Publishing Company Collection of Mathew B. Brady Civil War photographs, which included ten thousand negatives.

In 1944 the newly renamed Prints and Photographs Division assumed custody of the Farm Security Administration/Office of War Information files of more than one hundred thousand black-and-white photographs and negatives produced as photodocumentation of America. These photographs have since become widely known throughout the world as the results of a pioneering government project. They were commissioned in order to document the condition of American farmers, yet they demonstrate artistic excellence in their choice of subject matter as well as in their technical proficiency.

The first curator of photography was appointed in 1943, and his principal assignment was to bring order to the various photographic collections. The division had a self-indexing portrait file, a geographical collection sorted in portfolios arranged by state and city, and a stereographic file divided into general subject categories. However, vast numbers of photographs were merely tied in bundles and heaped in copyright registration sequence in the southwest attic of the Library of Congress Building.

The photographs were initially sorted according to simple subject categories such as sports, animals, and personalities. The second step consisted of filing some of these pictures under specific subject headings and others in large homogeneous groups (for example, photographs of the Spanish American War). The concept of "lots" which had earlier been used for the Farm Security Administration photographs was applied to the general collections. "Lots" are defined as batches of pictures which fall into logical groups by virtue of their creator or donor, the overall title of a picture story, or the unifying subject matter. The small staff of the division saw the "lot" system as a helpful cataloging device which enabled them to control vast numbers of images without having to resort to individual cataloging of each item.

The American Red Cross transferred about fifty thousand photographs documenting activities of the organization at home and overseas to the Library in 1944. Two years later the Library acquired Roger Fenton's pioneering photographs of the Crimean War. Thousands of Nazi photographs and graphic ephemera were transferred to the Prints and Photographs Division in 1947. These document the 1933–41 period from the viewpoint of the Third Reich. The Erwin E. Smith collection of eighteen hundred nitrate and glass negatives of cowboy life was donated to the Library in 1949. These were joined by Frank George Carpenter's photographs from around the world, some acquired from commercial firms, some taken by Carpenter while he was preparing his popular travel books.

In 1952 the industrialist and philanthropist Louis M. Rabinowitz presented two important portraits of Abraham Lincoln to the Library. The famous Brady-Handy Collection of Civil War photographs and negatives was donated to the Library in 1954, making the Prints and Photographs Division the principal research center for visual documentation of the Civil War period. This group of images includes several thousand plates by Levin C. Handy, who had continued the photographic studio work of his mentor Mathew B. Brady.

The Library's acquisitions of artistic photographs were as impressive as the additions to its documentary collections. The two schools of photography had developed side by side, one suffused by aesthetic preoccupations, the other pervaded by a desire to record events in a simple and straightforward manner. In the 1960s the artistic photographs were rearranged into a new sequence as "Master Photographs." Generally, photographs in this grouping must illustrate significant aspects

of the development of the art of photography, possess technical distinction, or be original works of art. Master photographs receive the same care as fine prints; they are individually cataloged under the photographer's name, mounted, and shelved in boxes.

In 1964 the A. Conger Goodyear bequest of twelve photographs of Abraham Lincoln came to the Library. It included a Preston Butler ambrotype of 1860, later widely known through an engraving. The following year the Library purchased glass plate negatives by Haas and Peale of Morris Island, South Carolina, during the Charleston campaign of 1863. G. Eric Matson, a Swedish photographer who lived in the American colony in Jerusalem, gave his collection of photographs of the Middle East to the Library in 1966.

In 1972 the Prints and Photographs Division had the good fortune of purchasing six daguerreotypes discovered accidentally in a flea market in San Francisco. These remarkably preserved architectural views, made about 1845 by John Plumbe, Jr., are the earliest photographic images of the city of Washington. And in 1973 descendants of Theodor Horydcak, a Washington photographer, presented to the Library his entire studio collection of over thirty thousand images, many taken in the nation's capital during the 1930s.

A recent acquisition is the Gilbert J. Grosvenor Collection of Alexander Graham Bell photographs. These are devoted to the many-faceted life of the inventor and depict his family and friends as well as his experiments and travels.

These seventeen articles originally published in the *Quarterly Journal of the Library of Congress* present a representative sample of the photograph collections in the Prints and Photographs Division. The division hopes they serve as a useful guide for researchers familiar with the collections and as a stimu-

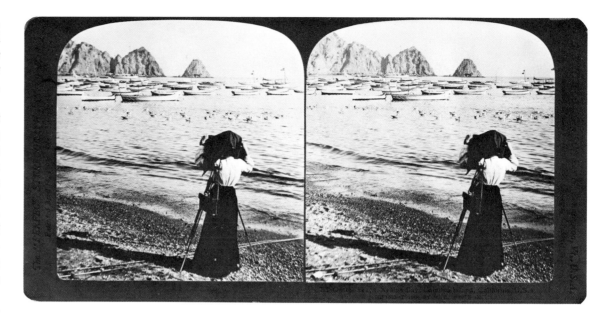

Photographing Avalon Bay, Catalina Island, California, 1906. LC–USZ62–56635 (half)

lating introduction for new patrons still unfamiliar with the resources of the Library.

NOTES

1. 9 Stat. 102
2. 11 Stat. 379
3. 13 Stat. 540
4. Library of Congress Archives, "Extracts From the Minutes of the Joint Library Committee, 1861–1898"
5. LCA–M

John Plumbe, Jr., and the First Architectural Photographs of the Nation's Capital

by Alan Fern and Milton Kaplan

It is a happy occasion when a public institution is able to acquire objects in superb condition that combine historical significance and visual attractiveness. In the past, the photograph collections of the Library of Congress have been enriched by the Mathew Brady and Brady-Handy Collections, by Roger Fenton's Crimean War photographs, and by the remarkable Haas & Peale Civil War plates. These are objects comparable to the presidential papers in the Manuscript Division or to the Giant Bible of Mainz in the rare book collection. In 1972 six daguerreotypes that are among the most remarkable early American photographs were acquired by the Library of Congress.

On January 29, 1846, the *United States Journal*, a Washington, D.C., newspaper, observed: "Mr. Plumbe's National Daguerrian Gallery at Concert Hall, is an establishment whose superior merits are well deserving the notice of all who feel an interest in the beautiful art of Photography. . . . We are glad to learn that this artist is now engaged in taking views of all the public buildings which are executed in a style of elegance, that far surpasses any we have ever seen. . . . It is his

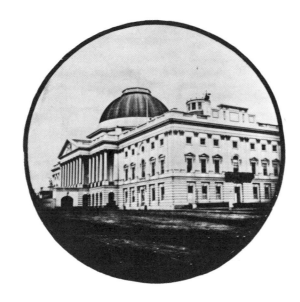

An early photograph of the Capitol by W. and F. Langenheim, July 1850. From "Views in North America, Series III, Washington, D.C." LC–USZ62–4963

intention to dispose of copies of these beautiful pictures, either in sets or singly, thus affording to all, an opportunity of securing perfect representations of the government buildings."[1] On February 20 of the same year, the *Daily Times* noted that "Views of the Capitol, Patent Office and other public buildings embellish the walls [of John Plumbe's gallery] and are the subject of universal commendation. . . ."[2]

One hundred and twenty-six years later, and some three thousand miles away, Michael Kessler, a California collector of early photographic apparatus, visited the Alameda flea market near San Francisco and purchased six rather tarnished daguerreotypes. Under the discoloration, the images were exceptionally fresh; after cleaning them, he sent photocopies to the Library of Congress Prints and Photographs Division for confirmation of his identification of two of them and for identification of the other four. Excitement ran high in the division, for after an examination of the images it was believed that five of the views undoubtedly were those referred to in the 1846 newspaper story and would, therefore, have the distinction of being the earliest

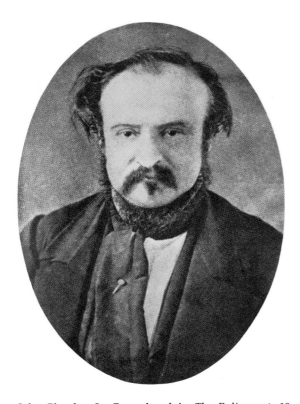

John Plumbe, Jr. Reproduced in *The Palimpsest.* 19 (March 1938).

The Capitol of the United States from the east. Daguerreotype (half-plate, approximately 4½ × 5½ inches), attributed to John Plumbe, Jr., about 1846. This is the view reproduced in the well-known "Plumbeotype" (lithograph) of about 1846. The statue on the north side of the portico is not in place, and the building is capped with Bulfinch's dome. The Potomac River and a few buildings of Southwest Washington are faintly visible at the left. Michael Kessler, the collector who discovered these daguerreotypes, owns another view of the Capitol, evidently by the same hand, taken from the southeast. LC–USZ62–46801

surviving photographic record of the nation's capital. The sixth daguerreotype was a view of the Battle Monument in Baltimore, surrounded by townhouses.

Perhaps the most attractive is the picture of the U.S. Patent Office on F Street between Seventh and Ninth Streets NW. Probably taken from a third floor window of the new Post Office across the street, it presents an interesting study in contrasts; we see the backs of houses and woodpiles, with some patches of snow, against the classical form of the Robert Mills building (started in 1836)

which today—extended to cover the entire block—houses the National Portrait Gallery and National Collection of Fine Arts of the Smithsonian Institution.

Two of the daguerreotypes are of the General Post Office, located on E Street NW, extending from Seventh to Eighth Streets. One view, taken from the Eighth Street corner, shows the bare trees of wintertime and the shop of Elijah Dyer, merchant tailor, as well as the sharply banked curbs which let water run off the crown of the street in inclement weather. The other view, taken from a po-

sition near Seventh Street, showing trees in full leaf and a cart, perhaps for delivery of hardware, at first seemed blemished by scratches. Close examination revealed that the scratches were wires—probably carrying Samuel F. B. Morse's new telegraph from his office on Pennsylvania Avenue to Baltimore.[3]

The White House, or President's House as it was then called, is photographed from the south. The traces of snow on the ground indicate the season, and the comparatively long shadows suggest a time either early or late in the day. Since the making of a daguerreo-

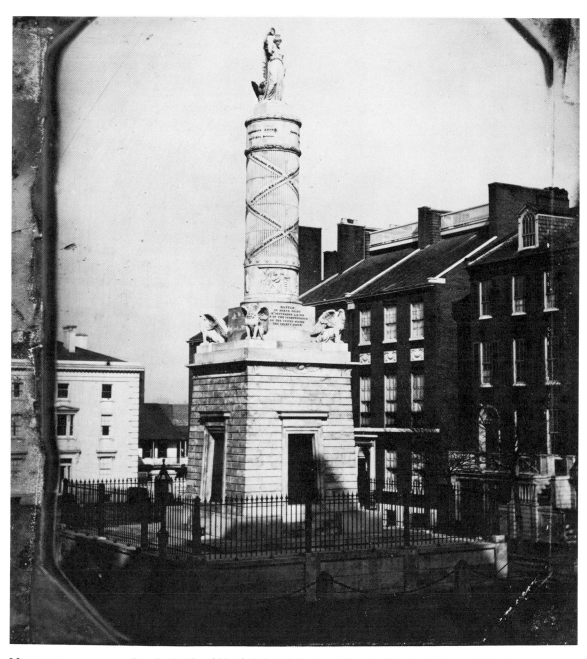

Monument commemorating the Battle of North Point. Calvert and Fayette Streets, Baltimore, Md. Daguerreotype (half-plate, approximately 5½ × 4½ inches), attributed to John Plumbe, Jr., about 1846. LC–USZ62–46806

type was not an exact science, the photographer would often set to work as early in the day as possible so as to have ample light available if he needed to make a new plate. If this daguerreotype was made in the morning, the image we see is a reversal of the scene, for the sun would have cast shadows to the left instead of the right. Such a reversal is normal in the daguerreotype and would make little difference in depicting such a symmetrical building as the President's House. However, in the other daguerreotypes where a shop sign or other written matter is included, the image had to be reversed through the use of a mirror or prism affixed to the lens of the camera.

The daguerreotype of the U.S. Capitol is, in some respects, the most interesting. The building, with the dome designed by Charles Bulfinch to replace the original dome destroyed by fire in the War of 1812, is presented in full view from the east. The Luigi Persico statue, "The Discovery Group," which was erected in 1844, is in place on the south side of the portico; the pedestal on the north side is empty, as it was until 1853. In front is the open cistern which served as a reserve water supply in case of fire; to the left is the Potomac River and a few rooftops in Southwest Washington. Smoke deflectors on each of the chimneys punctuate the roof.

Authentic pictures of the Capitol in the 1840s are rare, and apart from the architects' drawings, most of the drawings and prints of the building seem awkwardly proportioned. Until the flea market discovery, only two photographs of the Capitol taken during this period—both prints from paper negatives, or calotypes, by the Langenheims of Philadelphia—had been known, and though fascinating early examples of the art, these were far from satisfactory architectural photographs. One picture of the U.S. Capitol that

had always seemed a fairly acceptable representation was a little print that looked much like a lithograph but was mysteriously identified in its printed caption as a "Plumbeotype." It had received little attention, possibly because of its size, but its value as an important documentary picture of the U.S. Capitol was enhanced when the daguerreotype was acquired. A careful examination and comparison of the two images revealed that in every respect—size, the play of light and shadow, proportion—the plumbeotype corresponded to the daguerreotype. We can only conclude that the daguerreotype was the source of the plumbeotype and that the maker of the daguerreotype and the publisher of the plumbeotype were the same.

Ruel P. Tolman, curator of graphic arts at the Smithsonian Institution, observed in 1925 that the plumbeotype is not technically as intriguing as it sounds: it seems to be merely a hand-lithographed transcription of a daguerreotype.[4] The daguerreotype had been invented in 1839, in France, by Louis Jacques Mandé Daguerre, a painter of dioramas and landscapes.[5] One of the two original practical photographic processes (the other was the calotype), the daguerreotype produced images of incredible clarity and definition by the action of light on a sensitized metal plate. The plate was copper, coated with silver and polished to a high shine. It was sensitized by depositing iodine vapor on it, whereupon it could be exposed to an image focused through the lens of a camera. After a rather long exposure (later shortened by adding vapor of bromine to the iodine), it was developed in a darkened chamber by exposing it to mercury vapor. When development was complete, it was chemically "fixed," and when the excess chemicals had been washed away, the image could be seen by reflecting the polished surface against a dark background; the

highlights were formed by the whitish mercuric iodide, where light had focused on the plate, while the dark reflections created shadows where no light had exposed the plate. This seemed like magic, and the process (dedicated to the world by the French government) became a rage almost instantly, especially for portraits. Daguerreotypes, being photographic images on a metal surface, were unique; there was no negative from which numerous positives could be printed. One might make another daguerreotype of a daguerreotype, or else the image had to be multiplied through a hand-copying process.

Because of the Latin meaning of the first syllable of "plumbeotype," it might have been thought that the process of making these copies involved printing from grained lead, but rather than referring to the material used for making the print, the word evidently was coined from his own name by the very John Plumbe whose daguerreotypes had been so favorably noticed in the Washington newspaper. In 1846 he was the enterprising proprietor of the National Plumbeotype Gallery, the National Publishing Company, and Plumbe's National Daguerrian Gallery, all located at numbers 136 to 142 Chestnut Street in Philadelphia.

Plumbe was a pioneer American daguerreotypist. He and his staff were operators of considerable skill, and since his sitters were prominent, a number of reproductions of his portraits were produced by engraving and by lithography (especially by N. Currier, with whom he may have had some kind of formal arrangement). The artist took liberties with Plumbe's original daguerrian image: the engraver tended to preserve the plain dark background Plumbe normally used, but the lithographic artist not only adopted a free linear style of drawing (in contrast to the tonal rendition of the engravings), but also added

elaborate and often ridiculous backgrounds.

We do not know why Plumbe decided to go into the business of reproducing his own daguerreotypes. The earliest engraved and lithographed reproductions of his work by other publishers, as far as we know, date from 1846,[6] and it may well have occurred to Plumbe that this was a market he should try to enter himself. Whatever was in his mind, in 1846, in the Federal Eastern District Court in Philadelphia, his National Publishing Company took out a copyright for a *Daily National Plumbeotype Gallery*,[7] intending to issue a series of likenesses of great Americans, available on a daily basis to subscribers at several outlets around the country.

The venture does not seem to have met with much success. Today, plumbeotypes are relatively scarce. There are a few in public and private collections;[8] the largest single group, in the New York Public Library, contains but twenty-seven portraits, and altogether only thirty-one different plumbeotype subjects have been identified, a far cry from the hundreds promised to subscribers.

At least three forms of plumbeotypes seem to have been made. Portraits in a rectangular border belong to the series heralded in the advertisement. One such portrait of Levi Woodbury in the New York Public Library is signed in the border, "G Worley," probably George Worley, a Philadelphia lithographer active from 1846 to after 1860. This confirms Tolman's view that the plumbeotype involved the work of an artist; several different artists' styles can be detected in these portraits. The second form, portraits of prominent people, enclosed in ornate oval borders, appear as cover illustrations on a few pieces of lithographed music issued by the National Publishing Company, one of the Chestnut Street firms. On the back cover of these music sheets is the most elaborate announcement

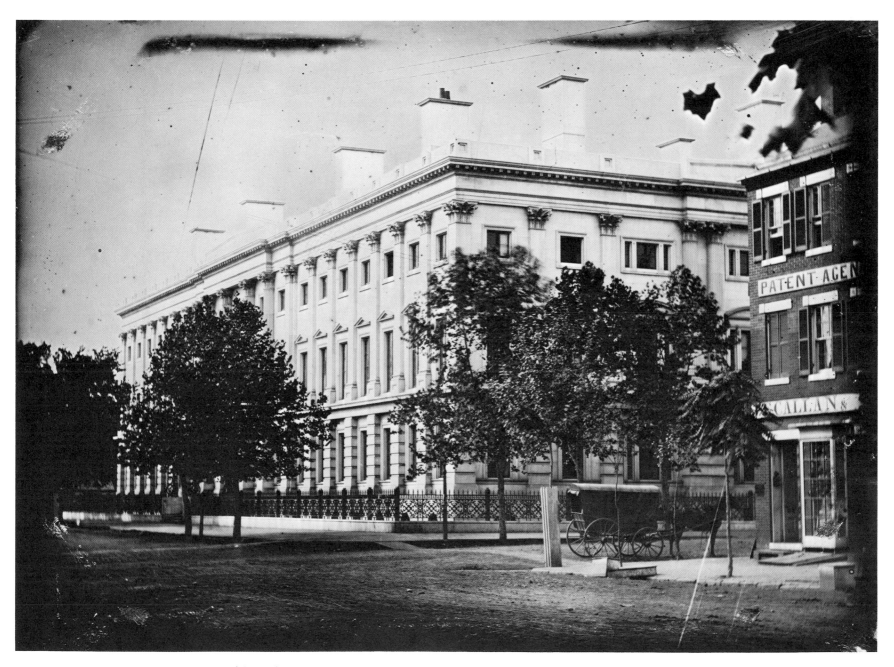

The General Post Office, from the corner of Seventh and E Streets NW, Washington, D.C. Daguerreotype (quarter-plate, approximately 3¼ × 4¼ inches), attributed to John Plumbe, Jr., about 1846. Two pairs of wires are visible, running across the plate from the upper left side. These may be associated with Samuel F. B. Morse's telegraph office, then in operation at Sixth and Pennsylvania NW. LC–USZ62–46803

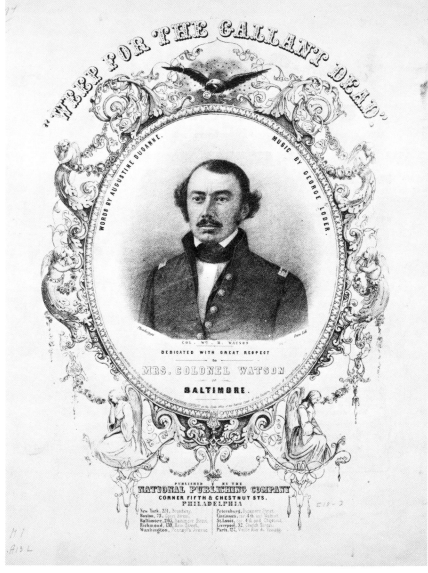

Washington Monument at Baltimore. Plumbeotype, copyright 1849, by the National Publishing Company, Philadelphia. The Hambleton Collection, Peale Museum, Baltimore, Md.

Plumbeotype in an oval border on cover of music sheet "Weep for the Gallant Dead," 1846. Music Division.

of the National Plumbeotype Gallery, and this ad is identical in three of the music sheets so far located; a fourth, in the New York Public Library, has a variant advertisement. The third kind of plumbeotype is surprising in terms of Plumbe's commercial venture; these are the pictures of buildings or monuments of national significance, like the U.S. Capitol. Plumbe's reasons for making these architectural plumbeotypes will be clear if first we follow his career up to the time he announced his Plumbeotype Gallery.

John Plumbe, Jr., was born in Wales in July 1809 and came to the United States with his family in 1821.[9] Early interested in the railroad as a career, he was employed as a track surveyor in the early 1830s in western Pennsylvania and Virginia. One of the first to propose the idea of a transcontinental railroad, he was a tireless correspondent and lobbyist in its behalf. In 1836 he moved westward and settled in Dubuque; in 1837 he was appointed prosecuting attorney for Dubuque County in the Iowa Territory.

It is difficult to pinpoint the exact date of Plumbe's entry into the new art of daguerreotypy. An advertisement in the Washington, D.C., *Daily Madisonian*, March 14, 1845,[10] claimed that the Plumbe National Daguerrian Gallery had been founded in Boston and New York in 1840 which, if true, would have given Plumbe the honor of being among the first commercial practitioners of the new art in the United States.

His entry onto the Washington scene, however, is more precisely documented. In December 1844, Plumbe's brother, Richard, wrote to Gen. George W. Jones from Dubuque:

Du Buque Dec 11th 44

Dear Sir: By a letter just received from my brother in New York he requests me to obtain from him any introductions and recommendations I can in this section of the country to members of Congress in Washington City—His object is to endeavor to get the use of a Committee Room in the Capitol for the purpose of taking Daguerreotype miniatures in . . . the likenesses of public individuals to enrich his Galleries of Portraits in New York, Boston, etc., which would do much to bring prestige. Knowing your feelings to be friendly towards my brother and also being aware that you have considerable acquaintances with the Public Officers and probably some Members of the present session of Congress, I have taken this opportunity of requesting your kind offices in the matter. Perhaps should you think fit, a single general letter of introduction—so addressed to any you might think would be of service to him might be all sufficient and which if you please you could transmit to his address in New York . . . 251 Broadway at your early convenience—Trusting that you will not consider this request as encroaching too far on your kindness, I remain Dr. Sir,

Yours very respy

RICHARD PLUMBE.
To Genl George W. Jones, Mineral Point, Wis.[11]

General Jones, a prominent Delegate to Congress, was instrumental in securing the creation of the Wisconsin and Iowa Territories and was one of the first Senators from the state of Iowa. He recalls Plumbe in his autobiography[12] and was indebted to him for serving as secretary of the group that petitioned President Van Buren to appoint Jones as Governor of Iowa when the area was organized in 1838. Now Jones could return the favor, and evidently he did.

Whether or not a room was made available has yet to be learned, but within six weeks Plumbe had moved into the very lucrative Washington market. The first advertisement for his National Daguerrian Gallery and Photographic Depot was carried in the January 31, 1845, issue of the *Daily Madisonian*.[13] His was the first daguerrian studio in Washington, and he was the first professional photographer in the Capital.

Success came quickly. He became the photographer of the nation's notables. The newspapers reported that President-elect James K. Polk, ex-Presidents John Quincy Adams and Martin Van Buren, Speaker of the House John W. Davis of Indiana, and Supreme Court Justice Levi Woodbury had sat for their daguerreotype likenesses at Plumbe's.[14] An article in the *Daily Times*, March 5, 1846, noted that

among the thousands of portraits that grace the walls of [the New York] gallery, are those of Presidents of the United States and their ladies, Members of Congress, Bishops and other clergy, actors and actresses, indeed, almost every person of distinction or notoriety that has been before the public in many years.[15]

High praise was lavished upon Plumbe's work. Phrases and statements like "The most beautiful and finished portrait of the kind that we have ever looked upon,"[16] "We almost fancied the breathing original before us,"[17] "Professor Plumbe . . . is fully entitled to the appellation of the 'American Daguerre,'"[18] "He has attained an eminence which places him in the very first rank of the Daguerrean profession,"[19] "Mr. Plumbe has brought the Daguerreotype to absolute perfection,"[20] and "Miniature painting is scarcely heard of since the admirable specimens of this artist have become known"[21] appeared on the editorial pages of both New York and Washington newspapers.

Unfortunately, it was the practice of the times for merchants to encourage (or even purchase) editorial praise and attention in the newspapers, so it is difficult to judge how many of these comments represent unsolicited enthusiasm and how many were inserted by Plumbe himself. About the writers of the time, the editor of the *Photographic Art Journal* wrote in 1851: "The conceit of these men is unbounded. What *they* do—what *they* write is sublime—what *others* attempt is ridiculous." He goes on to observe that "The Daguerreotypist . . . particularly if he be poor, and unable by money bribes to gain the hearts of the caterers for the public eye and ear . . . must blow his own trumpet—but, mark you by the aid of the press—and that,

too, loudly, and he can only make a noise in proportion to the depth of his pockets."[22] It seems clear, no matter who wrote his publicity, that Plumbe was as well known as Brady in his time and as adventurous.

Plumbe was also given credit for "taking away the cadaverous and staring expression, [hitherto] a great drawback to the value of daguerreotype portraits,"[23] evidently by shortening exposure time. Furthermore, according to the March 5, 1846, issue of the *Daily Times*, "Professor Plumbe was the first who introduced coloring to these pictures." Robert Taft, in the only extended article on Plumbe's photography published so far, mentions this in passing;[24] otherwise this has been completely unnoticed in photographic history. When two of his portraits in the Prints and Photographs Division were examined, it was found that they were, indeed, delicately toned, a fact that previously had been overlooked.

The high technical quality of the architectural daguerreotypes certainly is in accord with these accounts of Plumbe's work. Unfortunately, it is not possible to assign exact dates to them, but since one of the views of the Post Office shows the trees in full foliage, and the *Daily Times* of February 20, 1846, as previously noted, reported that "Views of the Capitol, Patent Office and public buildings embellish the walls [of Plumbe's gallery]," it is very likely that they were taken between the summer of 1845 and the early winter of 1846.

In addition to the plumbeotype of the Capitol, only one other architectural plumbeotype is known, that of the Washington Monument in Baltimore. Plumbe probably intended to issue plumbeotypes of all of the views, but his apparent failure to do so is consistent with the next turn of events in his life.

In 1847, according to the reminiscences of others in the photographic business at that time, Plumbe found himself in financial difficulty and sold his establishments to his employees.[25] According to such biographical information as survives, he then returned to Dubuque. This would account for the termination of his Philadelphia publishing scheme so soon after it had been announced. His studios in various cities were carried on by others for some few years, under his name.

In 1849 he was on his way to California, where he lived from 1850 to 1854. While there, he pressed his railroad ideas and also wrote a pamphlet about Sutter's land claim.[26] He must have left his architectural daguerreotypes there, either in the hands of his family or as payment for a debt or service; it is known that his brother, Richard, and his nephew, John, were living in San Francisco in the 1890s.[27] Plumbe had done an immense amount of work on the railroad idea and had spent more than a decade formulating his plan for a southern route across the continent.[28] The government chose a northern route and turned to others for the planning and execution of the great undertaking. Another of his magnificent conceptions had failed. John Plumbe returned to Dubuque and in 1857 committed suicide.

This extraordinary man was the very embodiment of the American nineteenth-century adventurer; an immigrant, starting with little, creating a business empire. (The Washington City Directory for 1846 listed Plumbe galleries in Boston, Philadelphia, Baltimore, New Orleans, Saratoga, St. Louis, Dubuque, Louisville, Newport, and abroad in Paris and Liverpool, and he boasted of employing a staff of five hundred at the height of his career.[29]) He was involved in two other areas of significance to the growing nation: rail transport, and printmaking. It is also a mystery how—if the newspaper accounts of his success were true—so few of his daguerreotypes are known.

Despite the gaps in our knowledge, the significance of Plumbe's work can now be assessed with some confidence. The one extraordinary conjunction of a surviving daguerreotype with its lithographic reproduction is itself a significant contribution to American print history: it suggests that there is more to discover than had been imagined about the relationship between the photographic and printed image in the mid-nineteenth century.

January 1974

NOTES

1. *United States Journal* (Washington, D.C.), January 29, 1846, p. 2, col. 1. Several colleagues enthusiastically joined the search for material by and about Plumbe, most notably Josephine Cobb, retired from the National Archives, who shared her extensive research notes and discovered many new things when she examined the daguerreotypes. Jerald Maddox and Virginia Daiker in the Prints and Photographs Division and, from other institutions, Doris Adams, Paul Amelia, Mrs. Joseph Carson, Maud Cole, Wilson G. Duprey, Robert F. Looney, Lois B. McCauley, Elizabeth Roth, Wendy G. Shadwell, and David Tatham are among those who have been particularly helpful.

2. *Daily Times* (Washington, D.C.), February 20, 1846, p. 2, col. 6.

3. For information on the history of Morse's company see Edward L. Morse, "The District of Columbia's Part in the Early History of the Telegraph," *Records of the Columbia Historical Society* 3 (1900): 161–79.

4. Ruel Pardee Tolman, "Plumbeotype," *Antiques* 8, no. 1 (July 1925): 27–28.

5. Helmut and Alison Gernsheim, *L. J. M. Daguerre* (New York: Dover Publications, Inc., 1968).

6. For example, a portrait of James B. Bowlin, used as frontispiece to *United States Magazine and Democratic Review* 18 no. 95 (May 1846), and the N. Currier lithographs of Cassius M. Clay, James K. Polk, and Mrs. Polk, all date from 1846.

7. The copyright is entry number 459, dated November

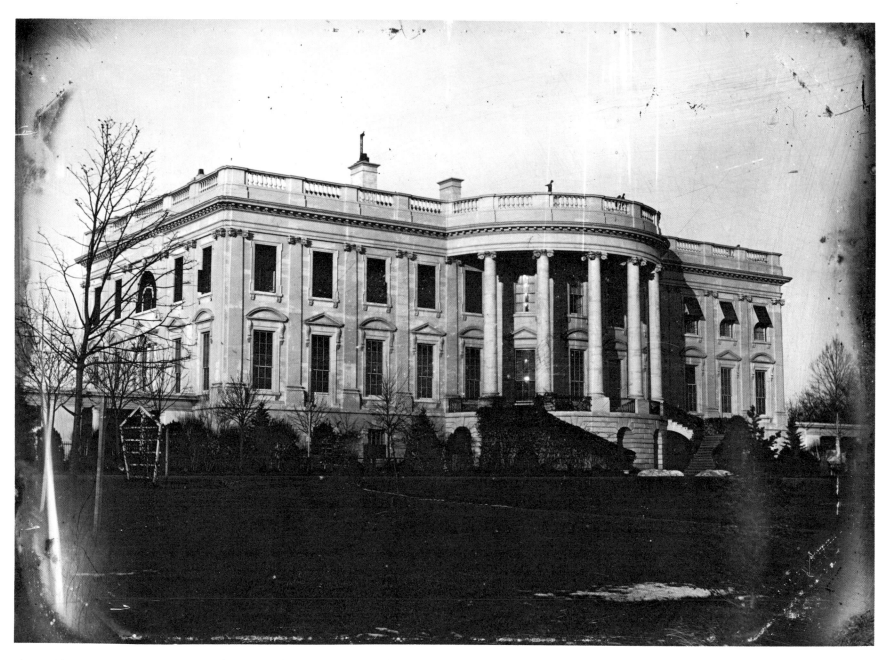

The President's House (White House), Washington, D.C. Daguerreotype (half-plate, approximately 4½ × 5½ inches), attributed to John Plumbe, Jr., about 1846. Probably a wintertime photograph. If this view of the south side of the White House was taken in the morning, as were the other daguerreotypes in the group, it was made without the reversing prism used in the other pictures and, therefore, shows the building in a reverse orientation. LC–USZ62–46804

18, 1846, in the records of the Court of the Eastern District of Pennsylvania, now in the Rare Book Division of the Library of Congress. The copyright claimant was the National Publishing Company.

8. See the list appended to this article. In the files of the New York Public Library Print Room is a copy of a letter dated September 12, 1932, written by Clarence Brigham of the American Antiquarian Society to a Charles H. Taylor of Boston, discussing the nature of the plumbeotype and the scarcity of surviving issues of the *Plumbe Popular Magazine*, published weekly from October 31 to November 28, 1846.

9. The most substantial biographies of Plumbe are "John Plumbe, Originator of the Pacific Railroad," by John King, in *Annals of Iowa*, 3d ser. 6, no. 4 (January 1904): 288–96, and "John Plumbe, America's First Nationally Known Photographer," by Robert Taft, in *American Photography* 30, no. 1 (January 1936): 1–12. Plumbe is also discussed in two books by Floyd and Marion Rinhart: *American Miniature Case Art* (New York: A. S. Barnes, 1969) and *America's Affluent Age* (New York: Barnes, 1971).

10. *Daily Madisonian*, p. 3, col. 1. Robert Taft, in the *American Photography* article cited above (pp. 1–2), states that Plumbe became acquainted with daguerreotypy during a visit to Washington in 1840; Taft indicates that Plumbe met Stevenson, an itinerant daguerreotypist and student of Wolcott, while Plumbe was visiting Washington on railroad business. Although the statement is plausible, we find no further evidence to substantiate it. Samuel C. Busey's "Early History of Daguerreotypy in the City of Washington," written in 1898 and published in *Records of the Columbia Historical Society* 3 (1900): 81–95, gives an inaccurate account, but our search of advertisements, directories, and journalists' accounts has uncovered no daguerreotypist at work in Washington professionally before Plumbe; Philip Haas has been reported as working experimentally as early as 1843.

11. Letter in Iowa Department of History and Archives, Des Moines (General George W. Jones Collection, vol. 5). This letter was transcribed from a microfilm at the National Archives by Josephine Cobb, who kindly brought it to our attention.

12. John Carl Parish, *George Wallace Jones*, Iowa Biographical Series (Iowa City: The State Historical Society of Iowa, 1912), p. 172.

13. *Daily Madisonian* (Washington, D.C.), p. 3, col. 1.

14. *Daily National Intelligencer* (Washington, D.C.), December 10, 1845, p. 3, col. 5, and March 11, 1846, p. 1, col. 2; *Daily Times* (Washington, D.C.), February 20, 1846, p. 2, col. 6, and March 13, 1846, p. 2, col. 6.

15. *Daily Times* (Washington, D.C.), March 5, 1846, p. 3, col. 1.

16. *Daily Times* (Washington, D.C.), March 13, 1846; p. 2, col. 6.

17. Ibid.

18. *United States Journal* (Washington, D.C.), January 29, 1846, p. 2, col. 1.

19. *Daily Madisonian* (Washington, D.C.), January 31, 1845, p. 2, col. 2.

20. Ibid., quoting "The editor of the New York Mirror."

21. Ibid.

22. *Photographic Art Journal* 1, no. 3 (March 1851): 141.

23. *Daily Madisonian* (Washington, D.C.), March 14, 1845, p. 2, col. 6.

24. Taft, pp. 6–7.

25. Busey, pp. 84 and 92; Taft, p. 10.

26. *A Faithful Translation of the Papers Respecting the Grant made by Governor Alvarado to John A. Sutter* (Sacramento, Calif.: Sacramento Book Collectors Club, 1942; reprint of pamphlet published in 1850). Translation by W. E. P. Hartnell of Governor Alvarado's grant, with remarks on the grant by John Plumbe.

27. Parish, p. 172. The "autobiography" was written shortly before the death of General Jones in 1896.

28. See King article cited above and also "Plumbe's Railroad to the Moon," by Jack T. Johnson, in *The Palimpsest* 19, no. 3 (State Historical Society of Iowa, March 1938): 89–97. Plumbe himself wrote *Memorial Against Mr. Asa Whitney's Railroad Scheme* (Washington, 1851), directed to the U.S. Congress, and *Plumbe's Memorial Pacific Railroad* (n.p., 1850), in defense of his plan.

29. Rinhart, *America's Affluent Age*, p. 223.

A Checklist of Daguerreotype Images by John Plumbe, Jr., and Reproductions

This is an attempt to gather together all of the currently known daguerreotypes made by or attributed to Plumbe. Included are images specifically described by earlier writers, those reproduced in various media (including plumbeotype), and surviving original daguerreotypes. When no location is given, the present whereabouts are unknown. The authors will be grateful for any additions or corrections to this list.

I. Identified Portraits

1. Adams, Charles F. *Lithograph*, 1848, by N. Currier, after a daguerreotype by Plumbe. See also Van Buren. LC

2. Adams, John Quincy. *Daguerreotype* seen by correspondent in the *Daily Times* (Washington, D.C.), February 20, 1846. *Plumbeotype*, NYPL

3. Anderson, Alexander. Reference to *daguerreotype* portrait made in New York before 1858 in books on Anderson by Benson Lossing and Frederic Burr.

4. Bancroft, George. *Plumbeotype*, NYPL

5. Beck, John B., M.D. See Faculty of the College of Physicians and Surgeons . . .

6. Binns, Alderman John. *Plumbeotype*, NYPL

7. Bowlin, James B. (St. Louis, Mo.). *Engraving* in *United States Magazine, and Democratic Review*, May 1846, after daguerreotype by Plumbe.

8. Breckinridge, John, D.D. *Plumbeotype*, drawn [on stone?] by A. Newsam after painting by Sartain, NYPL and SI

9. Burke, Edmund (U.S. Commissioner of Patents). *Engraving* in *United States Magazine, and Democratic Review*, 1847, p. 73, after daguerreotype by Plumbe.

10. Calhoun, John C. (Senator, South Carolina). *Plumbeotype*, NYPL

11. Cass, Lewis. *Plumbeotype*, NYPL

12. Childs, Albert, and Nathaniel Ruggles. *Daguerreotype* (½ plate, tinted), stamped "Plumbe" and with written date November 25, 1842. LC

13. Childs, Henry, George Childs, and Stephen Childs. *Daguerreotype* (½ plate, tinted), stamped "Plumbe" and with written date November 25, 1842. LC

14. Clay, Cassius M. *Lithograph*, 1846, by N. Currier, after daguerreotype by Plumbe. LC

15. Clay, Henry. *Lithograph*, 1848, by N. Currier, after daguerreotype by Plumbe. LC

16. Cole, Anna Maria. *Plumbeotype*, NYPL (used as cover for music sheet "Child of the Angel Voice and Lute!")

17. Corcoran, Thomas. *Plumbeotype*, NYPL

18. Coskery, Henry B. (Rector of Baltimore Cathedral). *Plumbeotype*, NYPL

19. Davis, John W. (Speaker of the U.S. House of Representatives). *Daguerreotype* seen by correspondent to *National Intelligencer*, December 10, 1845.

20. Dewey, Rev. Dr. Orville. *Plumbeotype*, NYPL, NYPL–P, and SI

21. Dickinson, Daniel S. *Engraving* in *United States Magazine, and Democratic Review*, August 1846, after daguerreotype by Plumbe.

22. Faculty of the College of Physicians and Surgeons of the University of the State of New York. Portraits on stone by F. Davignon from daguerreotypes by Plumbe; *Lithograph* of G. and W. Endicott . . . N.Y. Published by Samuel S. and William Wood; copyright 1846. Portraits of Doctors Beck, Gilman, Parker, Smith, Stevens, Torrey, and Watts. LC

23. Gilman, Chandler R., M.D. See Faculty of the College of Physicians and Surgeons . . .

24. Hannegan, Hon. Edward (U.S. Senator, Indiana). *Engraving* in *United States Magazine, and Democratic Review,* June 1846, after daguerreotype by Plumbe.

25. Hilliard, Henry W. *Plumbeotype,* NYPL

26. Houston, Sam. *Plumbeotype,* NYPL

27. Hoyt[?], D. N. *Plumbeotype,* NYPL and NYPL–P

28. Irving, Washington. *Engraving on wood* by T. Johnson, ca. 1850, after daguerreotype by Plumb[e]. NYPL–P

29. Johnson, Cave. (Postmaster-General). *Plumbeotype,* NYPL

30. Johnson, Richard M. (U.S. Vice President). *Plumbeotype,* NYPL

31. Lane, Louis M. *Plumbeotype,* NYPL, NYPL–P, and Carson

32. Lewis, Ellis (judge, Pennsylvania). *Engraving* in *United States Magazine, and Democratic Review,* 1847, p. 355, after daguerreotype by Plumbe.

33. Mowatt, Mrs. *Plumbeotype,* NYPL

34. Pakenham, Sir Richard (British Minister). *Plumbeotype,* NYPL and SI

35. Patterson, Robert (Major-General, U.S. Army). *Plumbeotype,* NYPL

36. Parker, Willard, M.D. See Faculty of the College of Physicians and Surgeons . . .

37. Plumbe, John, Jr. *Plumbeotype* (self-portrait[?]), NYPL

38. Polk, James K. (President-elect). *Daguerreotype* seen by correspondent to the *Daily Madisonian,* February 22, 1845. *Lithograph,* 1846, by N. Currier after daguerreotype by Plumbe. LC

39. Polk, Mrs. James K. *Lithograph,* 1846, by N. Currier, after daguerreotype by Plumbe.

40. Pratt, Zadoch (Member of Congress, New York). *Engraving* in *United States Magazine, and Democratic Review,* 1846, p. 473, after daguerreotype by Plumbe.

41. Ringgold, Major. *Plumbeotype* used as music cover to "Major Ringgold's Funeral March," copyright 1846. NYPL and Carson

42. Ruggles, Nathaniel. See Childs, Albert.

43. Seaton, Col. W. W. (Mayor of Washington, D.C.). *Plumbeotype,* NYPL and NYPL–P

44. Smith, Joseph Mather, M.D. See Faculty of the College of Physicians and Surgeons . . .

45. Shaw, Charlotte. *Plumbeotype* music cover for "Lady! The Rose I Give to Thee." Copyright 1846. AAS

46. Stevens, Alexander H., M.D. See Faculty of the College of Physicians and Surgeons . . .

47. Thomas, Francis (U.S. Representative, Maryland).

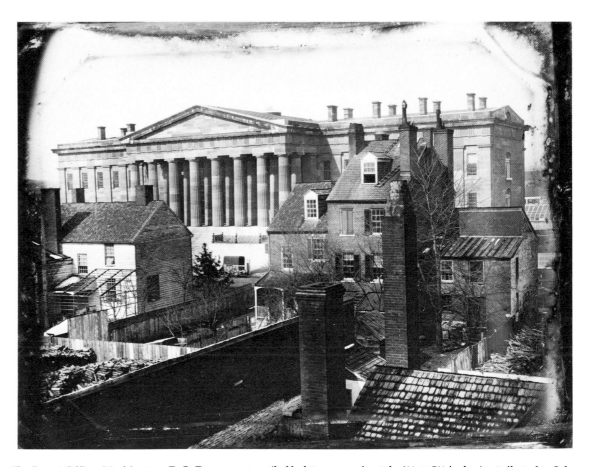

The Patent Office, Washington, D.C. Daguerreotype (half-plate, approximately 4½ × 5½ inches), attributed to John Plumbe, Jr., about 1846. Possibly taken from an upper floor of the General Post Office, this shows the F Street facade of the building; the camera is located near Seventh Street, and Eighth Street is at the left of the picture. Note the woodpiles and outbuildings in the foreground and the greenhouse and private homes in the right background. LC–USZ62–46805

Engraving, n.d., by A. Sealey, after daguerreotype by Plumbe. Carson

48. Thoreau, Henry David (supposedly). *Daguerreotype* reproduced in Rinhart, *America's Affluent Age,* p. 161.

49. Tibbatts, John W. (U.S. Representative, Kentucky). *Engraving* in *United States Magazine, and Democratic Review,* September 1846, after daguerreotype by Plumbe.

50. Tom Thumb, General. *Lithograph,* 1849, by N. Currier (Barnum's Gallery of Wonders, No. 1) after daguerreotype by Plumbe. LC

51. Torrey, John, M.D. See Faculty of the College of Physicians and Surgeons . . .

52. Van Buren, Martin. *Daguerreotype* seen by correspondent to the *National Intelligencer,* March 11, 1846, and to the *Daily Times,* March 13, 1846; *Plumbeotype,* NYPL; *Lithograph* by N. Currier, 1848, used as campaign banner with C. F. Adams. LC

53. Venus. *Daguerreotype* by Plumbe after painting said to be by Titian. Mentioned in Helen Nicolay, *Our Capital on the Potomac,* p. 283.

54. Warrington, Rose. *Plumbeotype,* NYPL

55. Washington, George. *Plumbeotype* after C. W. Peale lithograph (or painting), NYPL and Carson

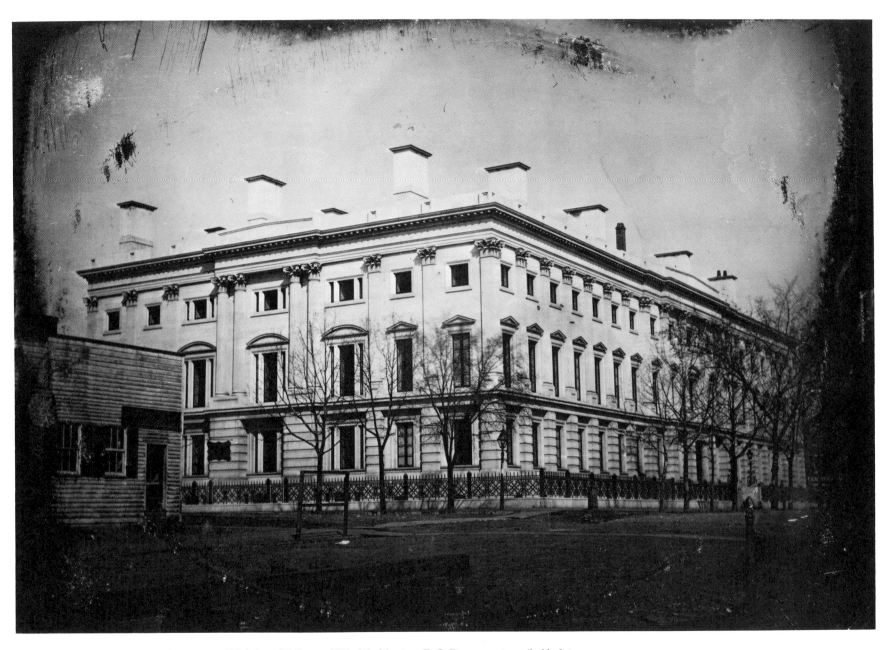

The General Post Office, from the corner of Eighth and E Streets NW., Washington, D.C. Daguerreotype (half-plate, approximately 4½ × 5½ inches), attributed to John Plumbe, Jr., about 1846. The shop of Elijah Dyer, Merchant Tailor, is on the left. LC–USZ62–46802

56. Watson, William C. *Plumbeotype*, NYPL and NYPL–P

57. Watson, Col. William H. *Plumbeotype* used as music cover for ''Weep for the Gallant Dead,'' copyright 1846. NYPL and LC

58. Watts, Robert, Jr., M.D. See Faculty of the College of Physicians and Surgeons . . .

59. Welby, Amelia B. *Plumbeotype*, NYPL

60. White, Rt. Rev. William, D.D. *Plumbeotype*, LC

61. Woodbury, Levi (New Hampshire Senator and judge). *Daguerreotype* seen by correspondent to the *Daily Times*, March 13, 1846; *Plumbeotype* (signed in border ''G Worley''), NYPL

62. Wright, Silas (Governor, New York). *Engraving* in *United States Magazine, and Democratic Review*, 1846, p. 349.

II. Unidentified Portraits

63. Man. (collection of Carla Davidson)

64. Old man with cane. 1844. (reproduced in Rinhart, *America's Affluent Age*, p. 224.)

65. Two young boys. 1846. (reproduced in Rinhart, *America's Affluent Age*, p. 297).

66. Old woman. 1841(?) (reproduced in Rinhart, *America's Affluent Age*, p. 23).

67. Two boys. (recently on the market, sold to an unidentified buyer.)

68, 69, 70. Three portraits. (collection of Josephine Cobb)

III. Buildings and Monuments

71. Battle Monument, Baltimore, Md. *Daguerreotype*, LC

72. Capitol, Washington, D.C. *Daguerreotype*, LC; *Plumbeotype*, LC, NYPL, NYPL–P

73. ———Another *Daguerreotype*, Kessler

74. Naval Monument (Washington?), *Daguerreotype* described by correspondent to *National Intelligencer*, January 28, 1846.

75. Patent Office, Washington, D.C. *Daguerreotype*, LC

76, 77. Post Office, Washington, D.C. (two views). *Daguerreotype*, LC

78. Washington Monument, Baltimore, Md. *Plumbeotype*, NYPL, MHS, PM, PFL

79. White House, Washington. *Daguerreotype*, LC

List of Abbreviations for Collections

AAS—American Antiquarian Society, Worcester, Mass.
Carson—Mrs. Joseph Carson, Philadelphia, Pa.
Kessler—Mr.Michael Kessler, Los Angeles, Calif.
LC—Library of Congress, Washington, D.C.
MHS—Maryland Historical Society, Baltimore, Md.
NYPL—New York Public Library, Rare Book Room.
NYPL–P—New York Public Library, Print Room.
PFL—Free Library of Philadelphia.
PM—Peale Museum, Baltimore, Md.
SI—Smithsonian Institution, National Museum of History and Technology, Division of Graphic Arts.

James B. Bowlin. Engraving after a daguerreotype by Plumbe. In the *United States Magazine and Democratic Review*, 18, no. 14 (May 1846).

Roger Fenton, Photographer of the Crimean War

by Hirst D. Milhollen

Fifteen years after the first successful experiments in photography in 1839, Roger Fenton, an Englishman from Lancashire, saw the possibility for pictorial documentation of the Crimean War. Messrs. Agnew and Sons of Manchester became interested in the idea and commissioned Fenton to make the trip to the Crimea. Although there are several photographs taken during the War with Mexico, this was the first war actually to be covered by a photographer. Besides Fenton, another Englishman, Robertson, had gone to the Crimea on a similar mission.

Like every pioneer, Roger Fenton was faced with many problems of technical equipment and supplies. He was fortunate, however, in the selection of Marcus Sparling as an assistant. Sparling was known as a shrewd, clever, and practical photographer, and he was conversant with the routines of military life.

The need for a perfectly darkened room (not likely to be found on the field of battle or before the beleaguered wall of Sevastopol) was satisfied when a carriage was secured from a wine merchant in Canterbury. Panes of yellow glass, with shutters, were fixed in the sides. A bed, which folded up into a very small space, and sections for fixing gutta-percha baths, glass-dippers, knives, forks, and

Roger Fenton. LC–USZ62–2318

spoons were constructed. This photographic van, as it was called, soon became a familiar sight on the Crimean battlefields.

The equipment which this early combat photographer carried to the Crimean beaches in 1855 included seven hundred glass plates of three different sizes, fitted in grooved boxes; five cameras; several cases of chemicals; a small still with stove; three or four printing frames; gutta-percha baths; dishes; and a few carpenter's tools. In addition to these purely photographic supplies, several boxes of preserved meats, wine, biscuits, harness for three horses, a tent, tools, and a great many smaller things likely to be useful were purchased, everything being packed in thirty-six large boxes.

After much delay, Fenton and Sparling sailed in the middle of February on the ship *Hecla*. Arriving in the harbor of Balaklava in March with his five cameras of assorted sizes, baggage, horses, and van, Fenton received his first impression of the war while still aboard the *Hecla*, jammed in the narrow harbor surrounded by hundreds of ships and thousands of fighting men. Here he watched the flashes of red light over the hills toward Sevastopol and listened to the heavy thunder of artillery.

The next morning Fenton went ashore with

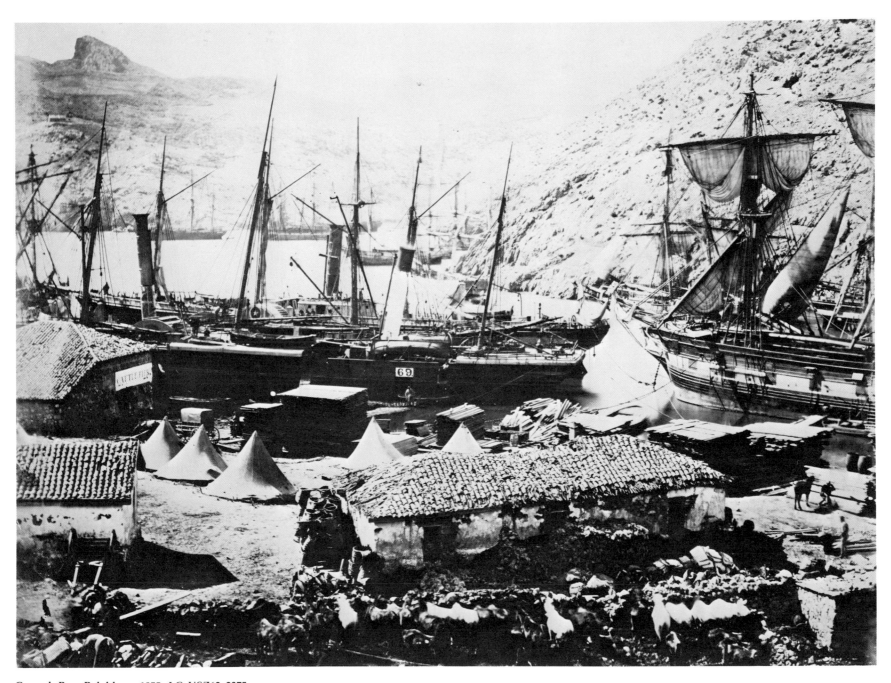

Cossack Bay, Balaklava, 1855. LC–USZ62–2375

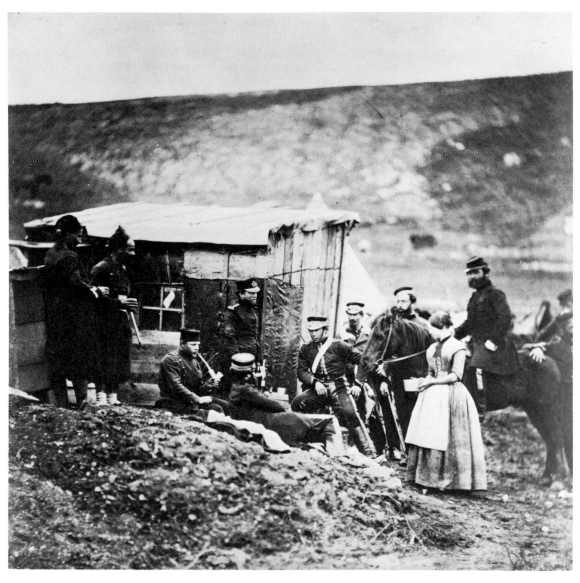

Captain of the Fourth Dragoons with his men. The appearance of a woman is rare among the Fenton photographs. LC–USZ62–47544

his baggage, but was unable to unload the van containing his photographic laboratory because of its size. After searching for two days, after going to the admiral and to the captain of the port, receiving from every one kind attention and promises of assistance, but finding that either the promised barge was loading with shell and would not be empty or that the barge was there but that the men who belonged to it had just been ordered elsewhere, Fenton finally managed to reach the shore safely with all of his equipment. After making arrangements with Colonel Harding, the Commandant of Balaklava, for permission to erect a hut to store his numerous boxes of equipment, he took a few pictures on the spot.

Fenton began to work seriously, occupying himself for some time in taking views in the town of Balaklava and its neighborhood and the cavalry camp beyond Kadikoi. Later, with the aid of six artillery horses, he moved up to the front where he remained until the end of May, when he obtained leave to join the Kerch expedition. He returned to camp in time to witness the attack on the Mamelon by the French and on the Quarries by the British troops. On the day of these battles Fenton photographed General Pelissier at a very early hour and the group of three commanders-in-chief in council.

Later, Fenton drove his van near the besieged city of Sevastopol to secure a good view of that portion which was under bombardment. This bulky vehicle speedily attracted the attention of the enemy, who doubtlessly supposed it contained ammunition or other military supplies and made it a target for their shells. Fenton soon acquired coolness in the presence of danger, even when he heard the shells whistle about his wooden vehicle, and fall around it, and though on one occasion a well-directed shell

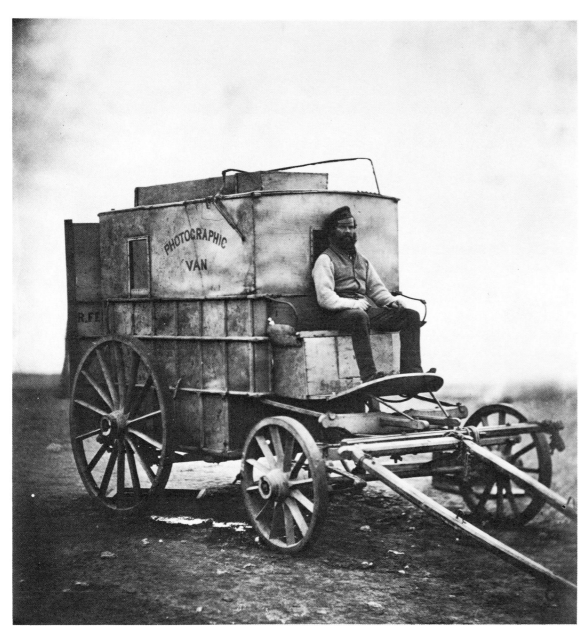

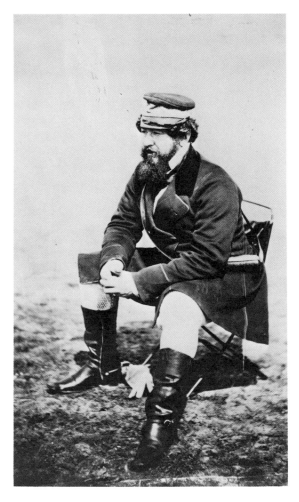

Times Special Correspondent William H. Russell. LC–USZ62–68258

The photographic van used by Roger Fenton during the Crimean War. Fenton's assistant, Marcus Sparling, is on the van. LC–USZ62–2319

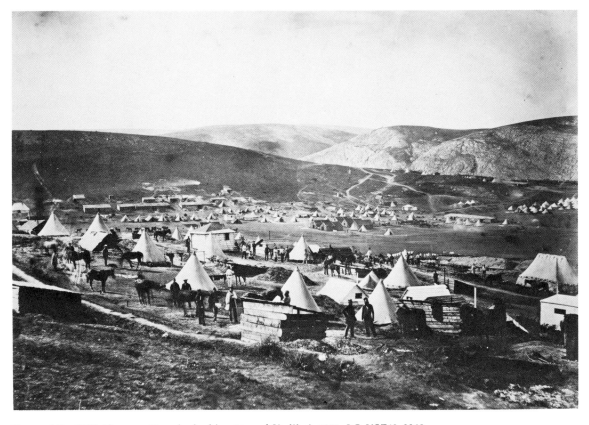

Camp of the Fifth Dragoon Guards, looking toward Kadikoi, 1855. LC–USZ62–2369

struck its upper part and tore off a portion of the roof.

In a letter written on April 4, 1855, Fenton described some of the other difficult conditions under which he worked:

I get on very slowly with my work here. The labour is in itself great & many pictures are spoilt by the dust & heat, still more by the crowd of people of all ranks who flock around.

Twenty-five days later, on April 29, he wrote:

I am really bothered with applications to take portraits, this after all is my chief hindrance, if I refuse to take them I get no facilities for conveying my van from one locality to another, if I take only those that the public care about, I generally find that they have no time or dont like humbug, or want their horses taken & not themselves.

Back in England, Messrs. Agnew and Sons were getting impatient about the financial success of this new adventure. Fenton was well pleased with the results of his work and in a letter of June 9, 1855, to an unidentified friend wrote:

Dear Joe, I got your note yesterday & have just time before post to answer it. Agnew distresses himself for nothing, he is sure to make lots of money by the transaction, even I could. As for sending him the negatives, he does not know what he asks. They would be ruined in a fortnight in the hands of anyone he could get to print them. Besides they are not all his. I shall start from here as soon as I can.

Fenton returned to England with around 350 negatives from which he was able to obtain prints of a high quality. The Library of Congress was fortunate to acquire 269 of these photographs from a Fenton descendant. Among these pictures are photographs of battlefields and camp life, views of the harbor at Balaklava, and portraits of the leading commanders of the British, French, and Turkish armies as well as the men in the ranks. Unlike Mathew Brady in the Civil War, Fenton was not able to cross over to the enemy lines and photograph the opposing army.

Some of the remarkable photographs with titles on the backs in what is thought to be Roger Fenton's handwriting, are: Field Marshall Lord Raglan; Lt. Col. Clarke Kennedy; the duke of Cambridge; Sir Colin Campbell; Commissary General Felder; Lt. Gen. Sir John Campbell; Omar Pacha (commander of the Turkish army); Lt. Col. Prince Edward of Saxe Weimar; Maréchal Pelissier, G. C. B. (commander of the French army); General Sir James Simpson; Lt. Gen. Sir George Brown,

G. C. B., K. A.; General Bosquet giving orders to his staff; Council of war held at Lord Raglan's headquarters the morning of the successful attack on the Mamelon—Lord Raglan, Maréchal Pelissier and Omar Pacha (Lord Raglan, who fell a victim to dysentery, died soon after this photograph was taken); Private in full marching order; Zouaves and soldiers of the line; Mr. William Simpson, the artist; The photographer's van; Cavalry camp near Balaklava; Balaklava, looking seawards, the commandant's house in the foreground; Landing place, ordnance wharf, Balaklava—Genoese Castle in the distance; The town of Balaklava; Balaklava Harbour, the Castle Pier; General view of Balaklava; Cossack Bay, Balaklava; Artillery wagons, view looking toward Balaklava; Mortar batteries in front of picquet house; Quiet day in the mortar battery; Landing place, railway stores, Balaklava—looking up the harbor; The Valley of the Shadow of Death.

Roger Fenton was one of the early promoters of the London Photographic Society and for several years after its establishment filled the post of honorary secretary. His photographs taken in the Crimea were exhibited in the Suffolk Street Gallery and in Paris. While in Paris, he was commanded to present himself at St. Cloud where he was received with the greatest kindness by the emperor, who spent an hour and a half in looking over the collection.

Fenton contributed many articles to the London Photographic Society's *Journal*, which offered valuable information and the results of his experience to his fellow photographers. Some of the more important articles concerned the waxed-paper process, Herr Pretsch's photo-galvanographic process, collodion prepared from methylated ether, the law of artist's copyright, and Professor Pelzval's lenses.

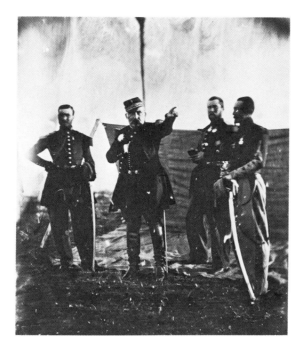

General Bosquet giving orders. LC–USZ62–2449

Montenegran soldiers. LC–USZ62–68257

In later years, however, he allowed photography to "lie on the shelf" and devoted himself to other pursuits. He practised law for some time and was also connected with the stock exchange. He died on August 8, 1869, after an illness of six days, at the comparatively early age of fifty.

August 1946

23

Two Photographs of Abraham Lincoln

A Calvin Jackson Ambrotype and a Mathew B. Brady Negative

by Paul Vanderbilt

In 1952 two original photographic plates showing Abraham Lincoln were presented to the Library by Mr. Louis M. Rabinowitz of New York City. One is the ambrotype made at Pittsfield, Ill., by Calvin Jackson in 1858, during the period when Lincoln was engaged in the debates with Stephen A. Douglas. The other is the negative of the photograph commonly known as "The Universal Lincoln," probably made on February 9, 1864, by Mathew B. Brady, which has been adopted for official use by the government and which appears engraved on the United States five-dollar bill. These acquisitions bring to the Library the third earliest portrait of Lincoln which can still be located as an original and the original of the most frequently reproduced of all Lincoln photographs, the one which Robert Todd Lincoln called "the most satisfactory likeness" of his father.[1]

The ambrotype was made during the afternoon of October 1, 1858. After being driven in a wagon "drawn by six black horses" to the Pittsfield town square, Lincoln delivered a speech lasting about two hours. He then went "with Dr. D. H. Gilmer, a lawyer, to the car of an itinerant ambrotypist, C. Jackson, and two portraits were made, $3\frac{1}{4} \times 5\frac{1}{2}$ inches in size. One was finished for Mr. Gilmer, the other is believed to be destroyed."[2] That the ambrotype kept by Gilmer is the one acquired by the Library is confirmed by its bearing a small paper label on which is written in ink: "Lizzie Gilmer, Pittsfield, Illinois. This ambrotype belongs to Lizzie Gilmer, Pittsfield, Illinois." It later passed into the collection of Charles F. Gunther of Chicago, from whom it was acquired by Oliver R. Barrett; and Mr. Rabinowitz purchased it for the Library at the Barrett sale in February 1952.

A word of explanation needs to be given about the term "ambrotype," which applies to a technique of mounting or presentation and not to a technique for making a plate. An ambrotype is a thin photographic negative, made by the wet collodion process on a glass plate, but set in a case like a daguerreotype and kept as an original rather than as a master for producing multiple prints on paper. Though the plate is actually a negative, it is mounted so that when viewed by reflected rather than transmitted light it appears as a positive image. The plate is backed up by a black substance of some sort—either a velvet lining in the case, or black paper or enamel on the back of the plate itself—so that the thin parts of the negative show through to the black backing and appear as the "darks" of the image; the opaque portions, on the other hand, are developed so as to have a white or light surface and they appear as the "lights" of the image. The same plate, removed from its case and dark backing and held up to transmitted light, appears as a negative, the thin parts appearing as "lights" and the opaque parts, regardless of their surface color, as "darks." The ambrotype technique occupies an intermediate position between daguerreotypy and photographic printing from negatives, and was used only from about 1854 to about 1858.

The earliest portraits of Lincoln, according to Lorant,[3] are apparently these:

(1) Daguerreotype attributed to N. H. Shepherd, 1846 (Meserve, No. 1, dates this "about 1848"). Original in the Library of Congress.

(2) Photograph by Alexander Hessler, February 28, 1857 (Meserve, No. 6). Negative lost in the Chicago fire of 1871.

(3) Ambrotype by S. G. Alschuler, April 1858 (Meserve, No. 5, places this in the fall of 1857). Original owned at one time by Charles F. Gunther, but present location unknown.

(4) Ambrotype by Amon T. Joslin, April 1858 (Meserve, No. 2, ascribes this to 1853). Location of original unknown.

(5) Ambrotype by A. B. Byers, May 7, 1858 (Meserve, No. 7). Original at the University of Nebraska.

(6) Daguerreotype by P. Von Schneider, July 1858 (Meserve, No. 3, dates this "about 1854"). Known only from photocopies.

(7) Ambrotype by W. P. Pearson, August 28, 1858 (Meserve, No. 11). Original destroyed in a fire at the Century Building, New York City, in 1888.

(8) Ambrotype by Calvin Jackson, October 1, 1858 (Meserve, No. 12). Presented by Mr. Rabinowitz to the Library of Congress.

Extensive inquiry has failed to turn up any of the plates mentioned above as of unknown location. Hence, if this chronological sequence be accepted, the Library has two of the three earliest locatable originals.

But the plate has an importance beyond that of its early date. As a strong characteristic likeness of Lincoln it is surpassed only by the seventh listed above, made by Pearson in 1858. The other early portraits, including the first daguerreotype, do not show Lincoln to very good effect. The Library's ambrotype, despite its poor condition—it has been defaced by attempts at cleaning, which left a multitude of scratches—is the most appealing and sympathetic of the earliest plates now existing as originals.

The Brady negative of Lincoln acquired by the Library is one of several which, according to Meserve, were made on Tuesday, February 9, 1864.[4] Mathew B. Brady, who is best known for his photographs of the Civil War, was the founder of one of the most prominent studios in Washington, and photographed Lincoln at least twenty-nine times. In his later years he took into his business his nephew,

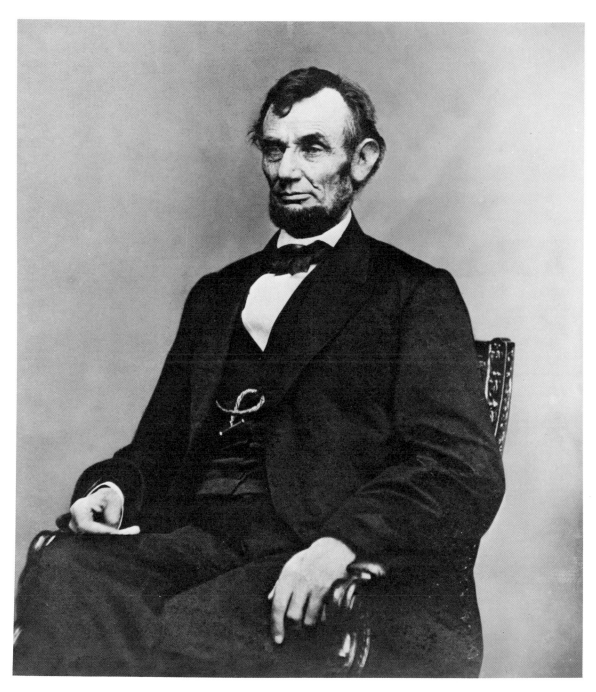

Photograph of Abraham Lincoln by Mathew Brady, February 1864 (Retouched). LC–USP6–2415A

Levin C. Handy, who received the Lincoln negative from him and passed it on to his daughters, the proprietors of the Handy studio; from them it was purchased by Mr. Rabinowitz. Thus the negative's provenance is established with unquestioned authenticity.

It has, unfortunately, suffered at the hands of time. Some time during the late nineteenth century it became cracked all the way down the middle, and it suffered further damage from heat and water in a fire at the Handy studio during the First World War. But while marred, the negative is still a strong and beautiful likeness, and Lincoln's face, except for a minute surface crackling, has survived well.

Meserve's dating of the photograph is, apparently, not positive.[5] Brady did not enter the portrait for copyright until the following year, 1865. The most specific reference to Lincoln's sitting for his portrait on February 9, 1864, is found in Francis B. Carpenter's *Six Months at the White House* (New York, 1866), p. 35:

> At three o'clock the President was to accompany me, by appointment, to Brady's photographic galleries on Pennsylvania Avenue. The carriage had been ordered, and Mrs. Lincoln, who was to accompany us, had come down at the appointed hour, dressed for the ride, when one of those vexations, incident to all households, occurred. Neither carriage or coachman was to be seen. . . .
>
> At this point, having finished his letter, the President turned to me and said: "Well, we will not wait any longer for the carriage; it won't hurt you and me to walk down." . . .
>
> The walk, of a mile or more, was made very agreeable and interesting to me by a variety of stories, of which Mr. Lincoln's mind was so prolific.

That Carpenter, the painter who was to become a longtime resident at the White House, accompanied Lincoln to Brady's studio is interesting to note. He had arrived in Washington the previous Thursday (February 4), his mission being to paint a portrait

showing Lincoln with his Cabinet on the occasion of the first reading of the Emancipation Proclamation. The case for making such a painting—urged upon Lincoln by Speaker Schuyler Colfax, Owen Lovejoy, and others—was apparently that having it reproduced and made widely known by engravings would be an excellent political move. Lincoln thought so well of the plan that he accepted Carpenter immediately, allowed him to stay in his conference room day after day and sketch while he transacted official business, and gave him hospitality at the White House for the six months required to complete the painting.

It is reasonable to suppose that the appointment at Brady's, made soon after Carpenter's arrival, was arranged in order to give Carpenter photographs to use in his work.[6] The pose of the Library's negative approximates that of the painting, and the other poses made at the February 9 sitting may also have been alternatives for his use.

There quite probably were political reasons, too, for the making of the photographs. The National Conference Committee of the Union Lincoln Association of New York had issued an address calling upon friends of President Lincoln to hold meetings throughout the State on February 22 to forward his nomination for reelection. With the coming campaign in view, good likenesses of the President would be needed. Even Lincoln's supporters could not claim with entire truth that his pictures represented satisfactorily the "sad, scrawny, intricate character who sat at the helm in the storm center in Washington." Typical of the hostile comments some of them inspired is one quoted by the *Charleston Mercury* from a Paris correspondent, in a paragraph headed "Lincoln's Phiz in France." Urging that export of the President's pictures to France be prohibited because of their mis-

use there, it continued: "The person represented . . . looks so much like a man condemned to the gallows that large numbers of them have been imposed on the people here as Dumollard, the famous murderer of servant girls, lately guillotined near Lyons."

A third reason for making a Lincoln photograph at this time may have been to secure one to use on the currency. Lincoln portraits had appeared on the one-dollar banknotes issued by the Bank of Commerce of Georgetown on April 23, 1860, on other issues of 1861 including the fifty-cent greenbacks, and on the United States legal tender ten-dollar note of 1862. The act prohibiting the use of portraits of living persons on the currency was not passed until 1866. Brady himself said in an interview that Secretary Seward made arrangements with him to have some portraits made for Treasury Department use on banknotes, and a contact print of the "Universal Lincoln" photograph received by the Library from the Handy studio is annotated in pencil "in 1864, at request of Sect. Seward," a statement based, according to the studio proprietors, on family tradition. We have not, however, found any Treasury Department statement or any pronouncement by Secretary of State Seward to support this view.

In the course of time the photograph did come to be selected as the official prototype for portraying Lincoln on the currency. An engraving from the Brady likeness was first used on the $100 United States Treasury note of 1869; this was executed by Charles Burt of Brooklyn, who also did the portrait of DeWitt Clinton which could be seen on stamps affixed to every pack of cigarettes. The Lincoln portrait later appeared on the $100 legal tender note of 1880, the one-dollar silver certificate of 1899, and the five-dollar bills from those of 1914 to the current issues of 1928,

1929, and 1934. It has also been reproduced on the four-cent brown postage stamp of 1890 and 1894, the five-cent blue stamp of 1903, the three-cent violet stamp of 1923, the $1,000 Series E Savings Bond, and the five-cent Chinese commemorative stamp of 1942. There have been innumerable unofficial uses as well—on at least fifty-one known varieties of counterfeit five-dollar bills, to cite only one example.

There are several descriptions of Lincoln by contemporaries who saw him at about the time the photograph was made. Francis B. Carpenter, recalling his six months at the White House, wrote as follows:

His head was of full medium size, with a broad brow, surmounted by rough, unmanageable hair, which, he once said, "had a way of getting up as far as possible in the world." Lines of care ploughed his face,—the hollows in his cheeks and under his eyes being very marked. The mouth was his plainest feature, varying widely from classical models,—nevertheless, expressive of much firmness and gentleness of character.

His complexion was inclined to sallowness, though I judged this to be the result, in part, of his anxious life in Washington. His eyes were blueish-gray in color,—always in deep shadow, however, from the upper lids, which were unusually heavy, (reminding me, in this respect, of Stuart's painting of Washington), and the expression was remarkably pensive and tender, often inexpressibly sad, as if the reservoir of tears lay very near

the surface,—a fact proved not only by the response which accounts of suffering and sorrow invariably drew forth, but by circumstances which would ordinarily affect few men in his position.

The Marquis de Chambrun, in his reminiscences of Lincoln, remarked to much the same effect: [7]

I have seen many attempts at portraits of Mr. Lincoln, many photographs; neither his portraits nor his photographs have reproduced, or are likely ever to reproduce, the complete expression of his face; still more will they fail in the reproduction of his mental physiognomy.

He was tall, but his bearing was most peculiar; the habit of always carrying one shoulder higher than the other might make him seem slightly deformed. . . . Nothing seemed to lend harmony to the decided lines of his face; yet his wide and high forehead, his gray-brown eyes sunken under thick eyebrows, and as though encircled by deep and dark wrinkles, his nose straight and pronounced, his lips at the same time thick and delicate, together with the furrows that ran across his cheeks and chin, formed an ensemble which, although strange, was certainly powerful. It denoted remarkable intelligence, great strength of penetration, tenacity of will and elevated instincts. [8]

And finally there is Walt Whitman, writing in *Specimen Days* of the month of Lincoln's assassination:

Probably the reader has seen physiognomies (often old farmers, sea-captains, and such) that, behind their homeliness, or even ugliness, hold superior points so subtle,

yet so palpable, making the real life of their faces almost as impossible to depict as a wild perfume or fruit-taste, or a passionate tone in the living voice . . . such was Lincoln's face, the peculiar color, the lines of it, the eyes, mouth, expression. Of technical beauty it had nothing—but to the eye of a great artist it furnished a rare study, a feast and a fascination.

August 1953

NOTES

1. Letter from Robert Todd Lincoln to Frederick Hill Meserve, March 30, 1910. See Frederick Hill Meserve, *The Photographs of Abraham Lincoln* (New York, 1911), p. 85, no. 85.

2. *Ibid.*, p. 46, no. 12, quoting Truman H. Bartlett of Boston, Mass.; see also Paul M. Angle, *Lincoln, 1854–1861* (Springfield, Ill., 1933), p. 248.

3. Stefan Lorant, *Lincoln, A Picture Story of His Life* (New York, 1952); see also the same author's *Lincoln, His Life in Photographs* (New York, 1941).

4. The others made at the same sitting, according to Meserve, are those he numbers 39, 41, 81–87, 108, and 119.

5. It is assigned to February 9, 1864, upon advice from Dr. Louis A. Warren, whose reasoning appears in *Lincoln Lore* (Fort Wayne, Ind.), no. 133; see also nos. 193, 211, 245, and 392.

6. He used Meserve No. 39, the well-known picture of Lincoln with his son Tad, shown looking over one of Brady's albums of photographs.

7. The author is indebted to Mr. David C. Mearns for bringing the two following quotations to his attention.

8. Marquis de Chambrun, "Personal Recollections of Mr. Lincoln," in *Scribner's Magazine*, January 1893.

A Preston Butler Ambrotype of Lincoln

by Alan Fern and Hirst D. Milhollen

About 120 different photographic portraits were made of Abraham Lincoln,[1] all but three of them during his last eight years. F. H. Meserve, who collected and cataloged the Lincoln photographs, observed that since many of the portraits were made by such processes as the daguerreotype, which give no negative, the portraits were multiplied by rephotographing onto copy negatives. The original plates, and glass plate negatives made directly from the sitter (when this process was used), are very scarce.[2]

The Library of Congress was fortunate to be able to commemorate Lincoln in the centennial year of his death by announcing the receipt of twelve important Lincoln photographs, a bequest from A. Conger Goodyear, who died April 23, 1964.

Of the photographs in the Goodyear bequest, 11 are copy photographs, made in some cases during Lincoln's lifetime, but not original exposures. While they are valuable additions to our collections, they are not excessively rare. One portrait is not in this category, however, and is one of the most precious single pictures to enter the collections in many years.

It is an ambrotype, or positive photograph on glass, 5¾ × 4½ inches in size, intended for viewing against a dark background, taken in Springfield, Ill., by Preston Butler on August 13, 1860. It is in an original frame of gilt and black wood, measuring 7¾ × 6½ inches. Little is known about the photographer apart from the facts that he had a commercial portrait studio and that he made four photographs of Lincoln for the use of sculptor Leonard W. Volk, but the history of the photograph itself is more complete.

The Republican presidential candidate was an easy mark for the caricaturist, and the opposition lost no time in taking advantage of this. Even some of the "friendly" portraits seemed to work against Lincoln. In Sandburg's words:

> Montgomery Blair told [Francis B.] Carpenter that one of the early pictures of Lincoln, "a hideous painting," had given an unfavorable impression of the President's looks. Carpenter replied: "My friend, Brady the photographer, insisted that his photograph of Mr. Lincoln, taken the morning of the day he made his Cooper Union Speech . . . was the means of his election. That it helped largely to this end I do not doubt. The effect of such influences, though silent, is powerful."[3]

Mr. Brady may have claimed too much of the credit for improving Lincoln's visual image with the electorate. Another Lincoln supporter, Judge John M. Read of Philadelphia, had also been distressed by the uncomplimentary pictures available, and about the time of the Cooper Union speech decided to have a portrait painted which could be used in the campaign. Judge Read commissioned the Philadelphia artist John Henry Brown (1818–91) to paint a flattering portrait of Lincoln, for which he would be paid $175 and an additional $125 in expenses. Brown set out for Springfield at once, nervous about the prospect of flattering a man reported to be so homely, but was immensely relieved upon meeting Lincoln to find him a man of strong and engaging appearance.

Lincoln, busy with his political duties and besieged with requests from artists for sittings, still could not refuse Mr. Brown. The artist wrote: "He at once consented to sit for his picture." A time-saving device was proposed, and "we walked together from the Executive Chamber to a daguerrean establishment. I had half a dozen ambrotypes taken of him before I could get one to suit me."[4]

Only two of Butler's ambrotypes can be identified today, one in the Library of Congress and the other in a private collection in Boston (when last located). The photograph in the Goodyear bequest appears to be the one used by Brown in painting his miniature on ivory. The painting was widely admired and passed into the possession of Robert Todd Lincoln after his father's death. It served its original purpose well, for an engraving by Sartain was made almost as soon as the portrait was completed and was widely circulated by the Republicans during the campaign.

The Library's ambrotype, listed in Mes-

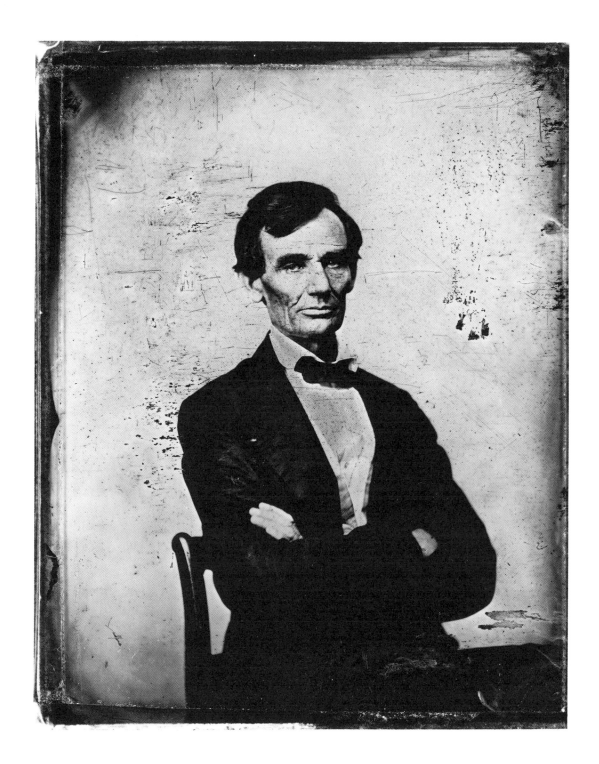

erve's catalog as No. 29, shows the candidate as he was half a year before he grew his beard, seated with arms folded in a straight-backed chair. The ambrotype itself came into the possession of William H. Lambert, the noted Lincoln collector, who purchased it, according to McMurtry, from a Mr. Brown of Philadelphia, possibly a relative of the painter. The photograph remained in the Lambert collection until the sale of Lambert's library and pictures at the Anderson Gallery in 1914, when among other items, 3,298 lots of Lincolniana were sold at auction. The Butler ambrotype fetched $450 (lot 773, sale of Thursday evening, January 15, 1914), a very high price for that time, and the winning bidder was Mr. Goodyear.

January 1966

NOTES

1. Frederick Hill Meserve and Carl Sandburg, *The Photographs of Abraham Lincoln* (New York [1944]).
2. Ibid., p. 25.
3. Ibid., p. 9.
4. From the diary of John Henry Brown, quoted in Charles Hamilton and Lloyd Ostendorf, *Lincoln in Photographs* (Norman, Okla., 1963), p. 369. See also Robert Gerald McMurtry, *Beardless Portraits of Abraham Lincoln* (Fort Wayne, Ind., 1962).

The Mathew B. Brady Collection

by Hirst D. Milhollen

Although the place of his birth has been designated differently by several biographers, family tradition holds that Mathew B. Brady was born near Albany in Warren County, New York, probably in 1823. He died in New York City in 1896 as the result of an accident. Brady, an artist by temperament, acquired his technical knowledge of photography in Paris, where it is said that he met Daguerre. At this time, while only a boy of sixteen, he became interested in the discoveries of Daguerre, Niepce and Fox-Talbot and in the crude beginnings of photography. With the introduction of the collodion process of Scott-Archer, he adopted the science as a profession. During twenty-five years of labor as a pioneer photographer, he took the likenesses of political celebrities of his time as well as of other eminent men and women throughout the country.

In 1861, at the beginning of the Civil War, Brady, foreseeing the importance of making a pictorial record of the conflict, asked permission of the Federal Government to demonstrate the practicability of Scott-Archer's discovery. The request was granted and he invested heavily in cameras which were specifically constructed for the hard usage of warfare. These cumbersome cameras were operated by what is known as the old "wet-plate" process. With him went Alexander Gardner, the English "wet-plate" expert.

After securing his equipment, he pro-

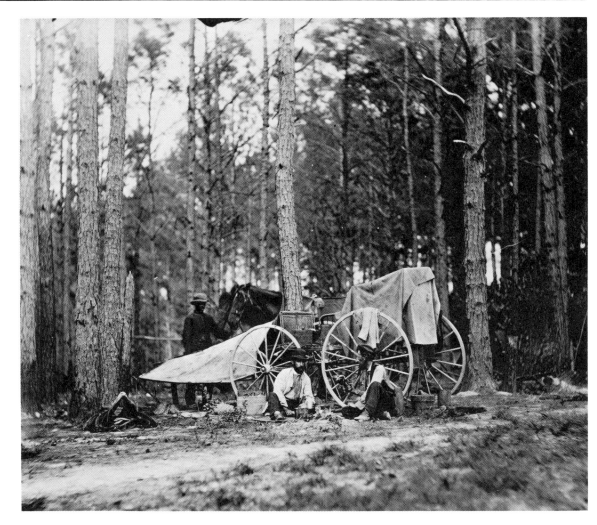

Mathew Brady's photo outfit. LC–B8184–B–5077

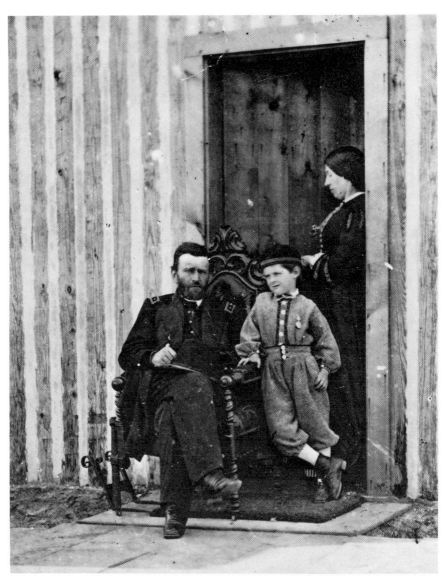

Ulysses S. Grant with his son and wife. LC–B8184–1026

Top: Officers of the Fifty-fifth New York Infantry at Fort Gaines. LC–B8184–B–550

Bottom: Fort Totten powder gun. LC–B8184–7249

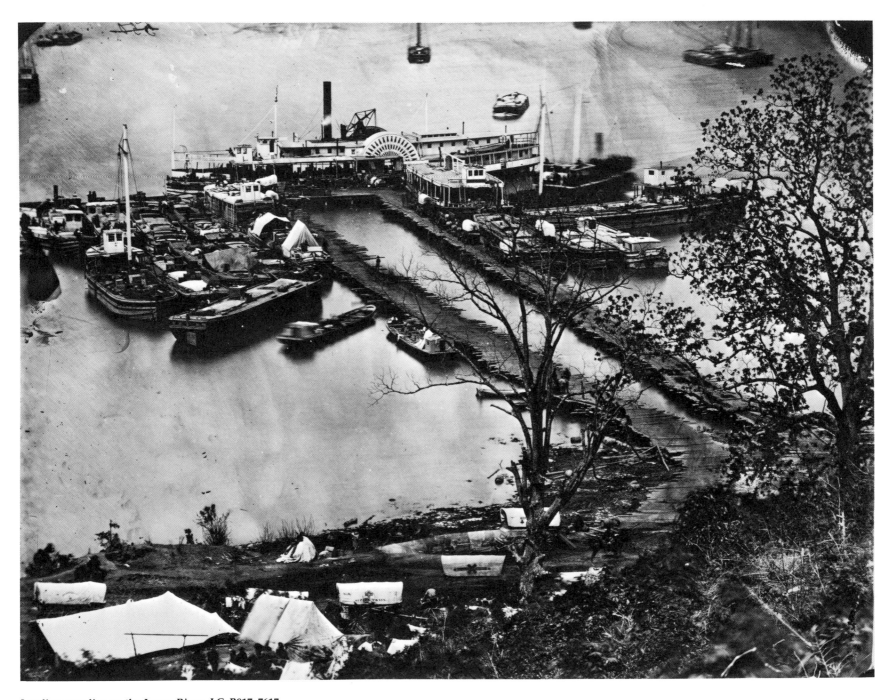

Landing supplies on the James River. LC–B817–7617

ceeded to experiment and was so successful that he attracted the attention of President Lincoln, General Grant and Allan Pinkerton (known as Major Allen [*sic*]), chief of the Secret Service. Equipment was then rushed to a corps of assistants with all divisions of the army; some of it even found its way into the Confederate ranks. Brady himself passed through the Confederate lines, but the secret has never been divulged how he gained the confidence of such men as Jefferson Davis and Robert E. Lee. It is certain that he never betrayed the confidence reposed in him, and the negatives were not used as sources of military information.

Since Brady was unable to raise money, his only recourse was credit. This he secured from Anthony & Co., who by importing photographic materials into America from Europe founded the trade on this continent. The next difficulty was finding men of sufficient knowledge to operate a camera. Nearly every able-bodied man was in the war or doing war work, and among those available, few had the knowledge of chemistry required for photography at that early stage of its development. Brady, undaunted by these obstacles, plunged into the project of preserving on glass scenes of action of the great Civil War. Always pressing toward the firing line, planting his camera on the field of battle, sometimes before the smoke of artillery and musket fire had cleared, he came out of the war with his thousands of glass negatives perpetuating scenes of a great and crucial drama of our history.

With the close of the war Brady was in the direst of financial straits. He had spent every dollar of the money accumulated in his early portrait work and was heavily in debt. Seven thousand of his negatives were sent to New York City as security for Anthony & Co., his

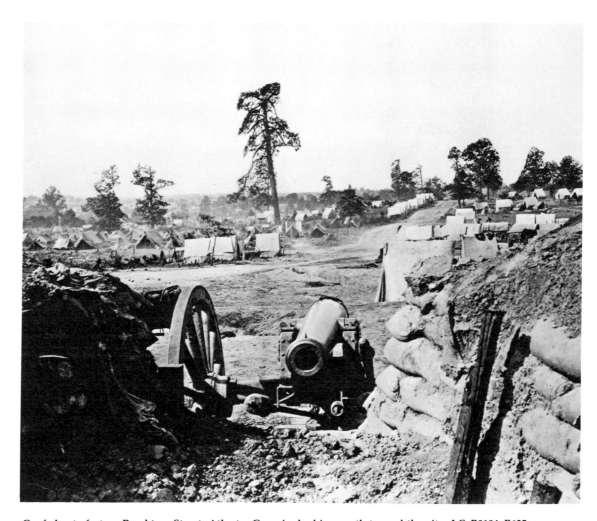

Confederate fort on Peachtree Street, Atlanta, Georgia, looking south toward the city. LC–B8184–B635

largest creditor, while a second set of six thousand negatives were placed in a warehouse in Washington. In 1866, in order to raise funds, he exhibited proofs of his negatives in the galleries of the New York Historical Society. In the same year the National Academy adopted a resolution in which it acknowledged the value of the Brady collection as "a reliable authority for art and an important contribution to American history," endorsing the proposal to place the collection permanently with the New York Historical Society. Fortunately for the Library of Congress, this was never done.

General Grant had been interested in the work of Brady on the battlefield and in a letter, written on February 3, 1866, spoke of it as "a collection of photographic views of battlefields taken on the spot while the occurrences represented were taking place. . . . I knew when many of these representations were being taken and can say that the scenes are not only spirited and correct, but also well chosen. The collection will be valuable to the student and artist of the present generation but how much more valuable it will be to future generations."

Brady said that he always made two exposures of the same scene, sometimes with a slight shift of the camera which gave a slight change in the general view. This accounts for the two collections. The collection of six thousand negatives stored in Washington was purchased at auction by the U. S. Government in 1874 for $2,840 when Brady was unable to pay the storage bill. General James A. Garfield was fully acquainted with the conditions under which the pictures had been taken and the subsequent impoverishment of Brady. He insisted that something be done for the man who had risked all he owned in the world and had lost the results of his labors. General Benjamin Butler, Congressman

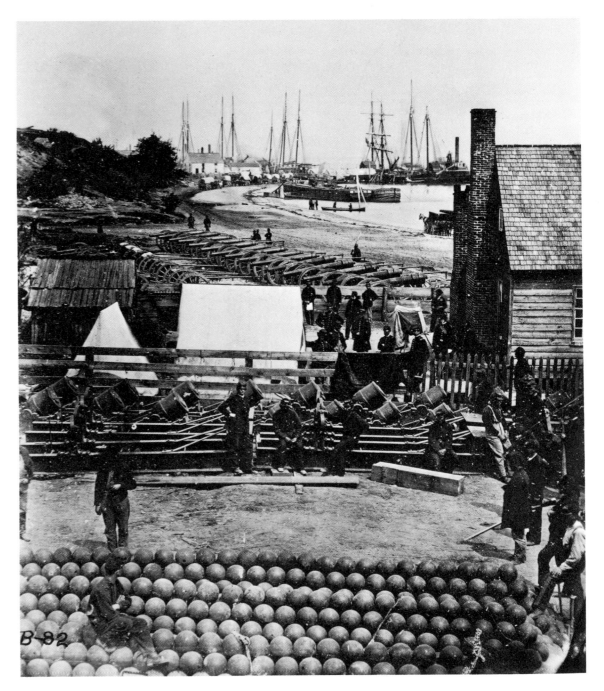

Yorktown, Virginia. LC–B8184–B82

34

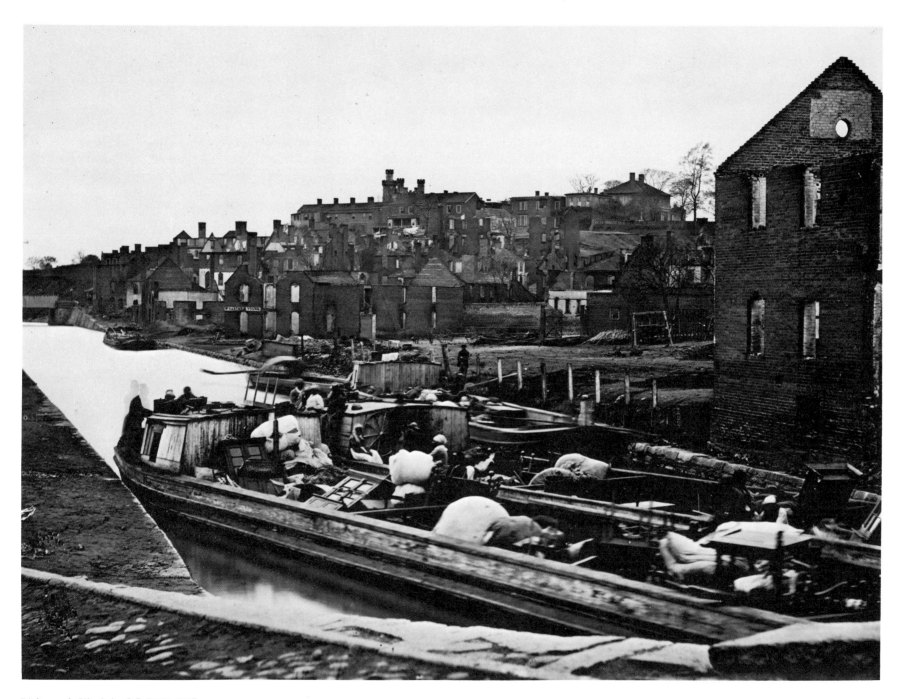

Richmond, Virginia. LC–B817–7617

from Massachusetts, also felt the injustice, and on his motion a paragraph was inserted in the Sundry Civil Appropriation Bill for $25,000 "to enable the Secretary of War to acquire a full and perfect title to the Brady Collection of photographs of the war." Too late to save him a vestige of business credit, the government came to Brady's relief. On April 15, 1875, the sum of $25,000 was paid him. Since Brady, during the years of waiting, had been unable to satisfy the demands of his creditors, an attachment was placed on the negatives in storage in New York. When judgment was rendered to his creditor, Anthony & Co., the negatives became the property of that firm.

Several years later, John C. Taylor of Hartford, Connecticut, a veteran of the Civil War, found the seven thousand negatives stored in an old garret in New York. With General Albert Ordway and Colonel Rand, he purchased the negatives from Anthony & Co., and finally purchased the Brady negatives from his partners in the transaction.

The next owner of this collection was Edward B. Eaton, the first president of the *Connecticut Magazine*. He had become interested in the historical significance of the Government Brady Collection and requested permission to reproduce the photographs from the War Department in Washington. He found the only way to bring the scenes before the public was through the private collection then owned by Taylor, which not only included practically all of the six thousand views in the War Department Collection (now deposited in The National Archives) but was supplemented by a thousand additional ones. Eaton therefore purchased the collection from Taylor and, in 1907, reproduced over two hundred scenes in a book entitled *Original Photographs Taken on the Battlefield During the Civil War of the United States by Mathew B. Brady and Alexander Gardner, Who Operated Under the Authority of the War Department and the Protection of the Secret Service.*

In 1910 a volume entitled *Photographic History of the Civil War From the Original Negatives of the Famous Brady Collection Taken on the Battlefields Under the Protection of the Secret Service* was published by the Patriot Publishing Company, Springfield, Massachusetts, of which Eaton was the president, director, and principal stockholder in the company. When the Patriot Publishing Company was dissolved in 1926 the collection of negatives was again placed in storage. Eaton died on December 27, 1942, and, to satisfy a claim for storage by the Phelps Publishing Company, the collection was sold at auction by court order. When the sale took place on December 11, 1943 in the District Court of Springfield, Massachusetts, the collection was purchased by the Phelps Publishing Company, from which it was acquired by the Library of Congress.

April, May, June 1944

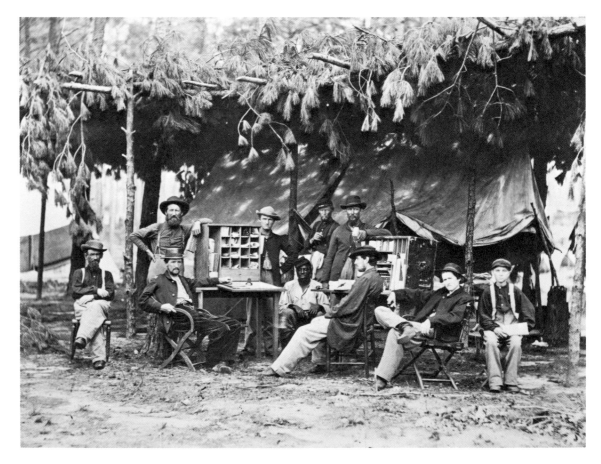

Ninth Army Corps Ambulance Office. LC–B8161–7538

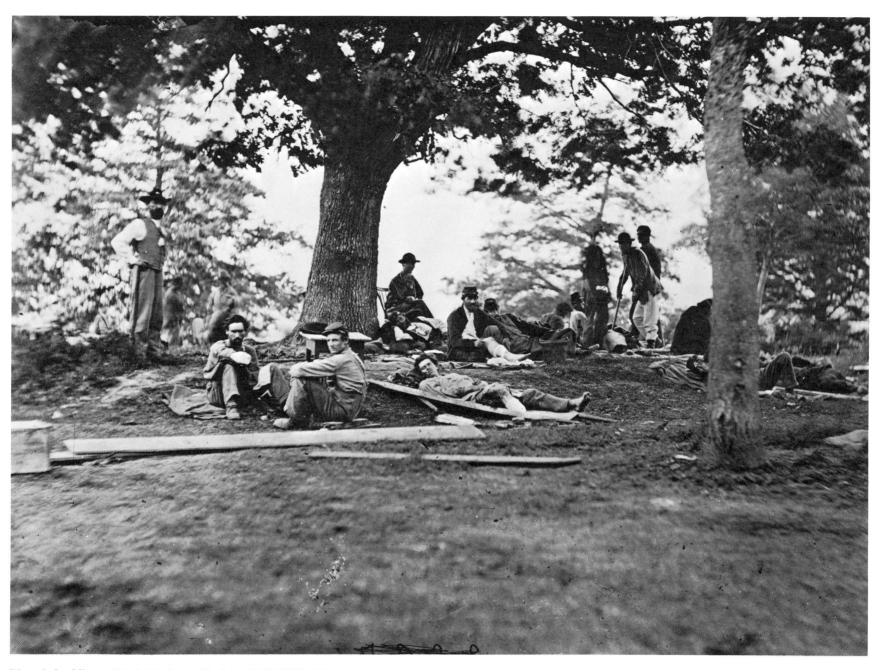

Wounded soldiers at Fredericksburg, Virginia. LC–B8184–B–462

The Brady-Handy Collection

by Hirst D. Milhollen

Levin C. Handy, photographed by Ed Pulliman, 1931.
LC–BH–827–4003

When, in September 1954, the Library of Congress acquired some ten thousand original, duplicate, and copy negatives from the L. C. Handy Studios of Washington, D. C., it became the possessor of a unique and valuable record of the local national scene. Spanning nearly a century, from the early years of photography in the 1840s, it represents the stock that the late Levin C. Handy received from his illustrious uncle, Mathew B. Brady, and the files that he himself accumulated as a practicing photographer until his death in 1932. It had been Mr. Handy's wish that these should become part of the pictorial records in the Library.

Despite Mathew B. Brady's importance in the history of photography, the details of his life are not very well documented. He was born, according to his own statement, in Warren County, N.Y., about 1823. It is believed that he began his experiments in what he called the "Daguerrean Art" about 1842, some two years after its introduction into this country by Samuel F. B. Morse. A New York City directory for 1843–44 lists him as a "jewel case man," following which—in the 1844–45 issue—he is recorded both as a "jewel, miniature, and surgical case manufacturer" and as operating a "Daguerrian miniature gallery" at the corner of Fulton Street and Broadway. In 1847 he moved his gallery to 205 Broadway and for the next ten years he applied himself to making a reputation as a fash-

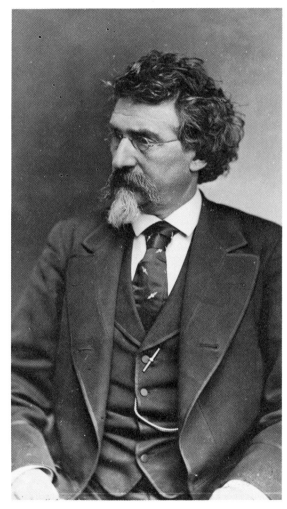

Mathew B. Brady, photographed by L. C. Handy.
LC–BH826–2681

ionable photographer, drawing his clientele from wealthy residents of New York City and from prominent people of his day.

Almost from the beginning, Brady realized the importance of preserving the likenesses of noteworthy as well as notorious people in the news. He went to lengths to seek out famous and interesting personages and pose them before his camera, often seeking no payment in return. He also collected pictures made by his competitors, and thus unknowingly created vexing problems for those seeking to distinguish his own work among the plates he accumulated.

To carry out more fully his idea of photographing the nation's great, Brady opened a gallery in Washington, D.C., early in 1849. On February 14 he visited President Polk at the White House and made what is thought to be the first daguerreotype of the President of the United States in the executive office. On the following May 5 a new President, Zachary Taylor, walked into the gallery and posed for three pictures. But even the prestige of so distinguished a clientele could not make it profitable to maintain operations in the Capital, and after a few months he closed the gallery and returned to New York.

It was nearly ten years before Brady opened his second Washington gallery. Meanwhile, great strides had been made in the art and science of photography. In 1851 an Englishman, Frederick Scott-Archer, had invented the "wet collodion plate" process, by which a negative was produced from which unlimited numbers of copies could be made—a vast improvement over the old method whereby only one daguerreotype could be made from each exposure. Photographs could now be executed cheaply, and almost anyone could afford at least a carte-de-visite. There now was little doubt that an up-to-date establishment in Washington would prosper. Early in

Prints Division, Library of Congress, shortly after the opening of the Main Building. LC–BH836–266

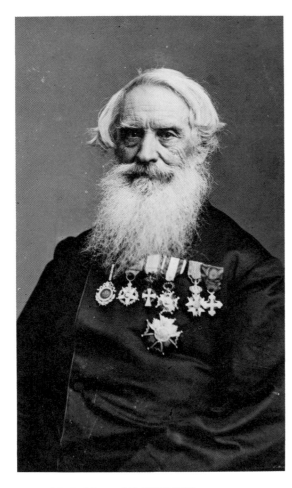

Samuel F. B. Morse. LC–BH82–1963

1858 Brady installed Alexander Gardner, an expert in the "wet collodion plate" technique, as manager of a new gallery at Seventh Street and Pennsylvania Avenue, Northwest.

A contemporary newspaper dispatch which Brady preserved gave this description of the new enterprise:

A favorite resort is the photograph gallery of your fellow-citizen, Mr. Brady. He has taken a house near the National and Brown's Hotels, which he has arranged with exquisite taste and without regard to expense. His gallery of portraits is most valuable and interesting. The great men of the Past and Present are there presented in lifelike attitudes and features, the very expression of the countenance being transferred with such wonderful accuracy to the paper that one almost expects to hear him speak. It is a collection of historic men, men who have made and are making their country great. . . .

His operating room exhibits the same chaste selection of color and furniture as his gallery. Vases and pretty things are scattered about, while a judicious and most artistic arrangement of screens prevents that blinding effect of the light which is so annoying to the sitter, and productive of that contraction of the eyes which so interferes with the fidelity of the likeness. . . .

Pleasing as is the show room of Mr. Brady's studio, an examination of his scientific work shop will be yet more agreeable to those who are so fortunate as to be admitted to the Penetralia. There are many workmen busy in the nice preparation of plates, mixing acids, finishing of the photographs, frame making and boxing up. In a word, a complete laboratory, engravers and carpenters' shop. The most curious arrangement to us was Mr. Brady's machine for producing the electric light so necessary for the completion of the photographs, and which, as he playfully observed, allows him to create his own sun-light or moon-light at pleasure.

In 1860, his business prospering, Brady opened his most elaborate establishment in New York City, at the west corner of Broadway and Tenth Street, down which it extended for about a hundred and fifty feet. The grand opening of the "National Portrait Gallery," as he named it, was described as follows in a contemporary newspaper:

In Broadway all merchants become princely, all trades palatial. . . . The day is not far distant when every branch of human industry will have its representative palace along the line of our great thoroughfare; and scarce a month passes over one's head that we are not called upon to chronicle some new effervescence of the magnificent enterprise which is doing for New York what CAESAR-AUGUSTUS did for Rome.

The latest of these manifestations was on Thursday evening thrown open to inspection of the curious in such matters, and of the wise Gothamites of the Press, by Mr. Brady, the prince of photographers on our side of the water. For months past, this name . . .has entirely disappeared from Broadway. Brady has been in New York, of course, and no further from his old temple than at the corner of Bleecker-street, but hidden there is a chaos of hair-dressers, glove-dealers and miscellaneous men of bazaars; he has been Brady rather by faith than by sight to the sight-seers who associate his name with one of the established pleasures of the Metropolis. . . .

The occultation is over now, and at the corner of Broadway and Tenth-street Brady has reappeared on a scale and after a fashion which strikingly illustrates the development of photography into a colossal industry worthy to take its place with the most significant manufacturers of the country. The prosperity which makes such an establishment possible as this which Brady has now opened, throws a marvelous light upon the means which we shall bequeath to our posterity of knowing what manner of men and women we Americans of 1860 were.

. . .

The new Brady Gallery has been baptized the "National Portrait Gallery." It deserves the name, and more. It is cosmopolite as well as national. The ample stairway of rich carved wood introduces you to a very Valhalla of celebrities, ranging over two continents, and through all ranks of human activity. . . . In this deep-tinted luxurious room, are gathered the senators and the sentimentalists, the bankers and the poets, the lawyers and the divines of the State and of the nation, kept all in order and refined by the smiling queenliness of all manner of lovely or celebrated women. . . .

Mr. Brady has converted a four story house into a palace of light—absolutely catching the blue sky, and making it permanent in the glasses of his operating-room.

But there was more to be done than to open new and finer photographic galleries. Brady's attention was focused on the leading figures in the crisis which was now rending the nation. He added photographs of all of the members of the Thirty-Sixth Congress to his National Portrait Gallery, and on February 23,

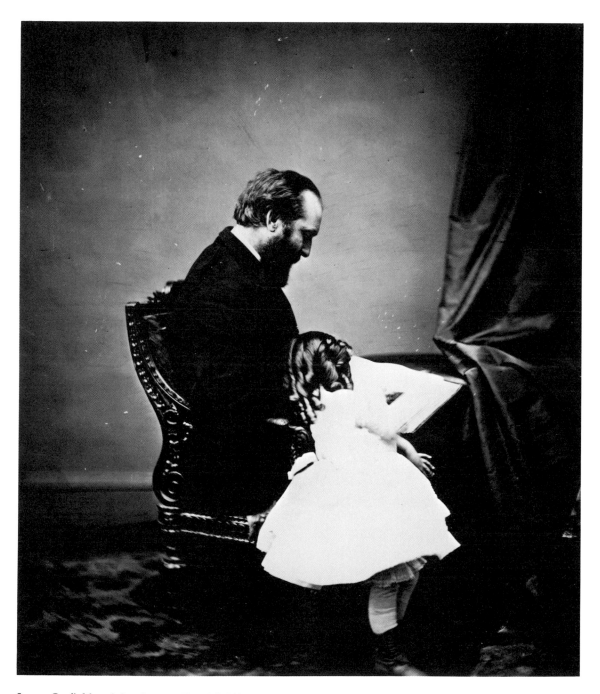

James Garfield and daughter Mollie. LC–BH83–1940

Nathaniel Hawthorne. LC–BH82–4096

1861, he photographed President-elect Abraham Lincoln for the second time. And when the impending war between North and South became a reality, he embarked on his most ambitious venture—making a camera record of the entire conflict.

How successfully Brady carried out his project is well known. Beginning by photographing the marshaling of Union forces in the Washington area and taking on-the-spot pictures of the Battle of Bull Run, he organized a large staff of workmen (at one time amounting to no fewer than 22 "teams") who traveled with the armies and compiled a pictorial record of unparalleled value. Brady spent most of his time directing this new kind of commercial enterprise, but he also was able to make occasional trips to the battlefields. He was at Antietam and Fredericksburg in 1862; reached Gettysburg shortly after the end of battle; stood by Cooper's Battery on June 21, 1864, and watched the bombardment of the Confederate defenses around Petersburg; and, at the close of the war, was in Richmond, where he had the good fortune to photograph Robert E. Lee.

Brady's outlay for his venture was considerable, amounting, by his own estimate, to more than a hundred thousand dollars. Circumstances combined to place him in a desperate financial position. In 1864 he took into his business a partner, James F. Gibson, whose management of the Washington office was a total failure and involved them in a number of lawsuits for non-payment of bills. Brady had counted on selling his war views in large numbers to discharged soldiers, but this means of recouping his fortunes failed to materialize. Facing bankruptcy, he began to dispose of his New York property and other holdings, and turned to the United States Government for help. The New York *Times* of February 8, 1869, carried this dis-

Sculptress Vinnie Ream Hoxie. LC–BH83–2397

42

Robert E. Lee. LC–BH831–565

cussion of his proposal to sell his collection of negatives and daguerreotypes:

Mr. M. B. Brady, the well-known photographer, offers to transfer to Congress, on favorable terms, his extensive and admirable collection of photographic views of prominent incidents and scenes of our recent war, together with the portraits of prominent Americans which he has taken during the last twenty or twenty-five years. This proposition deserves the careful and favorable consideration of Congress, to which it is made. No such faithful and lifelike record of any great war exists in the world as that which Mr. Brady has made of our great civil struggle. He made it the special object of his most assiduous efforts during the war to secure these memorials of its most striking incidents. Wherever anything of interest or importance was going on, in any section of the country and at every period of the contest, Mr. Brady was certain to be present, either in person or through his agents, and his apparatus became as familiar to every division of the army as the headquarters of its Commanding General. . . . Included in this collection are the portraits of over 2,000 persons—mainly prominent and distinguished Americans, Generals, members of Congress, men of mark of every class and position in public life, but including also foreign Ministers, distinguished visitors, &c., &c. These give completeness to the whole, and make it unique and invaluable. . . .

Most of the *material* from which the views were made have ceased to exist. The battles are over,—the forts, bridges, &c, have been destroyed,—the camps have been broken up, most of the actors have disappeared, and the whole of the splendid but tragical pageant has vanished. These views are all that remain to re-present them to the eye.

It was not until March 3, 1871, that the Joint Committee on the Library took action on Brady's proposal and recommended to the House of Representatives that his "National Collection of the portraits of eminent Americans" be purchased. Congress, however, failed to act on the Committee's favorable report, and Brady was forced to give up both his New York and Washington galleries. His register bears the following note under date of August 27, 1873: "M. B. Brady closed in Bankruptcy"; and two months later the firm of Burgess & Company took over the business.

Labor Day parade on Pennsylvania Avenue in Washington, 1894. Under construction is the Post Office Building. LC–BH8233–15

In the following year Congress purchased a collection of Brady's negatives for the price of the bill for storing them, and in 1875 Brady was voted the sum of $25,000 for complete title and rights to them. Although this did not free him entirely from his debts, he was able to regain his Pennsylvania Avenue gallery in Washington. But he was unable to recover the reputation he had once enjoyed, and his closing years were in marked contrast to what he had characterized as the "golden years" of the 1840s and 1850s. He died on January 15, 1896, and was buried in the Congressional Cemetery in Washington.

The photographic files which Brady had not disposed of became the possession of his nephew-in-law, Levin Corbin Handy, and were moved to his studio at 494 Maryland Avenue, Southwest. Handy's first introduction to photography had been through his father, Samuel S. Handy, an assistant in Brady's Washington gallery during the 1860s. By 1870, when he was only fifteen years old, he had completed his apprenticeship and become one of the "operators" in the gallery. In the following year he appears to have launched his own business, and a Washington directory for 1872 lists his place of operations as 713 Seventh Street, Southwest. In 1882 he went into partnership with Samuel Chester, and it is believed that they established a studio on the second floor of a carriage-house at the rear of 494 Maryland Avenue, Southwest. With the exception of two short periods, in 1883 (when Handy and Chester were associated with Brady at 1113 Pennsylvania Avenue) and in 1893 (when the gallery of Handy and Chester was at 919 F Street, Northwest), the Maryland Avenue address remained Levin C. Handy's permanent location, and it was there that he was residing when he died in March 1932.

In the course of more than thirty-five years Handy performed many services for the Library of Congress. Before the main building was completed, he recorded its progress in the various stages of construction, and when it was first occupied in 1897 he was on hand with his cumbersome camera to photograph the newly organized divisions and the proud members of the staff. To facilitate the sale and distribution of his photographs of the building to the general public, he was allowed to set up a stand on the basement floor of the Library, and when copies of material in the collections were requested he was authorized to perform the work. Often he would bring his equipment to the former Print Division and expose his plates there; sometimes he was allowed to borrow material from the Library and make copies in his own studio. In addition to his work as the Library's unofficial photoduplication service, he performed similar commissions for other Government agencies. Perhaps his most important single assignment was the making of a photograph of the original Declaration of Independence when the manuscript was in the Department of State.

Unlike his famous uncle, Handy was a quiet man and shunned newspaper publicity. In one of his rare interviews, which the Denver *Post* published on December 31, 1931, he is quoted as expressing this view on the art to which his lifetime had been devoted: "The excellence of fine portraiture should reflect in the portraits themselves; not in fancy trimmings and ornate gadgets. Moreover, good equipment—cameras and accessories—are prerequisite to good portraiture, and only practice can bring perfection. Besides, the real pictorialist must have a little of the artist's intuition."

In the files of the L. C. Handy Studios,

Along the C&O Canal, Georgetown. Mrs. Samuel Handy is pictured. LC–BH8233–25

when they were acquired by the Library from Mr. Handy's daughters, Mrs. George W. Evans and Mrs. Edgar C. Cox, the plates made by Brady and Handy were intermingled, and they were grouped for the most part according to a subject approach. In sorting, analyzing, and organizing them for use, the attempt has been made to determine as nearly as possible their original arrangement. As a result, many different series of negatives have been uncovered and identified which serve to throw light on the activities of Brady's New York and Washington galleries. Altogether, of the approximately ten thousand original, duplicate, and copy negatives, more than four thousand original wet collodion plates and thirteen hundred duplicates are believed to be from these galleries. In addition, there are over thirteen hundred original glass plates which have been assigned to Handy and his associates. The remainder are largely copy negatives by Brady and Handy of Members of the Fiftieth Congress, Civil War views, and various photographs, prints, and paintings made for their customers.

Of particular significance is the large group of original negatives of members of Congress, dating from about 1855 to 1890. In a sense, the acquisition of this group fulfills the recommendation made by the Joint Committee on the Library in 1871 that Brady's portraits of Congressional leaders be obtained for the Nation. Also of much interest is a small series of original negatives of views of Washington which are believed to have been made by Brady at the beginning of the Civil War and include some of the earliest representations of the National Capital.

Accompanying the negatives was a group of twenty-four daguerreotypes, among them portraits of Edwin Booth, William Cullen Bryant, Stephen A. Douglas, Albert Gallatin, Reverdy Johnson, Jenny Lind, Daniel Webs-

ter, Brigham Young, and Brady himself. Of special interest, too, is a volume entitled "M. B. Brady's Register," with entries from June 2, 1870, to January 1876, listing appointments for sittings and giving data about photographic work done in his Washington studio. The bare entries are interspersed with such illuminating comments as "refunded—Baby would not sit still," "Little boy in goat carriage," "Could not wait and wants his $2.00 back," "Did not sit—objected to price," and "Capitol Policeman to be charged half-price."

The Brady-Handy collection has been organized into thirty-five series, which are described below.

LC–BH82

Presidents of the United States, their wives, members of Congress, military and naval officers, actors, artists, religious leaders, and other notables. Included in this series are portraits of Presidents John Quincy Adams, Millard Fillmore, and Andrew Johnson; Mrs. Abraham Lincoln and Mrs. Ulysses S. Grant; Secretary of War Edwin M. Stanton; Generals Ulysses S. Grant, Joseph Hooker, John Sedgwick; Admirals David G. Farragut, David D. Porter; artists Constantino Brumidi and George P. A. Healy; William Cullen Bryant the poet; and Samuel F. B. Morse, artist and inventor. Portraits from Brady's New York and Washington galleries, 1855–65. A few copy negatives of "India Ink" portraits from Brady daguerreotypes. Original single "carte-de-visite" wet plate negatives size 2¼ × 3½ inches.

2,366 negatives, of which 1,309 are duplicates.

LC–BH821

Members of Congress, Union and Confederate officers, etc. Generals Pierre Gustave Toutant Beauregard, Arnold Elsey, Thomas N. Waul, and Mathew C. Butler. Chiefly glass copy negatives, with a few original wet plate negatives of Confederate Generals, the work of many photographers.

946 negatives, of which 6 are duplicates.

LC–BH822

Civil War views: Union Officer groups, camp fortifications, naval operations, etc. Original stereograph wet plate negatives, not in pairs; sometimes both halves are present. A few are not identified. Negatives by T. H. O'Sullivan and other photographers.

44 negatives, of which 19 are duplicates.

LC–BH8222

Civil War views and miscellaneous subjects by various photographers. Chiefly glass plate copy negatives, some used for making lantern slides.

115 negatives.

LC–BH823

Views of Washington, D. C.: Treasury Building, Washington Monument [unfinished], Trinity Methodist Church. From Brady's Washington Gallery, ca. 1860. Original stereograph wet plate negatives, not in pairs; both halves present with one exception.

7 negatives, of which 3 are duplicates.

LC–BH8233

Views and scenes in Washington, D. C.: The Capitol, White House, Baltimore and Ohio Railway Station, Chesapeake and Ohio Canal, inauguration of President Wilson, Labor Day Parade, Coxey's Army, etc. Original glass negatives of various sizes.

37 negatives.

LC–BH8234

Views and scenes in Washington, D.C.: The Capitol [under construction], interiors of the Capitol and White House, Government buildings, Carroll Row from the Capitol, street scenes, horsedrawn streetcars, Chesapeake and Ohio Canal, inaugurations, Library of Congress murals, etc., 1865–1930. Glass and film copy negatives of various sizes, the work of many photographers.

126 negatives.

LC–BH8235

Civil War portraits and views of miscellaneous subjects. Transparencies or lantern slides, some probably made for Brady's lectures on the Civil War; a number are reproduced in Roy Meredith's *Mr. Lincoln's Cameraman*, and many are described in Brady's lecture book prepared by Levin C. Handy.

66 transparencies.

LC–BH824

Presidents of the United States, members of Congress, religious leaders, authors, artists, actors, etc. Included in this series are Presidents Martin Van Buren, Andrew Jackson, and John Tyler; Robert Lincoln; authors Washington Irving and William Prescott; Adelina Patti, singer; Charles Parsloe, actor; Chester Harding, artist; Charles B. Calvert; and Charles Godfrey Gunther, Mayor of New York. Portraits from Brady's New York and Washington Galleries, ca. 1860–65. A few copy negatives of "India Ink" portraits from Brady daguerreotypes; original "carte-

Powerhouse after fire, Fourteenth Street, Washington, D.C., September 12, 1897. LC–BH836–83

de-visite" wet plate negatives; two or three exposures on a plate.

138 negatives.

LC–BH825

Civil War views: Camps, soldiers in groups, fortifications, ordnance and naval scenes. Early wet plate copy negatives of stereographs, two exposures to a plate, the work of various photographers.

48 negatives.

LC–BH8255

Civil War views: Soldiers in groups, battlefields, fortifications, ruins of Richmond, the work of various photographers.

191 negatives.

LC–BH826

Members of Congress, justices of the Supreme Court, military and naval officers, and other notables. Included in this series are portraits of Presidents Ulysses S. Grant, Rutherford B. Hayes, and James A. Garfield; James G. Blaine of Maine, Alexander Stephens of Georgia, Oliver H. P. T. Morton of Indiana, and James Proctor of Kentucky; Generals Albert J. Meyer, William B. Hazen, and Montgomery Meigs; and Admiral John Worden. Original wet plate negatives chiefly from Brady's Washington Gallery, a few probably taken by Levin C. Handy.

472 negatives.

LC–BH8266

Members of Congress, Union Army officers, and other notables. Included are portraits of the Honorable Richard J. Haldeman of Pennsylvania; Montgomery Blair, Postmaster-General; Governor Rufus B. Bullock of Georgia; and Generals George H. Thomas and Winfield S. Hancock. Original wet plate negatives, two exposures to a plate.

26 negatives.

LC–BH827

Members of Congress, some photographed at the Capitol for the Fiftieth Congress album; members of the Pan American Conference (1889); and other notables. Included in this series are portraits of Robert Lincoln (1889), Lew Wallace, President Theodore Roosevelt, John H. Bankhead, Cassius M. Clay, Andrew Carnegie, and General Albert Ordway, from Brady's Washington Gallery and L. C. Handy Studios, ca. 1885–1900.

315 glass plate negatives.

LC–BH8277

Presidents of the United States, members of Congress, Lincolniana, Supreme Court justices, and other notables.

There are portraits of President Zachary Taylor, Roger B. Taney, Daniel Webster, Judah P. Benjamin, and Mrs. John J. Crittenden, wife of the Senator; the work of various photographers, 1845–1932.

636 negatives.

LC–BH828

Views of Washington, D. C., and vicinity: Bridges, churches, Government buildings, houses, statues, streets, horse-drawn streetcars, floods, Chesapeake and Ohio Canal, Baltimore and Ohio Railroad Station, Mount Vernon, etc.

148 negatives, probably by Levin C. Handy.

LC–BH8288

Views of Washington, D. C., and vicinity: The Capitol, White House, Library of Congress murals, statues and monuments; inaugural and transportation scenes, the Chesapeake and Ohio Canal, etc.

139 negatives, the work of various photographers.

LC–BH829

Constantino Brumidi paintings, murals in the Capitol, sections of the canopy of the dome, etc. Negatives from Brady's Washington Gallery, ca. 1865.

25 original wet plate negatives, two exposures to a plate.

LC–BH8299

Views of Washington, D. C., and vicinity: The Capitol, Smithsonian Institution, Agriculture Department, an old mill near Alexandria, the flood of 1889, streetcars, parks, statues, houses, etc. A few views are not identified.

58 original glass plate negatives and one transparency, probably by L. C. Handy, ca. 1885–1900, two exposures to a plate.

LC–BH832

Members of Congress, a few military and naval officers, educators, and other notables. Included in this series are portraits of William ("Parson") Brownlow, William Pitt Fessenden, Charles Sumner, Jacob D. Cox, Salmon P. Chase, John A. J. Cresswell, Thomas Nast, Prince Iwakura of Japan, Edwin Booth, and Generals J. K. Barnes, Randolph B. Marcy, John A. Rawlings, William T. Sherman, and Horace Porter. From Brady's Washington Gallery, 1860–75, some identified by last name only.

719 original wet plate negatives.

LC–BH831

Civil War military and naval officers, with several portraits of General Robert E. Lee. Included in this series are Union Generals C. C. Auger, William F. Barry, Samuel S. Carroll, George A. Custer, Francis Blair (and staff), Gordon Grainger, Judson Kilpatrick, Edward M. McCook, Alfred Pleasanton, Phil Sheridan (and staff); and Admiral David D. Porter. From Brady's Washington Gallery, 1860–65.

169 original wet plate negatives, and one transparency.

LC–BH832

Presidents of the United States and their families; members of Congress, a number of former officers in the Union and Confederate armies (not in uniform), military and naval officers, Indian groups, Justices of the Supreme Court, etc. Included in this series are portraits of Presidents Ulysses S. Grant and Rutherford B. Hayes; James A. Garfield's children and Robert Lincoln; Justices John Marshall Harlan and Morrison R. Waite; Samuel C. Pomeroy of Kansas, Hamilton Fish of New York, Robert B. Vance of North Carolina, John B. Henderson of Missouri, and others; Generals Benjamin Alvord, Orlando M. Poe, William T. Sherman, etc. Portraits from Brady's Washington Gallery, some probably by Levin C. Handy, 1865–80. Many have two exposures and sometimes different poses on one plate; some identified by last name only.

1,167 original wet plate negatives.

LC–BH833

Presidents of the United States and other notables. Portraits of Presidents William McKinley and Theodore Roosevelt; Mrs. Theodore Roosevelt (Edith Kermit Carow); Elihu Root; General Leonard Wood (not in uniform); Admiral George Dewey; and others. Chiefly by Levin C. Handy, 1890–1910.

45 original glass plate negatives.

LC–BH8331

Portraits of notables and miscellaneous subjects. Included in this series are negatives of paintings of Presidents John Adams, John Quincy Adams, Andrew Jackson, Millard Fillmore, Chester A. Arthur, and Grover Cleveland.

605 glass plate copy negatives.

LC–BH835

Views of Washington, D. C., and vicinity: Carroll Row from the Capitol, Greenough's statue of George Washington—East front of the Capitol; Ford Theater; Navy Department; War Department; Patent Office (interior); Smithsonian Institution; Treasury Department; White House (exterior and interior); House of Representatives; Reform School; Bladensburg Road; Lee Mansion, etc. From Brady's Washington Gallery, 1860–80.

26 original wet plate negatives.

LC–BH836

Views of Washington, D. C., and vicinity: Art galleries; embassies; Government buildings; Spanish-American War statues and monuments; churches; hotels; bridges; transportation and street scenes, etc. There are a number of Library of Congress pictures, both exterior and interior views. Chiefly by Levin C. Handy, 1890–1933.

885 original glass plate negatives.

LC–BH8366

Military activities of various units; the District National Guard at Camp McKibbin, Marshall Hall, Maryland; the 2nd, 3rd, and 6th Battalions. By Cruikshank, 1893.

34 original glass plate negatives.

LC–BH837

Views of Washington, D. C., and vicinity: The Capitol, White House, Library of Congress (interiors), churches, hotels, Pennsylvania Avenue in the 1840s, various inaugurations, and the burial of the MAINE dead in Arlington, on December 28, 1898, etc. By various photographers.

220 glass copy negatives.

LC–BH838

Historical paintings and prints: Paintings in the Capitol, early views of American cities, Brady's medals and awards, etc.

92 negatives, mostly glass plate copy negatives, some film.

LC–BH84

Civil War views, by Alexander Gardner and others: Officer groups, camps and fortifications around Petersburg, Va., etc.

14 original wet plate negatives.

LC–BH841

Civil War views, by various photographers: Officer groups, fortifications, dead on the battlefield, railroads, bridges, Lincoln at Antietam, etc.

55 glass plate copy negatives.

LC–BH85

Portraits and views in Washington, D. C., and vicinity: Library of Congress; D. C. Fire Truck D; Confederate veterans at Camp Ewell, Prince William County, Va.; Lower Merion High School students visiting in 1897; construction of Union Station; F Street, Northwest, in the 1880s; views of Washington from Washington Monument, etc., some not identified. Chiefly by Levin C. Handy.

48 glass plate negatives, of which 44 are original and 4 are copy.

Pension Office Building in Washington, decorated for the Inaugural Ball, 1893(?). LC–BH–836–189

Boys with goat cart, Washington, D.C., about 1880. LC–BH8233–31

LC–BH86
 Portraits of Abraham Lincoln and Theodore Roosevelt, views of inaugurations, some not identified.
 8 glass plate negatives, of which 2 are copies.

LC–BH87
 The Capitol, White House, Treasury Building, Library of Congress Main Hall, Abraham Lincoln obsequies.
 5 glass plate negatives (two wet plate), one of which is a copy.

LC–BH88
 William F. ("Buffalo Bill") Cody and two companions, and a broken negative of an unidentified group photograph, 1890–1900.
 2 original glass plate negatives.

May 1956

The Case of the Missing Photographers
Haas & Peale

by Milton Kaplan

"Curiouser and curiouser! cried Alice (she was so much surprised that for the moment she quite forgot to speak English)." And "curiouser and curiouser" became the month-long search to establish the identity of two men connected with the photographic record of the Civil War.

It was on the first of June 1966 that the Prints and Photographs Division acquired, through special purchase funds, twenty-five important original glass plate negatives taken during the summer of 1863 on Morris and Folly Islands in South Carolina, when the Union Army under the command of Maj. Gen. Quincy A. Gillmore began the Charleston campaign. The negatives, 4¾ by 7½ inches, were stored in what seemed to be their original wooden box.

There are photographs of General Gillmore, a horse and wagon which might have been the photographers' van, and a bomb-proof, splinterproof shelter. In one, the U.S. fleet stands offshore, in another the Confederate flag flies over Fort Sumter. Some tell a story in themselves: The camera has stopped the rogue's march for one tense second. A soldier, surrounded by a guard detail, wears a poster proclaiming his name, his company,

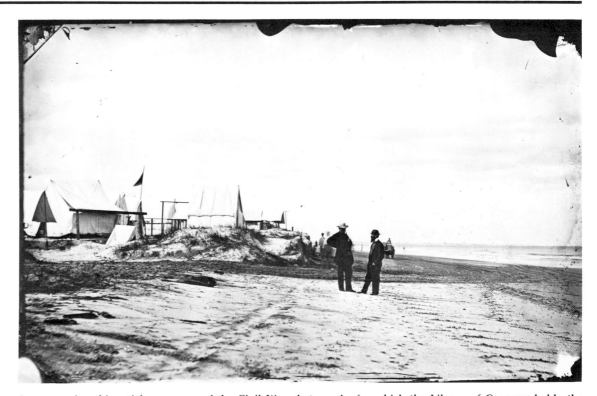

Accompanying this article are some of the Civil War photographs for which the Library of Congress holds the original glass plate negatives. They are scenes taken on Morris Island during the Charleston campaign in the summer of 1863. Unlike other Civil War negatives in the Library, some of these have the names of the photographers scratched into the emulsion—Haas & Peale. Little has been learned about this photographic team (see editor's note at the end of this article). Could the two men standing on the beach on Morris Island in this picture be Haas and Peale? LC–B8178–78

51

and his crime, "Thief; This man stole money from a wounded friend."

Two names—Haas & Peale—are scratched into the emulsion of ten of the plates. The names are not unfamiliar ones, for the collections contain a group of glass plate copy negatives so marked or bearing a printed caption "Photo[d] by Haas & Peale, Morris Island and Hilton Head, S.C." This is the only group of Civil War negatives the division staff has seen with names scratched on the plates. Of interest also are the clouds in one of the negatives. They are a part of the original image, whereas clouds in most other Civil War negatives are painted on the plates.

The newly acquired plates demonstrate vividly the gap in quality between the original images and the positive copies heretofore available. Where there had been smudgy grayness, now there is clarity. The new prints with their vitality and almost three-dimensional quality represent some of the best of the Civil War photographs.

The search for Haas & Peale both as individuals and as a firm began with city directories for the Civil War period—Baltimore, Boston, Chicago, Cincinnati, New York, Philadelphia, Pittsburgh, St. Louis, Washington, D.C.—and the New England business directory. Nothing was found.

The next stop was the published record. In 1865 D. Van Nostrand of New York City published Gillmore's *Engineer and Artillery Operations Against the Defences of Charleston Harbor in 1863.* Fourteen of the illustrations are lithographs by Julius Bien of New York, based on the Haas & Peale photographs. No credit is given in the book to the photographers and a letter to the publisher brought the information that the early records of the company were destroyed by fire in 1893.

Regimental histories of units which served on Morris Island during the Charleston cam-

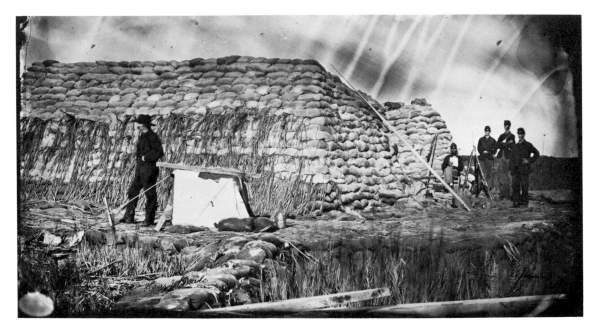

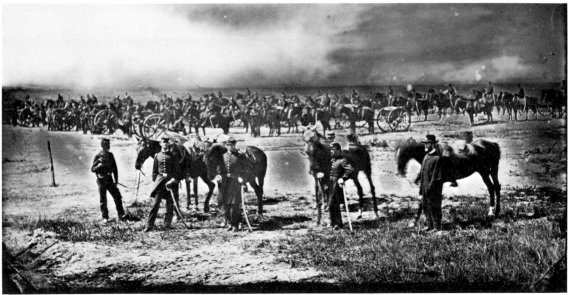

Top: The marsh battery from which the famous "Swamp Angel," an 8-inch, 200-pounder Parrott rifle, fired five miles into the city of Charleston until the gun exploded on the thirty-sixth round. LC–B8178–75

Bottom: A Federal artillery unit. LC–B8178–86

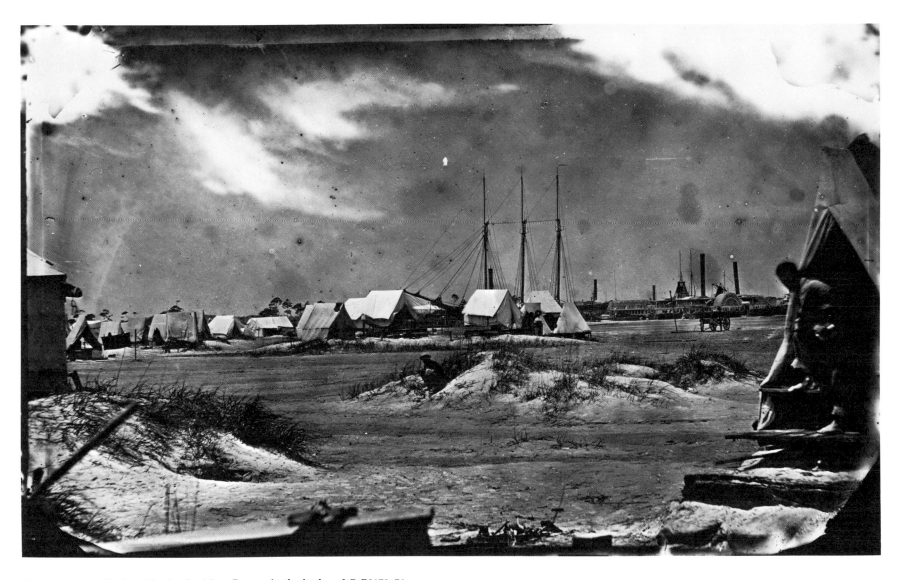

A camp scene with the sidewheeler Mary Benton in the harbor. LC–B8178–76

paign were checked next. Reproductions of various Haas & Peale photographs appear in several of them—*The Twenty-Fourth Regiment, Massachusetts Volunteers,* by Alfred S. Roe (1907), *History of the Seventh Connecticut Volunteer Infantry,* by Stephen W. Walkley, Jr. (1905), and *The History of the Thirty-Ninth Regiment Illinois Volunteer Veteran Infantry,* by Charles M. Clark (1889). No references to Haas & Peale were found either in the acknowledgments or in the text. (A footnote to history: The check of the 55th Massachusetts Infantry revealed that the culprit in the rogue's march deserted in July 1865.)

Four of the photographs are reproduced in *A History of the Civil War,* by Benson J. Lossing (1912). Reproductions of woodcuts or of pen-and-ink drawings based on several of the Haas & Peale photographs were located in *The Third New Hampshire and All About It,* by Daniel Eldredge (1893), and in *Battles and Leaders of the Civil War* (1887–88). Not one of these publications, however, contains any references to the photographers.

Lossing's *Pictorial History of the Civil War* 1868, vol. 3, p. 201) carries a woodcut of the photograph of the bombproof and splinter-proof shelter. At the bottom of the page is the startling note: "This picture is from a photograph by Samuel A. Cooley, photographer of the Fourth Army Corps."

Was Lossing right? Could the negative have been taken by Cooley? Was it possible that the other negatives had also been taken by Cooley and later acquired by Haas & Peale, who then put their names on the plates? This seemed unlikely, for the inscription on the plates reads "Photo^d by Haas & Peale." Stereographs and photographs taken by Cooley on Morris Island in 1864, discovered at the National Archives, were compared with the Haas & Peale photos known to have been taken in 1863. The Cooley photograph of the

Beacon House, which was used by Gillmore as a signal station, shows much greater destruction than does the one by Haas & Peale, which was taken at an earlier date. Therefore, Lossing was wrong.

Dispatches sent in by the New York *Herald* correspondent on Morris Island from July to November 1863 contained no references to any photographic work on the island. *Frank Leslie's Illustrated Newspaper* was equally unproductive, but the August 15, 1863, issue of *Harper's Weekly* provided the first lead. On page 525 appears a woodcut of General Gillmore, based upon a photograph credited to a Lieutenant Haas.

Miss Josephine Cobb of the National Archives, a recognized authority on the iconography of the Civil War, identified Lieutenant Haas as Philip Haas of Company A, 1st New York Engineers, who had enlisted in September 1861. Beaumont Newhall, of George Eastman House, suggests that Haas may be the daguerreotypist described in their files as follows: "Pioneer American daguerreotypist. Learned of daguerreotype in 1839 in Paris. Made, about 1845, multiple daguerreotype portraits using movable plateholder. First listed in New York City directory as daguerreotypist, 1846; appears in editions dated 1848, 50–57. Exhibited whole plate daguerreotype 'allegorical figure of a family man reading the paper at home' New York Exhibition, 1853–54."

Further examination of records in the National Archives uncovered the order book of the 1st New York Engineers, which contains Special Order No. 248, dated July 15, 1862, Hilton Head, Port Royal, detailing Haas for "special service at headquarters." On file also is a letter from Haas, dated May 13, 1862, Tybee Island, in which he asks for "a leave of absence for thirty days to go north—my supply of photographic material being en-

tirely exausted [sic] which require to be selected with great care." Another letter dated November 5, 1862, requesting leave on account of ill health is signed "Philip Haas . . . Photographer, General Staff." A comparison of the signatures on the two letters with the name on the negatives reveals certain similarities.

The records of the Department of the South contain synopses of two letters from Haas. One dated February 6, 1863, Hilton Head, requests the detail of a carpenter to make certain alterations in the Photographic Bureau; the other dated March 31, 1863, requests a private of the 76th Pennsylvania Volunteers for the Photograph Bureau.

Haas resigned from the Army on May 25, 1863, and the last reference to him found in the search is a letter dated May 27, 1863, in which he requests that the Quartermaster be ordered to take charge of certain photographic articles in his possession, "they being gov't property."

The evidence so far uncovered strongly suggests that the Haas of Haas & Peale was Lt. Philip Haas. Cornell University has an imprinted Haas & Peale photograph which connects him, somewhat tenuously, with the Morris Island campaign of 1863. It shows Drs. John Craven and Samuel A. Green and others examining a wounded soldier in a hospital in 1863. On file at the National Archives is a letter from Haas dated March 31, 1863, requesting that an order returning his photographic assistant to active service be countermanded. One line reads "Dr. Craven has said that he is entirely unfit for any heavy labor or exposure."

It seems strange that no references were found to his partner or to Haas & Peale in city directories, in published works, or at the National Archives. It is unlikely that two photographers and their bulky equipment could

have come ashore at Morris Island during wartime without having obtained permission from someone.

George Eastman House and the National Archives have photographs mounted on specially printed cards imprinted "Photod by Haas & Peale, Morris Island and Hilton Head, S.C." In addition, the Library's copy negatives show the same border and imprint. Haas & Peale seems to have been a fairly well-established firm.

Who were Haas & Peale? The answer may come some day. In the meantime, we wonder about one of the photographs which shows two men standing on the beach, deep in conversation. Could they be Haas & Peale?

Editor's note: After the publication of this article, Jerald C. Maddox, curator of photography in the Prints and Photographs Division, discovered the following paragraph in the December 1, 1863, issue of the *British Journal of Photography*:

"The photographer attached to General Gilmore's army, at Charleston, Mr. Washington Peale, writes home that he has had many narrow escapes. One day he was working within a mile of the enemy's guns, and as he had to climb a pole which had been erected for his accommodation, with a platform on the top, and a ladder to facilitate the ascent, several solid shot were thrown at him, all well aimed, but faulty in range. At last a shell exploded near him, part of which struck the ladder while he was in the act of descending, and inflicted some severe bruises on his person, but did not interrupt his work. He complained of the monotony of the endless sand reaches, and descants at length on a ramble he had taken inland among the trees, describing the birds and the flowers as if he enjoyed them exceedingly. His intention originally was to have gone north with an arctic expedition, and his outfit was procured with that intention; but the affair fell through, and he is now in a much warmer climate than he had expected to have been in."

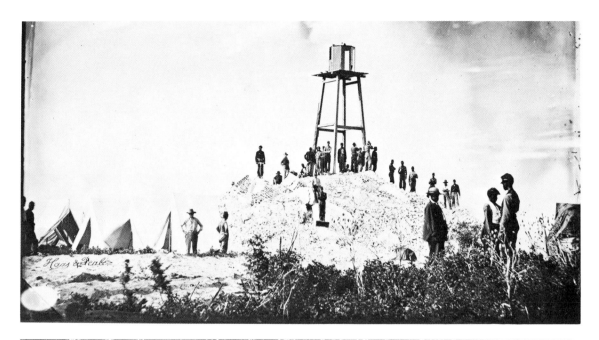

Top: The ruins of the Charleston Lighthouse. LC–B8178–26

Bottom: General Gillmore receiving a message from an orderly on Morris Island. LC–B8178–87

55

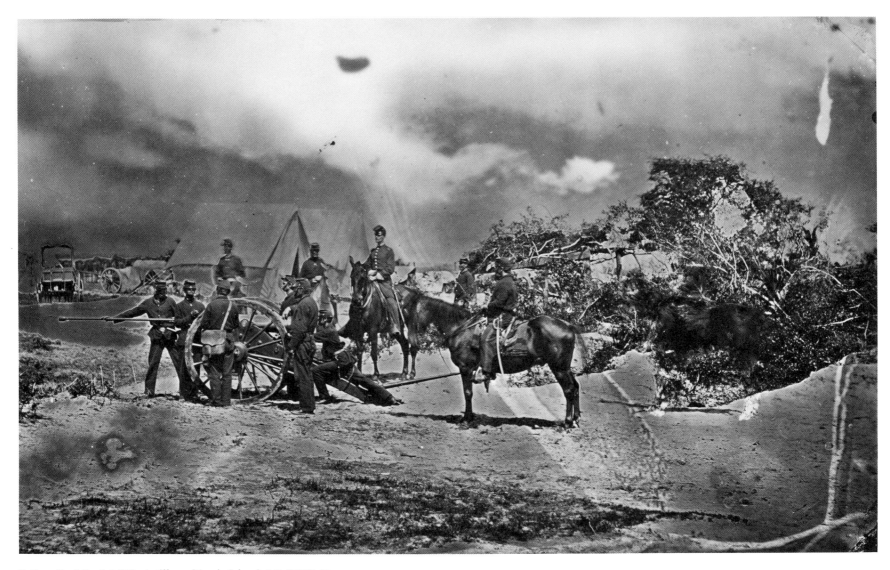

Battery B of the 1st U.S. Artillery, Morris Island. LC–B8178–41

HAAS & PEALE PHOTOGRAPHS

Original Negatives

The collection also contains glass plate copy negatives and prints (indicated by the letter A) and copy photographs without the corresponding copy negatives (indicated by the letter B).

1. The rogue's march, July 1863, Morris Island. B
2. Fort Sumter, August 23, 1863. A
3. View of the first parallel (a trench constructed by the Union forces parallel to the Confederate fortifications).
4. Beacon House after the struggle for Fort Wagner, July 18, 1863. B
5. Horse and wagon in palmetto grove, Folly Island. B
6. Bombproof and splinterproof shelter, part of Gillmore's works on Folly Island. A
7. Long view of Fort Sumter.
8. Battery Weed. A
9. Fort Putnam, the former Confederate Fort Gregg. A
10. Marsh battery (Swamp Angel) after the explosion, August 23, 1863. A
11. Another view of the marsh battery.
12. Battery B of the 1st U.S. Artillery or Henry's Battery. B
13. General Gillmore in front of his tent receiving a message from an orderly.
14. General Gillmore and his horse.
15. Ruins of the Charleston Lighthouse. B
16. Palmetto grove.
17. Fleet offshore.
18. Unidentified artillery.
19. Unidentified artillery.
20. Tent with two unidentified officers inside.
21. Unidentified camp scene with the side-wheeler *Mary Benton* in the harbor.
22. Beach scene, with tents at the left, and two unidentified civilians in center.
23. Similar scene with more of beach showing, but without civilians.
24. Tents and gun carriage wheels.
25. Interior of unidentified camp.

Glass Plate Copy Negatives and Prints

1. Battery Stevens. Two 100-pounder Parrott rifles.
2. Fort Sumter, November 10, 1863.
3. Naval battery. Two 80-pounder Whitworths.
4. Naval battery. Two 8-inch Parrott rifles.
5. Battery Strong. One 300-pounder Parrott rifle.
6. 300-pounder Parrott rifle, after bursting of muzzle.
7. Battery Brown. Two 8-inch Parrott rifles. Bursted gun.
8. Bursted gun in Battery Brown.
9. Battery Hays. Seven 30-pounder Parrott rifles.
10. Battery Reynolds. Five 10-inch siege mortars.
11. Battery Hays. One 8-inch Parrott rifle, dismounted.
12. Battery Meade. Two 100-pounder Parrott rifles, Morris Island.
13. Battery Rosecrans. Three 100-pounder Parrott rifles.
14. Bursted gun in Battery Rosecrans.
15. Battery Reno. Two 100-pounders and one 8-inch Parrott rifle.
16. Battery Kirby. Two 8-inch seacoast mortars.
17. Headquarters of field officers of the trenches, second parallel, Morris Island, S.C.
18. Bombproof for telegraph operator in trenches.
19. Full sap (a completed trench to the next parallel).
20. Bombproof, Fort Wagner.
21. Section of Captain Ashcroft's battery, 12-pounder Napoleons, in second parallel.
22. Two sections, Henry's Battery, 12-pounder howitzers, in second parallel.
23. Section of Lieutenant Birchmeyer's Battery, 12-pounder Wiards, Battery F, 3d New York Light Artillery, Morris Island.
24. General Gillmore and staff.
25. Beacon House. (Different view from original negative no. 4.)

Prints From Glass Plate Copy Negatives
(No negatives in LC collections)

1. Henry's Battery. Battery B, 1st U.S. Artillery, Morris Island. (Different from original negative no. 12.)
2. Battery Hays. Seven 30-pounder Parrott rifles.
3. Battery Hays. Seven 30-pounder Parrott rifles. (Both 2 and 3 are different from glass plate negative no. 9.)
4. 300-pounder Parrott rifle.
5. Gunboat *Commodore McDonough*.
6. Swamp Angel Battery, Morris Island. (Different from original negatives no. 10 and 11.)
7. 30-pounder battery in Fort Putnam.
8. General Gillmore's headquarters, Folly Island.

January 1967

Creative Photography 1869–1969

by Jerald C. Maddox

Creative Photography 1869–1969 was an exhibition of photographs chosen from the collections of the Library of Congress which surveyed the development of the art of photography over the last one hundred years—the period that saw photography become a means of aesthetic expression.

One of the first steps in this evolution was taken in 1869 with the publication of Henry Peach Robinson's *Pictorial Effect in Photography*, a copy of the first edition of which was the earliest item in the exhibition. Illustrated with original photoprints by Robinson, this was the first book-length statement of principles for an art of photography. Earlier statements do exist but not in as coherent or organized a form, just as there are photographs before 1869 that show a conscious aesthetic intention but which must be considered as isolated examples.

The theories and methods for artistic photography given in Robinson's book are heavily dependent upon the other visual arts, especially painting, and include basic rules for composition and arrangement of models. He explains his technique for producing artistic photographs by combining sections from several negatives to produce a single image. He also discusses methods for con-

Henry Peach Robinson. From *Pictorial Effect in Photography*. 1869. LC–USZ62–68934

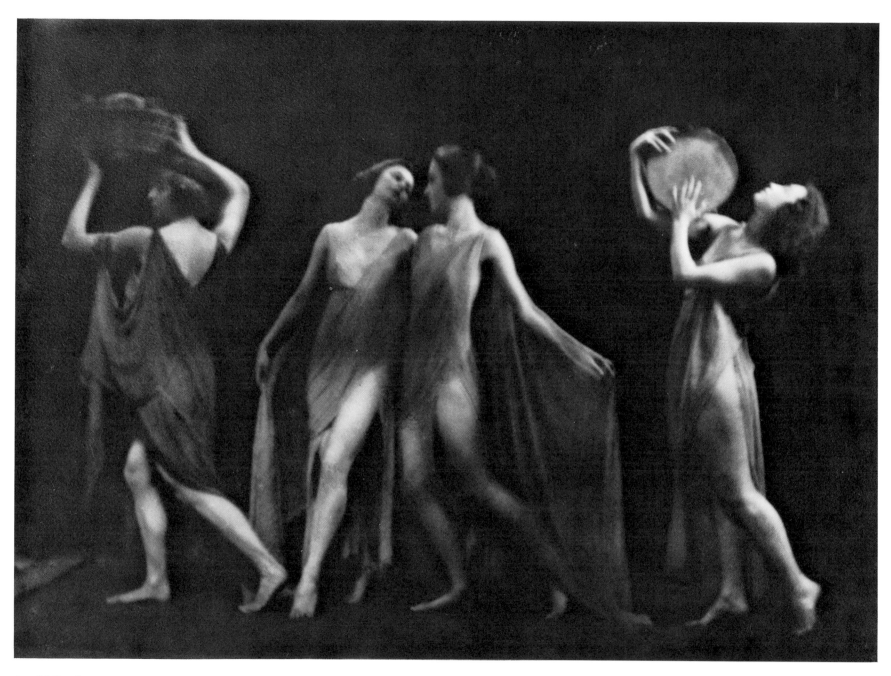

Arnold Genthe, "Marion Morgan Group (II)." About 1930. LC–USZ62–56201

trolling the scene to be photographed; for example, careful posing of the models and choosing the correct props and background. As a result, his photographs often appear contrived and artificial, but this is a characteristic they share with most of the other visual arts of that time.

Robinson's effect on the development of photography is difficult to judge, particularly in the light of subsequent history. His book went through many editions and undoubtedly reached a wide number of readers. His statements of basic rules are reflected in many later writings on this subject, but apparently few, if any, of the photographers who followed him specifically applied his methods to the point of making prints from combinations of negatives. Rather, his influence is seen in their use of self-consciously "artistic" subject matter.

It is possible that Robinson was ahead of his time, for when he wrote, photography was still a complicated process, requiring the use of wet plates and immediate development. It was a craft practiced mostly by professionals, who had little time or need for the aesthetics of photography. To produce photographs that were primarily art required a different environment, and this came about only with the appearance of large numbers of amateur photographers after the introduction, in the 1880s, of easily manageable dry plate negative materials. This period also saw a rapid increase in the commercial production of photographic materials and equipment, which simplified the photographic process, and this in turn brought about a great increase in the number of photographers who could concentrate on the aesthetics of the techniques of the craft. These included the amateurs who showed such an interest in artistic photography that most of its early development is because of their efforts.

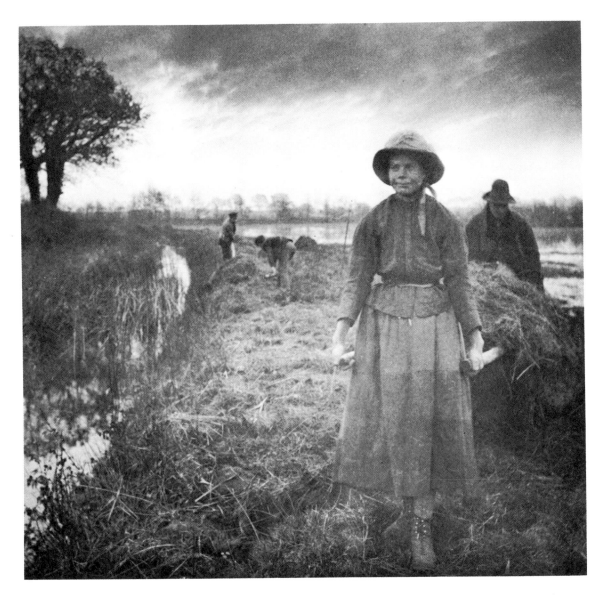

Peter Henry Emerson, "Poling the Marsh Hay." From Emerson's *Life and Landscape on the Norfolk Broads.* **1885.** LC–USZ62–56202

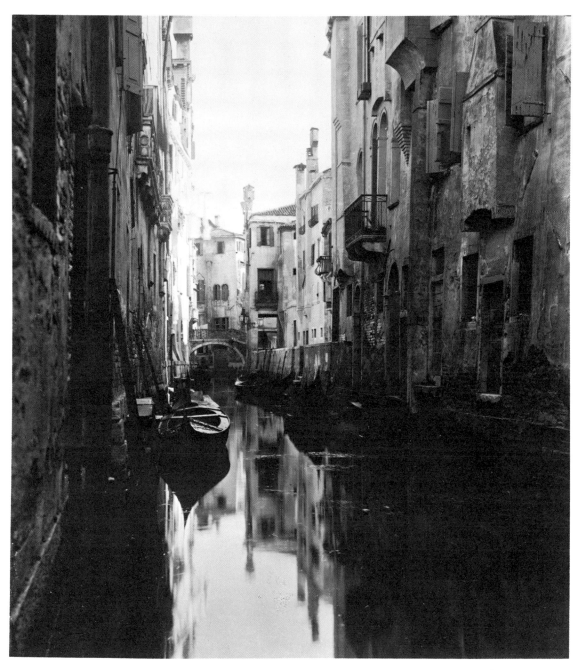

Alfred Stieglitz, "A Bit of Venice." 1894. (restricted)

Peter Henry Emerson, who began as an amateur photographer, made the next important contribution to photographic aesthetics. His influence spread, both through the exhibitions of his own photographs and through his writings. In 1885 he published *Life and Landscape on the Norfolk Broads,* a book illustrated with original photographs showing a use of photography that is basically naturalistic and opposed to the contrived and constructed images considered artistic by Robinson. Four years later he stated his principles for photographic aesthetics in his book *Naturalistic Photography.* Emerson did not approve of combination printing from several negatives but felt instead that the photographer should create his effect entirely through direct photographic techniques. One of these was the use of selective focus. Taking into account that the human eye focuses on only a limited area in its total visual range at any given moment, Emerson made photographs in which only part of the image was in sharp focus. This produced a picture that was largely out of focus and generally soft and blurred in appearance. This feature, often in an exaggerated form, came to be characteristic of much artistic photography during the next fifty years, especially of the work produced by those amateurs who were associated with the camera clubs that were so popular during this period.

In the twenty years following the publication of Robinson's book his influence had continued to spread, so that at the beginning of the 1890s there existed two fundamentally opposing approaches to artistic photography, one favoring the directly recorded image, the other a constructed and manipulated image. It is from this point that one can trace what amounts to a dichotomy in photographic aesthetics, as from phase to phase through the history of photography first one and then the

61

other of these approaches is favored. During the 1890s and the years preceding the First World War, a tendency toward the manipulated approach dominates. Following the war, and through the years to the sixties, the direct approach is favored, but not without important exceptions in the twenties. In the most recent decade the use of the manipulated image appears with increasing frequency and is a major current in contemporary photography. This recurring dichotomy emphasizes, perhaps more than anything else, how fundamental the ideas of Robinson and Emerson were to the development of photographic aesthetics.

Out of the ideas and work of Robinson and Emerson came the first organized efforts to produce artistic photography, appearing first in England, then quickly spreading to Europe and the United States and eventually throughout the world. In most cases, however, these efforts were centered in a few individuals, in some cases in a single individual, not in organized groups. One of these, and possibly the most important individual in the twentieth-century development of artistic photography, was Alfred Stieglitz. Born in the United States, Stieglitz received thorough technical training in photography in Germany. While in Europe he began to exhibit his photographs and soon won many awards. One of the first to notice him was Emerson, who awarded him a prize in an important exhibition and praised Stieglitz's work. Returning to the United States in the 1890s, he became a leader in the promotion of photog-raphy as an art, primarily through his writings and through exhibitions of both his own work and that of others. He eventually began to publish the magazine *Camera Work*, in which he showed the pictures of photographers he thought deserving. Many of these people were associated with Stieglitz in a group called the Photo-Secession, made up of individuals interested in artistic photography and who exhibited a wide variety of styles. Stieglitz himself practiced a straightforward photography, making only limited attempts to arrange or manipulate the image and rarely did this involve anything more than cropping and enlarging the original negative. More characteristic of the Photo-Secession was the approach found in the work of Clarence H. White and Gertrude Käsebier,

Alfred Stieglitz, "Lake George, New York." 1923. (restricted)

Alfred Stieglitz, "Lake George, New York." 1935. (restricted)

Alfred Stieglitz and Clarence H. White, "Torso." 1907. LC–USZ62–25088

which tended toward soft, blurred, romantic images, often with alterations and handwork done directly on the final print. Derived from Emerson, this style enjoyed a wide use and long life.

The first period of consistent development in the art of photography covered the years from about 1890 to 1920. While it was dominated by Stieglitz and the Photo-Secession group because of their frequent exhibitions and the publicity they received, it was also influenced by the work of independent individuals, some of whom were important figures in their own right. For a brief time during the late nineties, for example, F. Holland Day was almost as influential as Stieglitz. His style and choice of subject matter reflected the culture and taste of the time. Another independent figure, and one whose reputation has held up better than Day's, was Arnold Genthe. He worked for the most part in the characteristic romantic style, but—as his Chinatown pictures show—he was also capable of documentary photography. There were many European photographers whose work paralleled that being done in the United States, for example, Frederick Evans, a member of the Linked Ring, an English photographic group that preceded the Photo-Secession and had similar aims.

All these individuals emphasized the "art" of photography, particularly as it was exemplified in the single photographic print. Prints were treated as precious objects, carefully made and given elaborate settings with special mats and frames. Techniques which permitted handwork on and alteration of the print were common. The result was photographs that no longer looked like photographs, but rather like drawings, etchings, or lithographs. These techniques were used with many variations, but the two most frequently found were the platinum print and

F. Holland Day, "Elderly Man." 1905. LC–USZ62–52465

Gertrude Käsebier, "French Landscape." About 1900. LC–USZ62–56200

Clarence H. White, "The Orchard." 1902. LC–USZ62–62949

the gum print. The platinum print was made on paper coated with an emulsion using platinum salts, instead of the more common silver nitrate salts, as the light-sensitive element. The platinum print was permanent, but, more important, it produced an image having a long tonal scale, with a range of gradations that could not be achieved by any other technique. Platinum prints were expensive, however, and eventually the rising cost and scarcity of the material caused it to be abandoned. Palladium prints, using a different element, were a somewhat cheaper version of platinum prints, but they also became too expensive for general use.

The gum print was much less expensive than the platinum print and allowed the greatest freedom in manipulation of the image. The print was made on paper coated with an emulsion composed of potassium bichromate and gum arabic, with watercolor pigment to give color. This emulsion when exposed to light becomes increasingly insoluble in water as it receives more light. This means that the shadow areas of an image, which would be the thinnest portions of a negative, get the most light, and the lighter areas, where the negative is thicker, get less exposure. When the paper is placed in water, the more soluble areas of the emulsion in the lighter portions of the image wash away to expose the paper underneath. The extent to which the emulsion washes away can also be controlled by the temperature of the water and by direct work on the emulsion with a brush. With these techniques it is possible to alter the image to the point where it no longer appears to be a photographic image, but looks instead like a drawing, etching, or lithograph. Because the photographer coats his own paper, choosing the texture and color of the base of his print, he has more opportunity for creative expression. Moreover, he can recoat his

F. Holland Day, "Prodigal's Return." 1909. LC–USZ62–63110

66

Clarence H. White, "Jane Felix White." 1905. LC–USZ62–56199

Arnold Genthe, "Merchant with Bodyguard." About 1896. LC–USZ62–68933

Arnold Genthe, "Greta Garbo." 1925. LC–USZ62–70145

paper with additional emulsion and reprint several times in order to get a richer tonal scale. Some photographers have combined the two techniques, coating the gum emulsion on a platinum print and then reprinting, which produces a long tonal scale and richness of color not possible with either technique by itself.

A common feature of all these control processes is that they require long and patient darkroom work and a high degree of manipulative skill. As a result the photographs are usually made in small editions, and this, along with the obvious craftsmanship required, has sometimes been thought to more certainly make them works of art.

The extremes to which these methods were taken by some photographers brought a reaction to the Photo-Secession style, or pictorialism, as it was later known. The major direction of this reaction in the 1920s and 1930s is seen in what is known as "straight" photography. This is a difficult phrase to define, but essentially it refers to an approach that concentrates on the visible world and records it with as little alteration as possible in the photographic process. Although it is found in the the work of Stieglitz, who seldom went to the extremes of the other members of the Photo-Secession, it did not come into its own until after World War I with the work of Edward Steichen. An early member of Photo-Secession, Steichen turned to the straight approach after his wartime experience with aerial photography. His work of the twenties and thirties shows the sharpness and clarity that are characteristic of straight photography. Other examples in this period include the photographs of Paul Outerbridge, Jr., and Charles Sheeler and in the thirties and forties the work of Edward Weston.

Another form of the reaction is suggested

Frederick Evans, "Kelmscott Manor: In the Attics." About 1900. LC–USZ62–41660

69

Edward Steichen, "Sunday Papers: West 86th Street, New York." About 1922. (restricted)

in the work of Outerbridge and is given explicit expression in the work of Man Ray. This is abstract photography, a reflection of the movements in the art world of the same time. Outerbridge's emphasis on simple basic forms in many of his images certainly produces a photograph with a strongly abstract quality. Man Ray in his "Rayograph" moves further away from the recognizable representation of objects. The Rayograph, or photogram, as it is more commonly known, is basically a direct shadow pattern formed on light-sensitive material by objects placed on the material during a brief exposure to light. Some of the earliest experimental photographic images were made in this way, but the technique was not widely used as an end in itself until the twentieth century, when Man Ray and others took it up again. They expanded the technique by varying the objects placed on the light-sensitive material, using transparent, translucent, and solid objects that would produce different shadow patterns and gradations of tone. In his Rayographs, Man Ray makes an image that in itself is a work of art. For him it is not important that a photographic technique is used to make his images; the creation of abstract form is his primary end, and he enjoys the paradox of creating unfamiliar forms directly from common objects.

In the thirties the older forms of artistic photography were found less and less outside of the amateur camera clubs, while the newer straight and abstract approaches became increasingly prevalent among those considered to be creative photographers and among the professionals. Along with this, one is aware of a tendency for these two approaches to be used together and of their effect on photography generally. In the work of the photo-journalists, for example, increasing attention is paid to the aesthetic qualities

Edward Weston, "Tomato Field, 1937." (restricted)

Top: Edward Weston, "Tide Pool, Point Lobos, 1945." (restricted)

Bottom: Charles Sheeler, "Fuel Tanks, Wisconsin." 1952. (restricted)

of the photograph. Such documentary photographers as Walker Evans and Dorothea Lange combine reportage with a conscious awareness of aesthetic qualities. To many people, this—rather than the work of the Photo-Secession—is the purest statement of photographic aesthetics.

Through the thirties and into the forties, this tendency to a merging of styles increases. The straight "artistic" photograph and the documentary photograph are often no longer distinct entities, and in almost every case emphasis is on the highest possible level of photographic quality in the finished photoprint. This approach perhaps finds its ultimate expression in the photographs of Ansel Ad-

Man Ray, "Rayograph." 1927 (restricted)

Paul Outerbridge, Jr., "Telephone." 1923. LC–USZ62–68507

72

ams. His direct, intense approach to his subject is combined with an ability to control the photographic processes so precisely that the photographer at the moment of exposing his negative can visualize the final print. Adams' prints are beautiful objects and establish a standard for evaluating the aesthetic quality of photoprints.

During the fifties and sixties, this high standard of quality is generally maintained by photographers of all stylistic persuasions. The straight approach remains an underlying force today, expressing itself in several variations. In the work of Brett Weston it often shows a strong feeling for abstract form. Paul Caponigro uses it to present highly emotional, personal poetry. George Krause takes

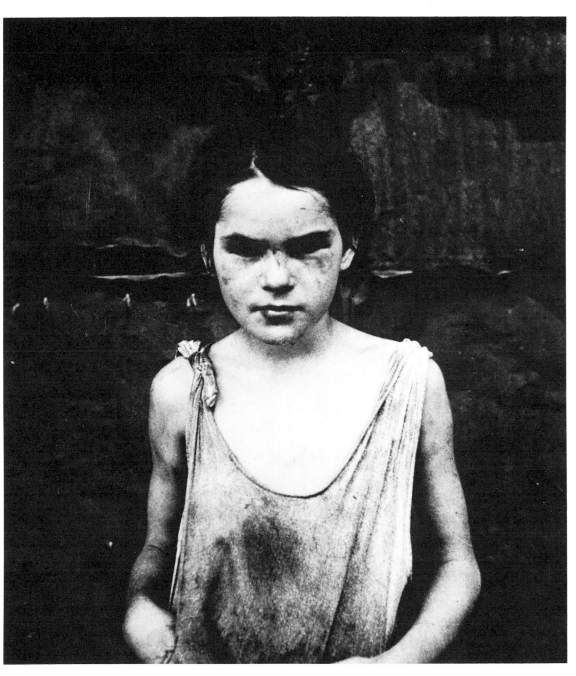

Paul Outerbridge, "Abstraction." 1921. LC–USZ62–69142 **Dorothea Lange, "Child Living in an Oklahoma City Shacktown." 1936. LC–USF34–9690C**

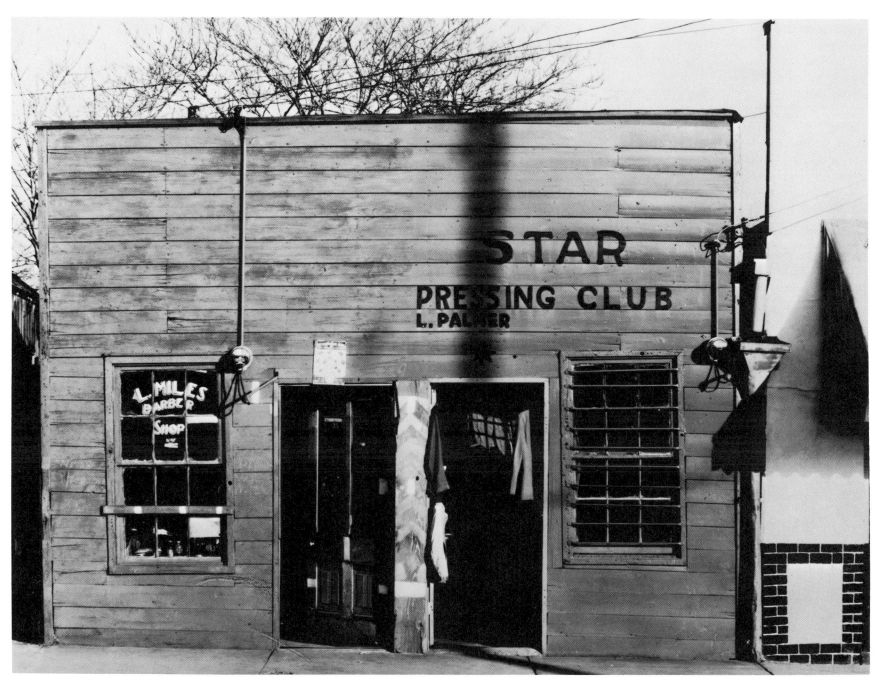

Walker Evans, "Negro Shop, Vicksburg, Mississippi." 1936. LC–USF342A–RA1317A

elements of reportage and straight photography and gives them an overlay of emotional association which makes his pictures something more than simple documents. The work of these men is, of course, only an indication of the range which contemporary photographic expression covers.

With the end of the sixties new trends are appearing. Manipulating the photographic processes to produce the expressive object and combining negatives to create a single image are methods reminiscent of another era. But there are also new ways of controlling the form of the image, which are possible because of advances in photographic technology: the use of high contrast materials to remove the gray tones from the image and make it a strictly black-and-white representation; repeating the same image several times in a single work to make an overall structural pattern; the combination of images, like separate frames from a motion picture, to present a single image; the calculated use of the various kinds of camera lenses to produce a distorted image. And all of these devices may be combined to create an even more complex image.

The works which result from these methods are, like the Rayograph, often nonphotographic in appearance. A survey of photography today might include some of the intaglios or lithographs now being made which use photomechanical processes, rather than the artist's hand, to produce the image on the plate or stone. These works are perhaps as much photographs as were the gum prints of sixty years ago. This is a potentially disturbing situation for the photographer working in the straight and reportage styles, because if present trends continue, photography as a medium of independent, individual aesthetic expression may disappear,

Brett Weston, "Baja California." 1967. (restricted)

Paul Caponigro, "Sandstone and Surf, Cape Kiwanda, Oregon." 1959. (restricted)

consumed by the current collaborative, multimedia forms of expression. Increasingly, still photography is being used as an element in some more elaborate or complicated medium—as images in a motion picture or as part of a slide presentation on multiple screens along with music and taped narration; or as a source of basic visual material to be used by the designer, printmaker, or painter.

But we cannot predict the future for still photography. Today it is a universal element in our culture, enjoyed, used, and practiced by millions. Increasingly numbers of exhibitions of photography suggest there is a wide interest not only in the present uses of the medium but also in its past. A few years ago no school offered a course in the history of photography as a creative medium; now such courses can be found at colleges and universities. Related to this is an increasing interest on the part of some contemporary photographers in reviving some of the older creative techniques and styles. This would suggest that although the "pure" creative use of still photography will probably remain a thing of the past, it will continue to be a touchstone and inspiration for aesthetic expression, not only for photography but for all graphic media. Beyond this, a review of aesthetic expression in photography to the present day reveals that still photography is an important and substantial part of our cultural history. This alone may assure its continuance.

January 1971

George Krause, "Untitled." About 1963. (restricted)

Essay on a Tintype

by Jerald C. Maddox

A tintype from the collection given to the Library of Congress by the photographer Frances Benjamin Johnston provides an unusual glimpse into the history of creative photography. This tintype is an example of the most ordinary kind of nineteenth-century popular image-making. Taken by a Philadelphia photographer in 1899, it shows two women and three men grouped in front of a flat, painted backdrop typical of the time. The individuals are identified by their signatures on the paper folder in which the tintype was placed; we find, reading left to right, below, Frances Benjamin Johnston, Henry Troth, and Gertrude Käsebier and, above, F. Holland Day and Clarence H. White.

At the time this tintype was made, the two ladies were established professional photographers: Mrs. Käsebier, in New York, was primarily a portraitist, while Miss Johnston, in Washington, D.C., was doing documentary work in addition to portraits. F. Holland Day was well known in this country and in Europe as a practitioner and advocate of artistic photography. Although an amateur, his reputation was perhaps second only to that of Alfred Stieglitz.[1] Clarence H. White was still a young bookkeeper in Newark, Ohio, who practiced photography as an amateur. He had come into national prominence during the previous two years, largely as a result of being discovered by Stieglitz when the lat-

ter was judging a photographic exhibition in which White's work was shown. Henry Troth was an amateur photographer from Philadelphia, active in the Photographic Society of that city and well known on a national level, having had a one-man show at the Camera Club of New York in December 1897.[2] White and Käsebier have since become established in the histories of photography, and Day's name occasionally appears in a sentence or footnote. Frances Benjamin Johnston was largely ignored until fairly recently when some of her early documentary work was republished in the *Hampton Album.*[3] Henry Troth has left almost no trace upon the scene; examples of his photographic work which remain in the Library of Congress show him to have been a competent worker, somewhat in the naturalistic tradition of P. H. Emerson.

The tintype is primarily interesting as a record of the occasion that brought these five photographers together. They gathered in the autumn of 1899 to serve as the jury for the second Philadelphia Salon of Photography, held at the Pennsylvania Academy of Fine Arts and sponsored by that organization and the Philadelphia Photographic Society. This exhibition, along with others held under similar conditions in 1898, 1900, and 1901, marked a turning point in the history of creative photography.

The first Philadelphia Salon,[4] held in 1898,

had been widely acclaimed as the beginning of a new era in creative photography. It was in several ways a departure from earlier exhibitions; perhaps most significant, it was the first exhibition of photography in America to take place with the active sponsorship of a recognized fine arts institution. Where earlier photographic exhibitions had based acceptance on technical competence within specific categories—genre, landscape, architectural, scientific—the rules of the Philadelphia Salon were changed to base acceptance solely on the artistic quality of the photograph. In addition, where previous exhibitions had often been selected by juries with little or no awareness of aesthetic qualities, this jury was composed of three painters and two artistically inclined photographers, Alfred Stieglitz and Robert S. Redfield of the Photographic Society of Philadelphia.

The Philadelphia Salon was also the first photographic exhibition in the United States which attempted to be international in scope. Such an exhibition had been discussed for some time, and Stieglitz in particular had hoped to organize it in New York City, but the circumstances had not been right and the Philadelphia Photographic Society won the honor of hosting the exhibition.

About fifteen hundred entries were received for the first salon, an indication of the widespread interest in creative photography

in the United States at that time. From these entries the jury chose 259 examples by one hundred photographers for the exhibition which opened to the public on October 24, 1898.

It was a great success both in terms of public response and critical reaction. The exhibition presented for the first time a large selection of photographs done in a style which had previously been discussed and seen in this country only to a limited extent. Photographers like Clarence H. White became nationally known because of this salon, which could be said to represent the public debut of creative photography in the United States.

Adverse criticism was relatively minor and was directed primarily to the small number of foreign participants.[5] European photographers had been invited, but few chose to enter. This was partially offset by the participation of most of the leading American photographers, including Stieglitz, Käsebier, and White, each of whom had ten prints in the show. F. Holland Day was represented by eight prints.

Public enthusiasm, along with the critics's generally favorable treatment of the exhibition, encouraged the sponsoring organization to make the Philadelphia Salon an annual event. It announced another exhibition for 1899 and named the jury. This is the group whose sober images are preserved in the tintype. It was the first all-photographer jury to judge a major photographic exhibition. This was a revolutionary step that not only suggested that photographers might be aesthetically sensitive, but also implied that in this respect they might be the equals of artists in the traditional media. In the light of some of the published statements of that time about the natural inferiority of photography to the other arts—which sometimes still appear—

LC–USZ62–45769

79

Girl with a Venus, about 1900, reflects Clarence H. White's preoccupation with "art for art's sake." The juxtaposition of the white figurine and the darkly costumed model exemplifies late nineteenth-century taste. LC–USZ62–68931

Henry Troth's quiet study, "Washing Day, Chartres, France," made about 1900, shows both a natural, straightforward approach to the subject and a carefully planned composition. LC–USZ62–68929

the all-photographer jury was, indeed, a bold innovation. It should be mentioned here, however, that in actuality the previous exhibition had been largely chosen by photographers. In an article which appeared in the June 1902 issue of *Photo Era*, Stieglitz stated that on the day of judging for the 1898 salon two of the painters were unable to attend and the remainder of the jury—two photographers and one painter—proceeded with the judging.[6] The two absent painters later saw the selections of the other jurors and gave their approval. Although this situation apparently was not widely known at the time, it undoubtedly had much to do with the decision to form a jury for the 1899 salon made up entirely of photographers.

The second exhibition was held in October and November.[7] A total of 1,130 photographs were received, of which 168 were from thirty-one specially invited exhibitors; the remaining 962 were submitted to the jury, and of this number 182, the work of eighty-eight artists, were accepted. The work of the five jurors was hung separately, a move which several writers noted with approval. It was a more restricted exhibition, with fewer entries than in the previous years. Photographers perhaps were aware that the jury would demand high quality.

The exhibition was generally well received, but some exhibitors were strongly criticized. Much attention was given to the work by members of the jury, and of these F. Holland Day was most frequently attacked.[8] This was in contrast to the reception given his work in 1898. The criticism centered largely on Day's attempt to represent religious subjects in some of his photographs. Many writers felt this was in bad taste and gave little consideration to the aesthetic qualities his photographs might have had. Negative comments were also made about the work of the other jurors, particularly Clarence H. White.[9]

Considering this criticism in the light of the more positive reception of the first salon, one might interpret it as indicative of a more mature approach on the part of the critics who, in evaluating the first exhibition, may have been lenient in view of the simple fact that it was taking place. This is probably true to some extent, but as one reads the various reviews and comments one becomes aware of an attitude that is not entirely objective. Obviously in the case of F. Holland Day the critics's reactions were prompted by his subject matter, but with other exhibitors the explanation is more obscure. When Clarence H. White was criticized for a lack of physical beauty in his models, one suspects that something other than a reasoned appraisal of the photographs prompted the critic's statement.[10] The exact reasons for the negative criticism are difficult to find, but as one reads articles and letters to editors published at the time, one senses that much of it was a personal reaction to Alfred Stieglitz and his circle, whose influence was strong in the Philadelphia Salons. Stieglitz and his followers had attained a worldwide importance, and some who were not part of this circle apparently were resentful. Others felt Stieglitz was too dogmatic in his critical decisions and in his evaluation of photographers.

All the members of the second jury were well known to Stieglitz, and he had reproduced examples of work by all of them in *Camera Notes*, the official publication of the Camera Club of New York, of which he was editor. He and Robert Redfield of the Philadelphia Photographic Society were closely associated, having served together on the jury of the first salon. Stieglitz's influence becomes even more obvious when we note that he was again a member of the jury for the third salon.

Adverse criticism increased with the third salon, held in 1900.[11] The organization of the exhibition was similar to that of the previous salons, and the jury was again made up entirely of photographers: Alfred Stieglitz, Gertrude Käsebier, and Clarence White, who had served on previous juries, and two photographers who had exhibited in the previous salons, Frank Eugene of New York and Eva Laurence Watson of Philadelphia. The significant fact about these photographers was that they were all associated with the pictorial movement being promoted by Stieglitz in the pages of *Camera Notes*.

Two hundred and four photographs made up the 1900 salon. Of this number 50 were by members of the jury and 36 were the work of especially invited exhibitors. The remaining 118 exhibits were selected from 883 photographs submitted to the jury. Once again this was a decrease from the previous years.

This growing exclusiveness might have been seen as indicative of a rise in the quality of the work shown, but with the exception of *Camera Notes* most of the photographic journals saw it differently. Signs of a rebellion against the pictorial approach defined by Stieglitz had been appearing, especially in the Philadelphia Photographic Society. It was a member of this group, Dr. Charles Mitchell, who began the open attack in *Amateur American Photographer*.[12] He was especially biting in his comments on the work of the jury members and complained about the "narrowness" of the exhibition. He asked for a more inclusive show where "genre work, [and] scientific or illustrative" photography would be shown.[13] Mitchell believed the emphasis on aesthetic quality to be excessive; he complained that "there are too many 'impres-

sions' and too few clearly conceived, thoroughly expressed realities; too few real pictures and too much 'trash.' "[14] These familiar phrases marked the opening of a battle that was fought in the pages of photography magazines for more than a year. [15]

The climax came when Dr. Mitchell brought about changes in the roster of officers of the Philadelphia Photographic Society. The new officers proceeded to change the format and rules for the 1901 salon. [16] A jury was chosen which included only three photographers among the five members, and only one of these, Frances Benjamin Johnston, had any connections with the more "advanced" school of photography. Reaction among the advanced photographers was strong; none of the group around Stieglitz and no members of the Linked Ring, [17] even though they were especially invited, participated in the exhibition. Some indication of this reaction is found in a letter to Miss Johnston from Eva Watson, a jurist of the 1900 salon who was later associated with Stieglitz in the Photo-Secession.

Awfully sorry to see your name on the jury. You'll have a picnic—the other people will be four to one. The Salon this year does not represent the same party in the Society—which might not necessarily be bad—if it did not represent one that has opposed and disapproved of what has been done. The Disapproval (in the Society) being of such an offensive kind that it is out of the question to take any part with them. [18]

The letter suggests that Frances Benjamin Johnston was the representative of the "advanced" school on the jury and would have to work against a majority of four. It would be interesting to know how the actual judging went and why Miss Johnston was chosen for the jury, but unfortunately there is no reference to these matters in her correspondence.

Stieglitz later noted that only 33 of the 102 photographers in the 1901 salon had ever exhibited before. [19] The exhibition was larger, showing 281 prints, and was broader in scope, but many felt that the aesthetic quality was lower than in the previous salons. Critic Charles Caffin referred to it as a show of student work, fuller of promise than of accomplishment. [20] He suggested that this type of work would be better shown in local exhibitions, leaving the international salons free to insist on the highest standards.

Not only were the critics (in some cases) displeased with the 1901 salon, but the Pennsylvania Academy of Fine Arts, reacting to the arguments and controversy surrounding the exhibition, refused to act as cosponsor with the Photographic Society. [21] The salon thereby lost official recognition as an exhibition having equal status with the traditional visual arts.

This marked the end of the Philadelphia salons as significant exhibitions. They had only three years of artistic importance—1898, 1899, and 1900—but during this time an example was established for later exhibitions. The Library's tintype is a record of one of the most significant decisions to result from these salons: that a jury made up of photographers was capable of judging photographs on the basis of something other than technical criteria. Interpreted more broadly, this image represents the efforts and ideas of many individuals, working with and writing about photography as a serious art—efforts and ideas which seemed to come together at this time, largely through these salons, and which eventually evolved into the Photo-Secession. One cannot say, of course, that the Photo-Secession and everything that followed came directly from the Philadelphia Salons, but certainly the reactions of Stieglitz and others to the events surrounding these salons provided a dramatic unifying factor which had not been present before. This tintype, taken by a photographer who probably would not have understood what the fuss was about, or cared, has become a record of a fundamental event in the history of creative photography.

January 1969

F. Holland Day's photographs were usually carefully thought out, like this study dated 1898. Models were chosen and costumed to convey an exotic quality. LC–USZ62–68982

Frances Benjamin Johnston's view from Chesapeake Bay of Hampton Institute, one of the first colleges for Negroes. **This and other more detailed** pictures Johnston made of the school were shown at the Paris Exposition of 1900. LC–USZ62–68930

Portrait of Miss B., made about 1900, reveals Gertrude Käsebier's early art training. The similarities to Leonardo's Mona Lisa are probably deliberate. LC–USZ62–66953

NOTES

1. Alfred Stieglitz (1864–1946) was an American photographer and a leader of the aesthetic movement in photography. In 1902 he founded the Photo-Secession, an association of independent photographers and a secession group from the Camera Club of New York. Its purpose was to break with conventional ideas of artistic photography and to explore new directions of expression. The center of the organization was the Little Galleries of the Photo-Secession in New York City, where Stieglitz was located and where many of the organization's exhibitions were held.

2. Review, *Camera Notes*, 1:119 (April 1898).

3. *The Hampton Album* (New York, The Museum of Modern Art, 1966). Forty-four photographs by Frances Benjamin Johnston from an album of Hampton Institute, with an introduction and a note on the photographer by Lincoln Kirstein.

4. Announcements in *American Amateur Photographer*, 10: 276–277 (June 1898), and *Camera Notes*, 2:23 (July 1898).

5. Joseph T. Keiley, *Camera Notes*, 2:113–132 (January 1899). Review, *American Amateur Photographer*, 10:548–554 (December 1898). E. Leo Ferguson, "Philadelphia Photographic Salon," *The Photographic Times*, 31:2–3 (January 1899).

6. Alfred Stieglitz, "Painters on Photographic Juries," *Photo Era*, 8:444 (June 1902).

7. Announcement in *American Amateur Photographer*, 11:204–205 (May 1899).

8. *American Amateur Photographer*, 11:518 (December 1899). *Camera Notes*, 3:161–164 (January 1900).

9. *American Amateur Photographer*, 11:517 (December 1899).

10. Ibid.

11. See review by Charles L. Mitchell, *American Amateur Photographer*, 12:560–568 (December 1900).

12. Ibid.

13. Ibid., p. 568.

14. Ibid.

15. Primarily in *American Amateur Photographer* and in *Camera Notes*, 4:226–227 (January 1901). See also comments by Stieglitz, *Camera Notes*, 5:121–122 (October 1901) and Dallet Fuguet, "The Salon Situation," *The Photographic Times*, 33:481–483 (November 1901).

16. Joseph T. Keiley, "The Decline and Fall of the Philadelphia Salon," *Camera Notes*, 5:279–299 (April 1902).

17. The Linked Ring Brotherhood was a group that seceded from the Photographic Society of Great Britain in 1892. Its members were young photographers who emphasized the esthetic approach to photography. Although primarily an English organization, foreigners were elected to membership, including the Americans Alfred Stieglitz, Clarence H. White, and Gertrude Käsebier.

18. Unpublished letter, July 25, 1901, Frances Benjamin Johnston papers, Manuscript Division, Library of Congress.

19. *Camera Notes*, 5:216 (January 1902).

20. Ibid., p. 215.

21. Robert Doty, *Photo Secession: Photography as a Fine Art*, Monograph no. 1 (George Eastman House, Rochester, N.Y., 1960), p. 26. Doty does not clearly document this fact in his book. Other sources, like the review cited in notes 19 and 20, seem to indicate that the salon did, in fact, take place in the Pennsylvania Academy of Fine Arts. So far it has not been possible to clarify this point from available sources.

The Arnold Genthe Collection

by Paul Vanderbilt

One of the principal phases of current policy concerning the pictorial collections of the Library of Congress involves the obligation to preserve the original negatives of those outstanding photographers whose work significantly records American life. Original negatives are, on the one hand, the prestige items of a photograph collection, the treasures held in respect, the unique basis (as are manuscripts) for whatever publication may already have taken place, the materials closest to their creator; and on the other hand, they form the most eminently practical part of a picture collection, since from them are derived, through photoduplication, the prints for future publication and republication. And virtually every negative collection includes a wealth of unpublished material that is often of great interest.

With the appointment in 1950 of Hirst Milhollen as Curator of Negative Collections, a definite, constructive step was taken to put the Library's many important collections of negatives in usable condition. For permanent preservation and efficient use, a collection must ordinarily be sorted so as to reconstitute, as a foundation, the original sequence. The various special series must be segregated and identified, and the whole collection must be provided with proper jackets which show the series, the number within the series, the type of film (if there is cellulose nitrate which must be isolated for safe storage), whether

John D. Rockefeller, Sr. LC–USZ62–5016

the negative is an original or a copy, and whether it has been printed for the files which are to serve as an index. This type of work on a large and diversified collection is naturally time-consuming, involving as it does the problems of weeding out hopelessly broken plates, having others repaired, selecting the best exposures from among apparent duplicates, and identifying unlabelled pieces. An order of precedence was accordingly established for the various negative collections in the Library, and Mr. Milhollen has devoted a full year to the first of these, the collection of Arnold Genthe.

Genthe, as a photographer, eminently deserves this degree of care in the national collection. As a technician, he did much to accomplish the revolution in photography which, coinciding with the development early in this century of improved processes of reproduction, gave to the art its present outstanding position; as a favorite of the elite and the personal friend of the famous, beautiful, daring, and hence newsworthy people of his time (both American and foreign), he used his studio as a center of brilliant social activity and took every occasion to compile an unequalled series of portraits, not at the level of a commercial studio but at that of an intimate memoir, throughout which appear such figures as David Belasco, Henry E. Huntington, Woodrow Wilson, Frederick W. Goudy, Paderewski, Frank Norris, the Divine Sarah, the members of the Three Hours for Lunch Club, and Father Parthenios, the Guestmaster of Mount Athos.

Genthe died in 1942 at the age of 73, and from his estate the Library purchased, at a figure representing some incidental expenses rather than the potential commercial value of the collection, virtually all of his work which had remained in his studio, the only notable exceptions being his series of often-repro-

duced negatives of the San Francisco earthquake and fire of 1906 (now in the San Francisco Palace of the Legion of Honor), and the late negatives made in Greece. The Library thus acquired something in the neighborhood of twenty thousand negatives, Genthe's original studio appointment and account books, several filing cabinets filled with proofs, and approximately a thousand fine, mounted prints. As sorted and arranged, the subject matter of the negatives falls into the following categories (discounting here the differentiation according to varying sizes, copies, and kinds of film): San Francisco portraits and miscellaneous subjects; New York portraits and other subjects; Isadora Duncan and the Duncan dancers; architectural studies in Charleston and New Orleans; missions; Acoma, N. M.; Guatemala and Cuba; European travel pictures; Morocco; Japan and Korea; the Ainus of the island of Hokkaido; San Francisco Chinatown; the Yosemite; personalia; autochrome color transparencies; and reproductions of paintings and other works of art.

Genthe's various books, several of which are in the Library's Rare Book Division, have spread the fame that surrounds his legend, but all together they reproduce only a fraction of his life's work:

Pictures of Old Chinatown . . .with text by Will Irwin. New York, Moffat, Yard and Co., 1908.
The Book of the Dance. New York, Mitchell Kennerley, 1916 [republished, Boston, 1920].
The Gardens of Kijkuit. Baltimore, Privately printed, 1919. Text by William Welles Bosworth. (Kijkuit is John D. Rockefeller's country estate in the Pocantico Hills on the Hudson. The Library of Congress does not have a copy of this book.)
Impressions of Old New Orleans. New York, Doran, 1926.
Isadora Duncan: Twenty-four Studies. . . . New York and London, Mitchell Kennerley, 1929.
Highlights and Shadows. New York, Greenberg, 1937.

To these should be added his autobiogra-

phy, *As I Remember* (New York, Reynal and Hitchcock, 1936), which was reviewed in the *Saturday Review of Literature* (Nov. 28, 1936) by William Rose Benét under the title "Super Camera-Man." There have also been a number of articles in newspapers and periodicals by and about Genthe as a photographer, among which are:

Rebellion in Photography, *Overland Monthly,* Aug. 1901.
Photo Hunt Bags Wedding Proposal. . . . *San Francisco Bulletin,* Sept. 6, 1908.
Studies Ceremonial Drunkards of Japan . . . Dr. Genthe Comes Back from Orient with Great Photograph Collection. *San Francisco Bulletin,* Oct. 9, 1908.
The Religious Ceremony of Getting Drunk; A Visit to the Ainus. . . . *New York Herald,* Mar. 31, 1912 (also used in *San Francisco Call).*
Old Chinatown. The Craftsman, Feb. 1913.
German-American Artist Who Perfected Color Photography. *The American Magazine,* May 1913.
In the Grand Canyon of the Colorado. *The Delineator,* Sept. 1913.
Pen and Inklings. *Harper's Weekly,* Oct. 10, 1914 (correspondence between Arnold Genthe's cat and Oliver Herford's cat).
Notable Photography; Three Unusual Portraits. *Century Magazine,* July 1915.
How Arnold Genthe Uses Sunlight to Capture Beauty. *The Craftsman,* Nov. 1915.
The New Dancing . . . by E. R. Lipsett. *The Delineator,* Feb. 1917.
No Beauty in "Chicken" Types, Says Arnold Genthe, Which Proves "Most American Men Do Not Know Beauty When They See It"; Insists "Beauty without Brains Is Not Beauty" . . . *New York Evening World,* Apr. 30, 1921 (interview).
What Makes the Modern Girl's Face Hard?. . . *New York World,* 1926 (interview).
Time's Whirligig in Chinatown, *Asia,* Apr. 1928.
The Revival of the Classic Greek Dance in America. *Dance Magazine,* Feb. 1929.
Le visioni artistiche di Rodi nelle fotografie di Arnold Genthe. *Il giornale d' Italia,* Dec. 9, 1931.
The Man Who Saved Garbo's Career . . . by Greta Montebel. *Screen Book,* July 1934.
Artists Who Work by the Sea at East Hampton, Long Island. *The Spur,* Sept. 1934.
The Human Side of Photography [by] Arnold Genthe. *Camera Craft,* Dec. 1934.

Minnie Maddern Fiske as Becky Sharpe. LC–USZ62–68256

Stella Block, striking this seaside pose, was a student of Isadora Duncan's. LC–USZ62–68255

Isadora Duncan. LC–USZ62–68254

Who Are the Queens of Beauty? by Arnold Genthe. *This Week (New York Herald Tribune)* Nov. 1, 1936.

Arnold Genthe, by D. Carter Bower. *Park Avenue Social Review*, Nov. 1936.

Ageless Luster of Greece and Rhodes. *National Geographic Magazine*, Apr. 1938.

Glorifying the Ugly? *New York Herald Tribune*, Jan. 15, 1939.

Dr. Arnold Genthe's Art. *New York Herald Tribune*, Jan. 21, 1939.

Camera Artist. . . . *Look*, July 30, 1940.

Earthquakes to Actresses. *Cue*, Oct. 18, 1941 (a review of Genthe's exhibition: Fifty Portraits of the Theatre . . . at the Museum of the City of New York).

Letchworth Village; Arnold Genthe Photographs a Famed Village for Mental Deficients. *U. S. Camera*, Nov. 1941.

Obituaries in: *Publishers' Weekly*, Aug. 15, 1942; *Art Digest*, Sept. 1942; and *Current Biography* for 1942.

Genthe's non-photographic bibliography should include various romances which he wrote for German newspapers while he was a student, his doctoral thesis in classical philology on a manuscript of Marcus Annaeus Lucanus in the University library in Erlangen, a treatise on German slang (1892), his articles on artists such as Korbel, Boronda, and Goldbeck, his review of Arthur Davidson Ficke's *Chats on Japanese Prints* (*Forum* for February 1916), and the auction sale catalog of his own collection of Japanese prints at the Anderson Galleries in 1917. A selection of his Chinatown photographs was issued by Mills College as *Old Chinatown . . . a Photographic Calendar for the Year 1946*, and separate photographs have of course been used as illustrations in many articles. But the publications notably omit the great portraits, most of which were made as private commissions, and which constitute the real importance of the Library's holdings.

Arnold Genthe was no exception to the tendency which photographers have to surround themselves with a legend. In his case, the legend concerns chiefly his fame as a ladies' man, and his autobiography includes,

"The Boss of the Fish Dealer's Court," New Orleans. LC–USZ62–68250

for those who are interested, a section entitled "Why I Did Not Marry." Women apparently did flock to him to be photographed and were ecstatic in their pleasure at his interpretations—a flattery of poetry and candlelight effect. His studio was his library, filled with books, fine furniture, and oriental paintings; his sittings were momentary incidentals to a memorable occasion, when other notables were likely to appear; his clients became his friends and these contacts were pursued with gay parties and correspondence. His sports were horsemanship and billiards, his handsome appearance that of one to the manner born, his tastes skilled in the choice of eating places, fine wines, works of art, and foreign adventure. A consummate egoist, it seemed natural to him that at a royal ball the Court Chamberlain should appear and say that Her Majesty commanded him to dance with her; that when he sent a personal photograph of himself to a newspaper friend, it should appear on the front page; that an old friend from Europe should be led to renew his acquaintance while idly thumbing through *Who's Who in America*; that Eleonora Duse should thank him by telegram; or that when he went for a walk he should encounter Theodore Roosevelt. Everything in his life was dramatic. One of his brothers was murdered in Fez and the other trampled to death by an elephant while hunting in Africa. So sure was his touch that when Mauritz Stiller, then renowned as one of Europe's best motion picture directors, died, he did so clutching in his hands Genthe's photograph (one of many) of Greta Garbo, who of all Hollywood beauties attracts the enthusiasm of the real art experts, whom Stiller had brought to America as his protégée, and whom Genthe was the first to discover here.

Dr. Genthe was interested in photography as such and he included a chapter on photographic history in the autobiography to which this account is obviously so much indebted. His admiration for David Octavius Hill is perhaps a key to his own approach, the exact opposite of rigid, posed portraiture, fanciful backgrounds, and glossy prints from sharp, hard negatives. His contribution was the union of art and the snapshot. His best portraits were made when the subject was unaware of the exposure, unposed and relaxed or animated in some natural activity. Often only a part of the face appeared, giving the effect of an impressionistic close-up, and his printing was generally soft and dark. He frequently used a small hand camera without a tripod and sought critical focus only when it was necessary. Genthe's aesthetic, revealed by his preferred tones and style of cropping, as well as by his tastes and standards, was essentially Japanese. His first blast at contemporary commercial practice and his defense of his own way of working were published in the *Overland Monthly* in 1901, and this course he pursued until late in his career. His work of the late 1920s and early 1930s, particularly that done in Greece and the Greek islands, is, however, solid interpretive documentation of a high and unaffected order, reaffirming the promise of his earliest pictures of San Francisco's Chinatown made in the late 1890s.

Born and raised in the heavy academic atmosphere of a typical German scholar's home, he originally intended to follow his father as a professor in some German university, probably in the faculty of classical philology. Early in life, however, though impecunious, he came in constant touch with distinguished people. Adolf Menzel, perhaps the most famous German painter of his time and a current favorite at court, was a cousin of Genthe's mother. Trained in intellectual discipline and the master of a number of languages, young Genthe in 1895 accepted a year's position in San Francisco as tutor to the son of a German nobleman who had married a California heiress. As a member of the household, he took advantage of the opportunity to make acquaintances among San Francisco society and in his leisure time wandered around the city which enchanted him. In Chinatown, he began to see things which obviously could not be put on paper by any means other than photography. According to legend, he simply decided to become a photographer, bought a small camera, went to the public library, and quickly read all the books on photography that were available.

Some of Genthe's Chinatown pictures were used by Ho Yow, the consul general at San Francisco, to illustrate his plea for the acceptance of his countrymen, "The Chinese Question," in the *Overland Monthly* for October 1901. *Asia* for April 1928 carries side by side some of these early photographs of "old" Chinatown and later ones taken by Genthe on a return visit in 1927, with his comments on change, the shearing of pigtails, the appearance of automobiles, and the general Americanization of what was once a completely foreign quarter.

The Chinese, because of their fear of and objection to being photographed, had to be caught unawares, and Genthe began of necessity with the technique to which the poor term "candid camera" work has later been applied. He joined a local photographers' club and in the club studio experimented with portraits of his friends, using the same technique of recording sudden impressions in natural sunlight which he had learned and perfected in the streets. This gave him so much pleasure and fitted so well his liking for people that, his tutorial job concluded, he gave up all thought of returning to Germany, rented a studio, sent announcements to all

the society friends of his former employers, and within a year was a fashionable success, a unique personality. He belonged to the Bohemian Club, developed a wide circle of friends among writers, artists, stage people, and society, published his first reproductions in *The Wave*, and made portraits of everyone of note, among them, it is interesting to mention, since he specialized in beautiful women, Marie Oge who later, as Mrs. Truxtun Beale, became a leader of Washington society. Her name is now perhaps most familiar in con-

The Butcher, Old Chinatown in San Francisco. LC–USZ62–65744

Top: Toy Vendor, San Francisco. LC–USZ62–68252

Bottom: Street scene, San Francisco. LC–USZ62–34662

"Loafers, young and old." LC–USZ62–34659

nection with the Truxtun-Decatur Naval Museum established by the Naval Historical Foundation in a part of her mansion on Lafayette Square.

The Chinatown negatives Genthe stored in the house of a friend outside of the city and those which have not deteriorated are now in the Library of Congress. But in the earthquake and fire of 1906, his studio and all of the other negatives of this early period were destroyed. Genthe might have been able to save them had he realized the full extent of what was happening, but during the disaster he was out photographing for days, making the record which served for the reconstruction of the event as a motion picture in which Clark Gable starred. His original album of contact proofs from the fire and earthquake pictures is in the Library's collection.

In 1908, Genthe further pursued his interest in the Orient by taking a trip to Japan and Korea where he continued his impressionistic snapshot technique to produce notable pictures of which the negatives are now in the Library. Especially interesting was his trip among the Ainus, the non-Japanese Aryan "primitives" who inhabit the northern islands. Genthe's autobiography recounts the story of a native who, pointing to a reproduction of Michelangelo's *Moses* on the wall of an English missionary's house, grinned and commented, "Him Ainu." While in the Orient, Genthe took the occasion to add considerably to his collection of works of art, an interest that yielded lifelong associations with prominent collectors, such as Charles L. Freer, J. P. Morgan, Senator William Andrews Clark, Dikran Kelekian, Otto H. Kahn, Jules Bache, and others. His pioneer autochrome copies of the paintings in the Morgan collection, which are of considerable interest in technical history, are now in the Library of Congress. Mr. Morgan presented one of

the duplicates, in a morocco case, to Thomas Fortune Ryan, himself a great collector as well as a noted financier. The latter remarked to Genthe that he kept this color plate of the Morgan Ghirlandaio in his office desk, and that when things "went wrong," he would take it out and, looking at it, would find his equilibrium restored.

The move from San Francisco to a studio in New York, made at the urging of friends, took place in 1911. Portraiture of the colorful personalities of public life, particularly of the stage and the dance, continued. But it must be said that a large part of the negative collection consists not of brilliant off-guard interpretations of well-known personalities, but of 5- by 7-inch glass plates of a relatively routine character. One of Genthe's attention-attracting incidents was his photographing of the profile of Gertrude Eddington, a stranger he happened to notice while passing on Broadway, who was at that time a chorus girl in a current musical comedy. The photograph deceived Karl Kitchen of the Sunday *World* into believing that he was looking at a photo-interpretation made in Paris from a closeup of a marble profile of the Venus de Milo. Gertrude and Venus together made a full-page spread and the former's salary jumped one thousand per cent. And the great authority on feminine beauty, with his academic title, was naturally selected as one of the jurymen for the first Atlantic City beauty competition.

Genthe himself and others have made much of his status as a pioneer in color photography, which he used for portraits, scenes from the drama, and commissions such as that in 1912 from John Patterson, President of the Dayton Cash Register Company, to picture in color his factory and the vegetable gardens of the plant's workers. His exhibition at the Vickery Galleries in San Francisco in the spring of 1911 may have been the first

Street in Spain. LC–USZ62–68251

exhibition in America of color photography—the point requires some clarification—but Edward Steichen certainly preceded him by some years in publication in natural color. In addition to those from the Genthe estate, a number of the several hundred original color autochromes in the Library's collection were obtained as a gift from the Museum of Modern Art in New York. Perhaps the ultimate prestige of Genthe's work was reached when, in 1913, he was commissioned by the White House to photograph in color the wedding of President Wilson's daughter Jessica and Francis Sayre.

A classical scholar as well as an admirer of the Orient to the end, Genthe in 1929 and 1930 took a trip to Greece, Rhodes, and other islands, which yielded some of his finest work and afforded him an opportunity to inspect the fifth-century palimpsest of the Gospels in the monastery of Esphigmenou, as well as other impressive treasures of Mount Athos. The Rhodian photographs, later acquired as a collection for the library of the Archeological Institute at Rhodes, won a diploma at the International Colonial Exposition at Rome, and many of the pictures of Greece and its architectural monuments have been exhibited and published in America.

Eager, adventuresome, productive, an exponent of the romantic life lived to its fullest, it is fortunate that a man of Genthe's qualities devoted himself to camera work and that so much of it has been preserved in the Library. Yet the qualification that many of us instinctively feel toward the prevalent attitude of his generation is constantly recalled, and is characterized perhaps by his comment, quoting Rodin and based on his experience at the museum in the castle by the Knights of St. John at Cos, that the best way to see a Greek statue is by the light of a candle moved about at will. May 1951

94

Burgos Cathedral in northern Spain. LC–USZ62–68249

Profile of Gertrude Eddington, once mistaken for a closeup of a marble profile of the Venus de Milo. LC–USZ62–5017.

Parthenon frieze. LC–USZ62–68253

Africa Through the Eye of a Camera
The Carpenter Collection

by Milton Kaplan

From the 1870s through the first three decades of the twentieth century, the stereograph, which brought a three-dimensional view of the outside world into America's living rooms, was a popular product with the picture-buying public. Stereograph companies were formed to capitalize on this interest, and photographers were assigned to cover people, places, and events, not only in the United States but all over the world. Much of the work they produced was deposited for copyright in the Library of Congress. Of the approximately 250,000 stereograph cards in the collection, about 2,600 are devoted to Africa.

Portraits of Liberian officials and photographs, drawings, and prints of life in Liberia and other parts of West Africa can be found in the collection of the American Colonization Society. The U.S. Navy expedition to observe the 1889 solar eclipse from Africa, the trip to Ethiopia in the 1920s by the famed husband and wife team of Martin and Osa Johnson, Kenyan life as recorded by the Kenya Information Service, African sculpture—these are just a few of the more than sixty different

Native water sellers ply their trade at the railway station, Beaconsfield, South Africa. LC–USZ62–39097

collections of pictures which provide source material for the study of Africa.

In 1888 Frank George Carpenter, American journalist, traveler, and author, accompanied by his wife, began the first of many trips to foreign countries. Extending over a period of thirty years, these travels resulted in many syndicated articles which appeared in American newspapers and in more than eighty books. In 1905 *Africa*, the first of Carpenter's books on the "dark continent," was published, followed in 1923 by *From Tangier to Tripoli* and *Cairo to Kisumu* and in 1924 by *Uganda to the Cape*. *Africa* was reissued in 1916, 1924, 1928, and 1929. To illustrate his books Carpenter not only took his own photographs but collected many others, such as a large group of gold-toned albumen prints, taken by local commercial firms operating in the countries he visited. The result was a superb visual record of these countries and continents. With the emphasis on the inhabitants, their daily life, and their environment, the Carpenter collection, which was presented to the Library of Congress in 1951 by his daughter, provides one of the important sources for the study of Africa in the Prints and Photographs Division.

January 1951

The series of photographs that follows is from the Carpenter Collection. The accompanying quotations are taken from Mr. Carpenter's books.

Fish (snook) boats arrive at Capetown, South Africa. In the distance is Devil's Peak. LC–USZ62–39096

Workers follow the compressed air drill in a gold mine in Johannesburg, South Africa. LC–USZ62–39095

Ivory from the interior is weighed for the customer in Mombasa, East Africa (now Kenya). LC–USZ62–39094

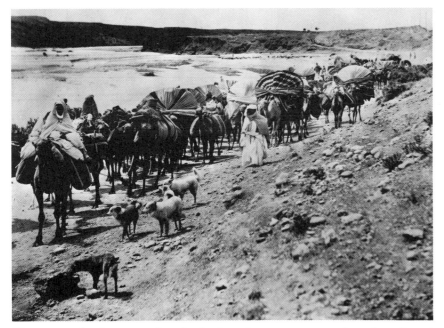

"Far out on the desert, moving slowly along in a great caravan, bound southward through the central Sahara. At the front, on fast, racing camels, are the chiefs of the tribes which make up the caravan. . . . Behind are the freight camels, scarred, dingy, and sullen." LC–USZ62–39101

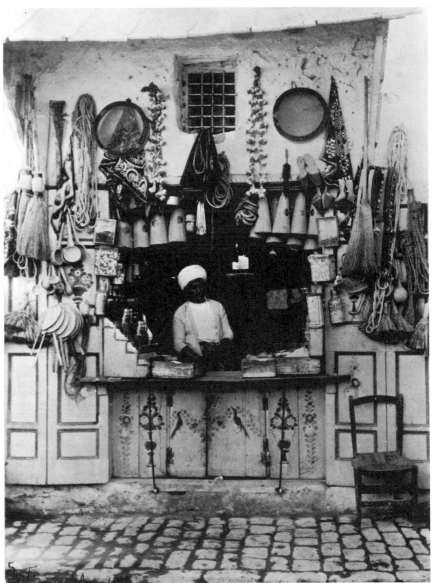

"The street [in the bazaar in Fez] is narrow, and facing it are boxlike stores. . . . Each man has his own kind of wares." LC–USZ61–1508

98

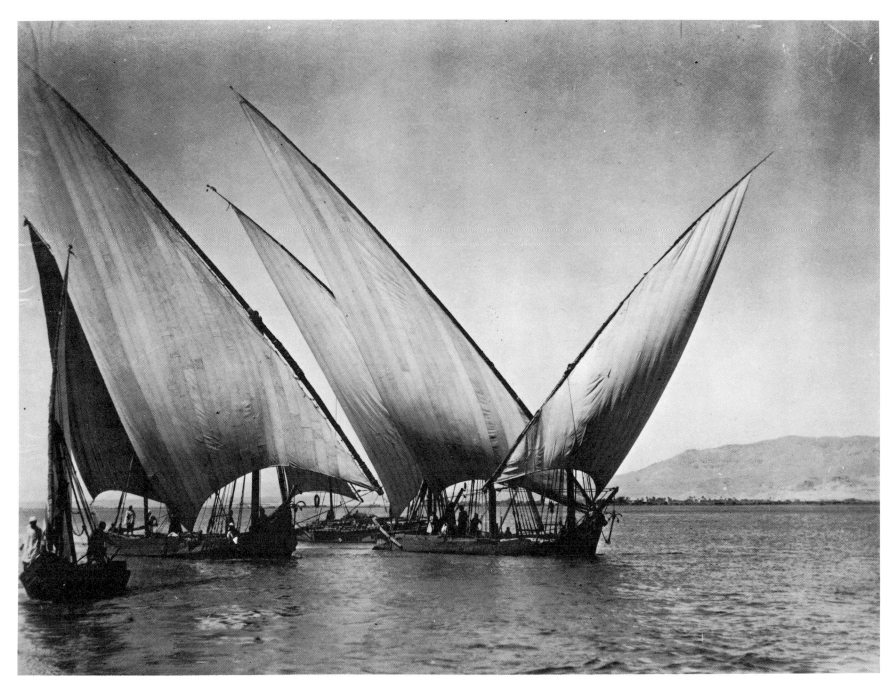

Feluccas on the Nile. LC–USZ62–39102

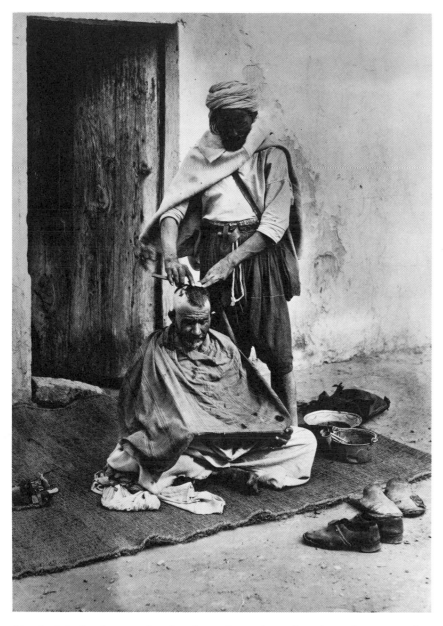

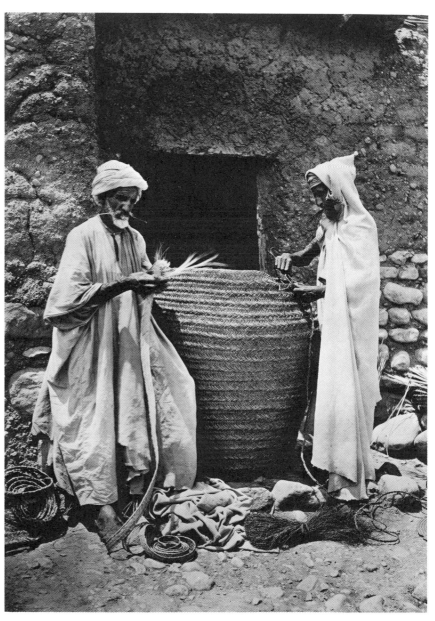

"**An Arab barber is a rough-and-ready** worker, using only water and no soap when shaving the heads of the victims." LC–USZ62–39106

"Many of the natives still store their wheat in great baskets beautifully woven by the patient hands of old men." LC–USZ62–39117

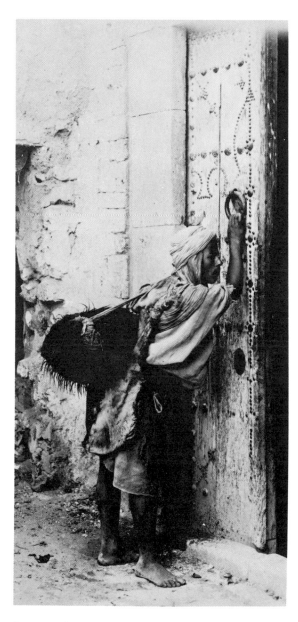

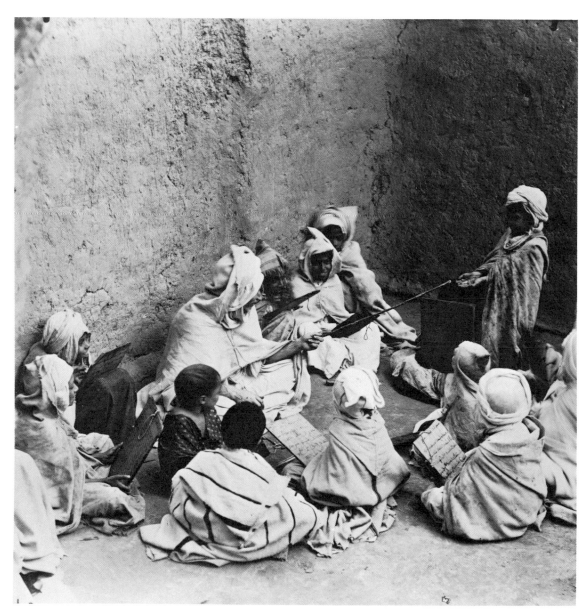

A porter of Tunis. LC–USZ62–39110

"The children of the oasis . . . all sit on the floor and study out loud. Instead of slates they have tablets of tin and wood, and they use brushes and ink in writing their letters." LC–USZ62–39109

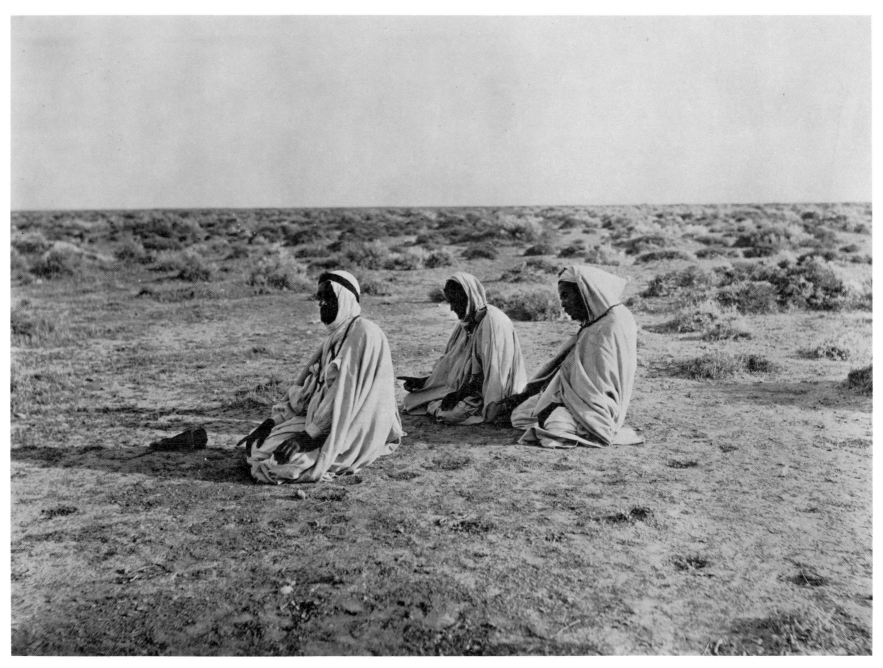

"We find mosques in the larger oases, and observe that the Arabs of our caravan say their prayers five times a day."
LC–USZ62–39103

102

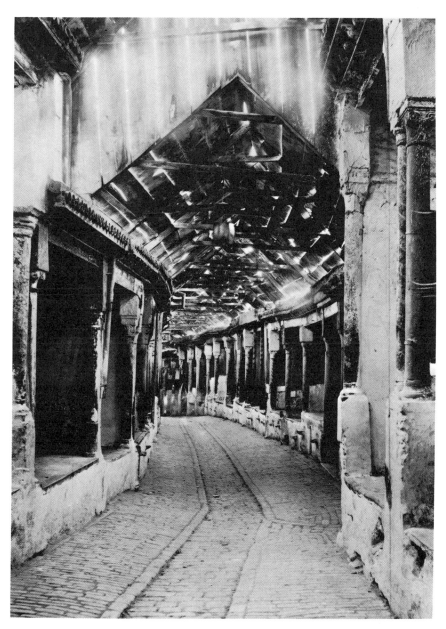

"The vaulted bazaars of Tunis are flanked with marble columns from Carthage, which the Arabs have painted over in red, yellow, and green stripes, so that they look like barber poles." LC–USZ61–1509

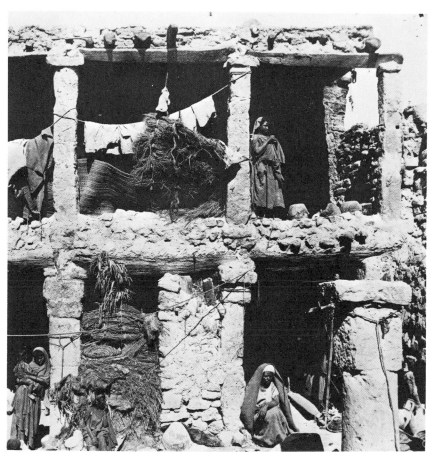

Cliff dwellings in Tunis. LC–USZ62–39107

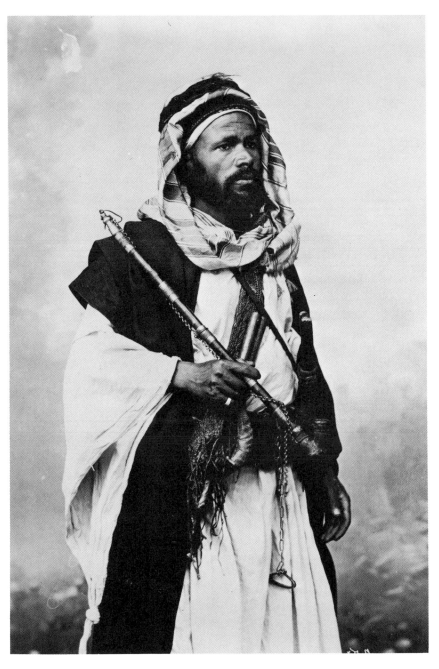

A camel driver of Sinai. LC–USZ62–38520

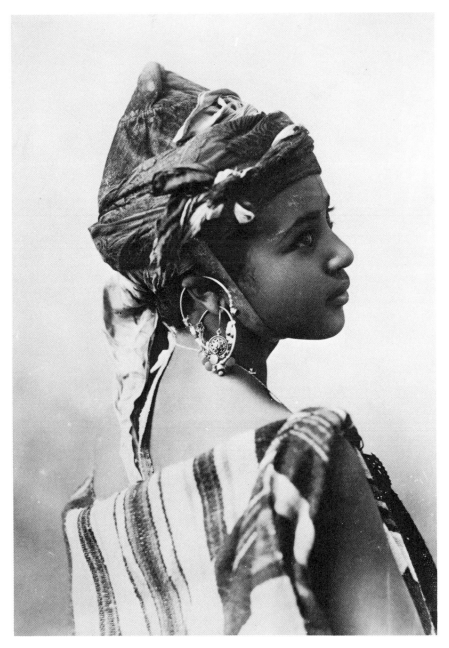

"The Ouled Nails are to be found in every oasis and there is a whole street given up to them in Biskra, the so-called Paris of the Sahara. They are . . . much like the Nautch girls of India, the Ghawazi of Egypt, or the Geishas of Japan." LC–USZ62–38521

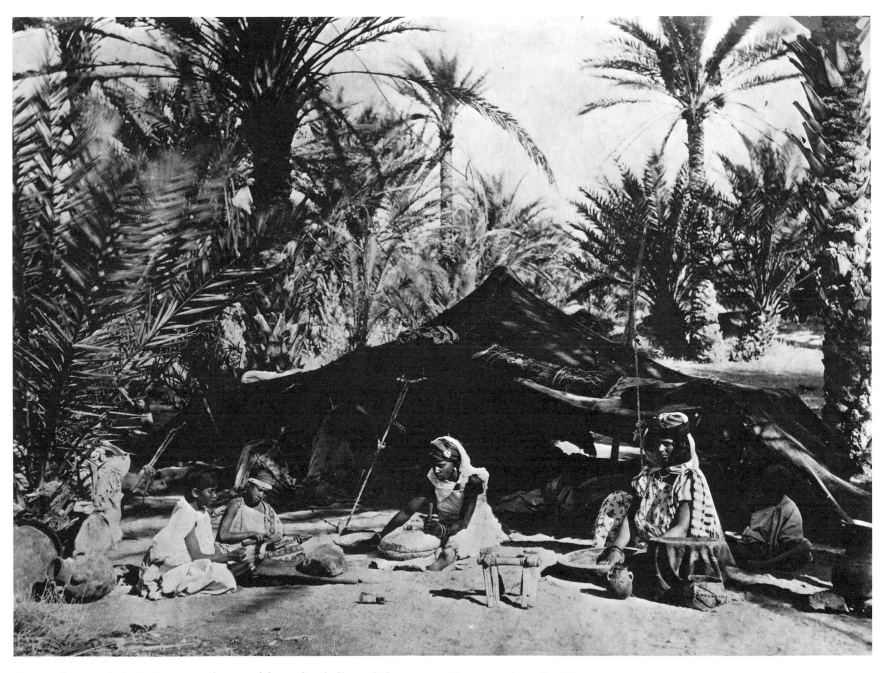

"Among the nomadic Bedouins women do most of the work, grinding grain between round stones and weaving the tents of camels' hair or wool." LC–USZ62–39113

Top: A village chief. LC–USZ62–38526

Bottom: "The fanatical dervishes keep the Moslems stirred up with their talk of a combination of the Faithful of the world under the green flag of the Jehed, or Holy War, against their Christian conquerors." LC–USZ62–38522

"In parts of Algeria the Tuareg desert policeman on his mehari is replaced by the Spahi mounted on a swift Arab horse. This one is on duty near Kairouan." LC–USZ62–39098

"Where ploughs are used, they are just the same as those of five thousand years ago. . . . The average plough consists of a pole about six feet long fastened to a piece of wood bent inward at an acute angle. The end piece, which is shod with iron, does the ploughing." LC–USZ62–39112

Top: Young Moroccan Jewesses. LC–USZ62–39100

Bottom: "Fellahs . . . are the descendants of the ancient Egyptians mixed with the various races which have conquered the country. Many of them own their farms, little patches often no larger than our village gardens. Others work as farm hands on the estates of rich landowners." LC–USZ62–39105

107

"In addition to the usual Mohammedan veils the wealthy ladies of Tunis also cover their heads with long embroidered scarfs, which they hold out far enough to enable them to watch their steps." LC–USZ62–39099

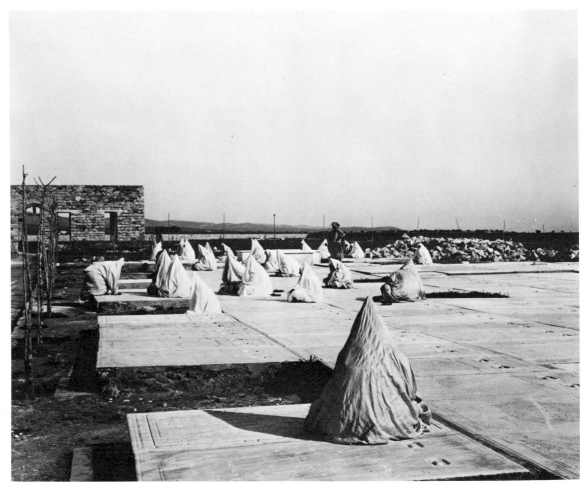

"The Jewish cemeteries [in Tunis] . . . have no tall monuments. The vaults, which are dug out so that their tops rest even with the surface of the earth, are covered with marble slabs of the same size and height, so that the whole surface of the cemetery appears to be one great marble floor. When the women go out to mourn, they sit down on the slabs over their dead and bob up and down as they wail out their grief." LC–USZ62–39108.

The Matson Collection
A Half Century of Photography in the Middle East

by George S. Hobart

The lunar-like appearance of Palestine from the summit of Mount Nebo, from which Moses gazed upon the Promised Land. This infrared telephoto shows the silhouettes of Bethlehem, Jerusalem, and the Mount of Olives on the horizon. The Dead Sea is at the left center. LC–M32–3315

In the fall of 1971 a young octogenarian with silvery hair and sparkling blue eyes could be seen in the Library of Congress, walking between Annex deck 4 south and the cafeteria two or three times each day. His name was G. Eric Matson ("G" for Gästgifvar, a Swedish family name), and for five weeks Library staff members came to know him well, for he worked six days a week, from seven to seven.

His work was really pleasure, for he was busy cleaning, identifying, and organizing his beloved group of photographic negatives which had been "lost" in East Jerusalem since 1946. These negatives are a part of the Matson Photo Service Collection, twenty thousand negatives providing a half-century's pictorial documentation of persons, places, and events in the Middle East, which was given to the Library of Congress by Mr. and Mrs. Matson in 1966.

Eric Matson was born in Nås parish in Dalarna, Sweden, on June 16, 1888. Eight years later his family, along with several other farming families, joined a small community of Americans in Palestine, founded in 1881 by Horatio Gates Spafford, a Chicago lawyer. These Americans and Swedes shared "a deeply felt need to dedicate their lives to simple Christian service to God and humanity. They pooled their resources, lived a communal life similar to that of the early church, and bent their efforts toward helping the people of the land."[1] The American Colony, as it came to be known, flourished through hard work and simple living, and in ministering to the sick and needy of Jerusalem, the colonists came to be loved by Arabs, Jews, and Christians alike. Yet the group was not without its detractors. Suspicions were aroused by the colony's "liberal policy," and malicious rumors circulated not only in Jerusalem but back in Dalarna. It was to probe these

Kaiser Wilhelm II, on the white horse, passes through the arch erected by the Jewish community of Jerusalem to honor his state visit in 1898. The inscription, in Hebrew and German, is verse 26 of the 118th Psalm: "Blessed is he that cometh in the name of the Lord: we have blessed you out of the House of the Lord." Theodor Herzl, founder of Zionism, hoped to gain the Kaiser's intercession with the Turkish sultan to permit Jewish colonization of Palestine. LC–M36–13724

The Kaiser and Kaiserin lead the royal cortege past the German Lutheran Church of the Redeemer. The dedication of this church, built on the foundation of an ancient Crusader church, was the ostensible reason for the royal state visit. The fact that the royal party traveled on Cook's Tour tickets prompted *Punch* to dub them "Cook's Crusaders." LC–M36–13726

reports that Selma Lageröf came to Jerusalem in 1899. The result was her novel *Jerusalem,* in which she portrays the Swedish emigration and life in the colony. Some twenty years later she was able to cite evidence of the settlement's accomplishments: "The colony now owned a great palace, situated not far from the Gate of Damascus, as well as six smaller buildings. It owned dromedaries and horses, cows and goats, buildings and land, olive and fig trees, shops and workrooms. Photographs of Palestine from its studio were sold all over the world, and it fitted out caravans which transported travellers far and wide."[2]

The American Colony Photo Department came into being as the result of a social need, as did many of the communal economic enterprises. Initially organized to meet the demand for photographic mementos of the state visit of Wilhelm II of Germany in 1898,[3] it grew rapidly to satisfy the increasing needs of tourism. Two of its new employees were Eric Matson and another teenager, Edith Yantiss, whose family came to Jerusalem from a Kansas farm in 1896. Eric and Edith learned quickly, by trial and error, all the complex techniques that separated professional photography from that of amateurs and experimented with new ones. They were particularly successful in using oil paints for hand coloring photographs, producing colored enlargements and sets of colored slides that became an important feature of their business. Eric and Edith were married in 1924, took over the photo department in 1934 as the Matson Photo Service, and worked together until her death in 1966.

Although the Matsons saw both world wars and many Arab-Jewish riots through the camera lens, the terrorist activities of 1946, aimed at forcing withdrawal of the British mandate, finally compelled them to leave Palestine. They fled to the United States with

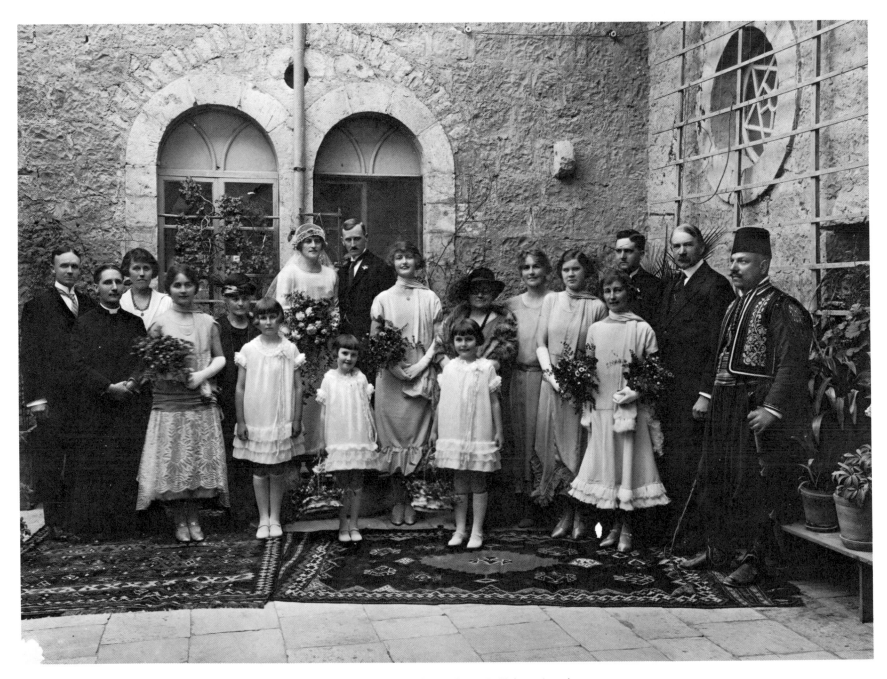

The wedding party of Eric and Edith Matson, 1924. The two men at the far right are Oscar F. Heizer, American consul to Jerusalem, and his kavass, a guard assigned to foreign consuls in Eastern Mediterranean countries.

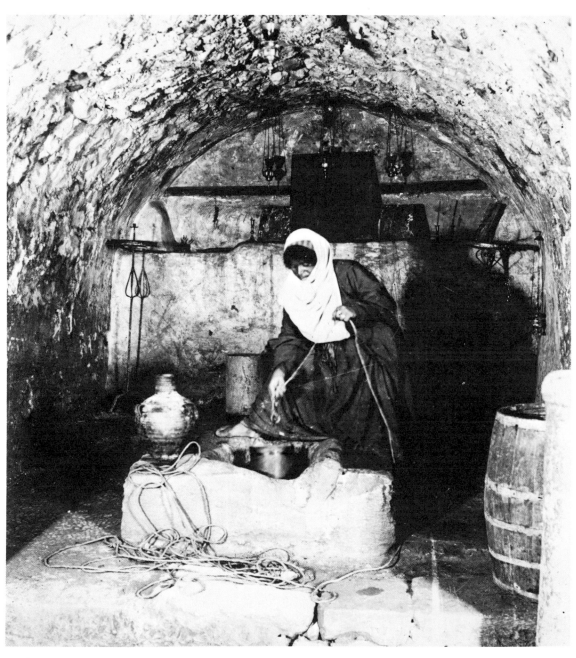

Jacob's Well, behind the village of Askar (ancient Sychar), about forty miles north of Jerusalem. This photo, taken about 1910, shows the well as it was when Jacob drew water from it and Jesus met the Samaritan woman. The well has long since been covered with marble and is now enclosed within a Greek Orthodox chapel. LC–M32–307A

their three children, leaving their life work behind to be collected and forwarded by trusted employees.

The Matson Collection shows the dramatic changes that swept over Palestine and the Middle East during World War I and the following mandate period, as well as the previous two decades of Turkish rule when the sites, customs, and dress were very like those of Biblical times. The titles of some of the Matson series of hand-colored slides are indicative of the importance accorded Biblical documentation:

"The 23rd Psalm, portrayed in the land of its inception"
"Blue Galilee: life of its fishermen and scenes on its shores"
"Ruth, the Moabitess"
"Bethlehem Juda: scenes of the first Christmas"
"Sites and scenes in Palestine bearing on Bible prophecies"
"Petra, caravan stronghold of the Nabateans"
"The life of Jesus of Nazareth"
"Babylon, land of exile"

There are many series devoted to the rites and ceremonies, occupations, and characteristics of various tribes and religious sects, Zionist activities and colonies, the natural resources of Palestine, and archeological expeditions and excavations. An exceptional series documents the disastrous locust plagues of 1915 and 1930, showing vegetation before, during, and after attack, the complete life cycle of the locust, and methods used to combat the infestations.

Among the special series are two pioneer projects in color photography for the National Geographic Society in the 1930s, using the Lumière and the Finlay color processes.[4] Another interesting assignment resulted in a large series of monochrome, Finlay color, and infrared photos tracing the Nile from its delta to its sources in Uganda.

Reviewing the techniques of his craft, Eric Matson says:

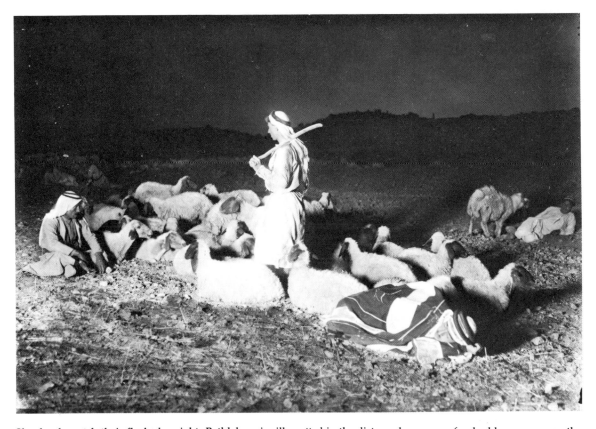

Shepherds watch their flocks by night. Bethlehem is silhouetted in the distance by means of a double exposure on the same plate, one in the evening and the second at night by flash. LC–M32–4003

In looking for the "right" composition, I rely on feelings and intuition. In general, particularly with black-and-white photography, I avoid taking outdoor pictures near the noon hour, when the sun is overhead; I prefer the lighting and the shadows provided earlier or later in the day. . . . In the early days, our picture-taking and processing were somewhat primitive and often improvised. We had to sensitize our own albuminized printing paper and used sunlight as our light source. Our earliest enlargements were made by placing a box camera through the window of a darkened room, putting the glass negative of the picture to be enlarged into the camera, and then projecting its image, by means of the daylight behind the camera, onto bromide paper that was placed on an easel inside the room at a distance determined by the desired size of the enlargement. . . . For a number of years, we used a "cabinet size" camera for 13 x 18 cm . . . glass plates. The camera had a division fixture and was used for taking stereoscopic views with a double lens. For a full-plate picture, the division was removed and a single lens used. We also used a large plate camera with which our 24 x 30 cm . . . negatives were taken. In later years, after glass plates were generally replaced by films, I used 9 x 12 cm films . . . and, to a lesser extent, the smaller, 6 x 9 cm film packs. . . . In the later years, our cameras included the German Plaubel Machina for press work, the German 9 x 12 cm Voigtlander, Eastman's Graflex, and, for 35-mm the Contax and Leica.[5]

The collection of negatives has been divided into three parts for purposes of cataloging and reference accessibility. The first part consists of those original negatives to which we have access through corresponding positive images. These five thousand 2- by 3-inch slide prints, which were the bulk of Matson's souvenir sales, are mounted in eleven large albums with an indexed catalog. A reader can now browse through scenes of the Middle East of 1900 to 1934 just as Matson's walk-in customers did in Jerusalem. However, he should be aware that the album prints do not reflect the excellence of the negative and show only the center portion of the negative image.

Part two consists of some eight thousand glass and safety film negatives, for which

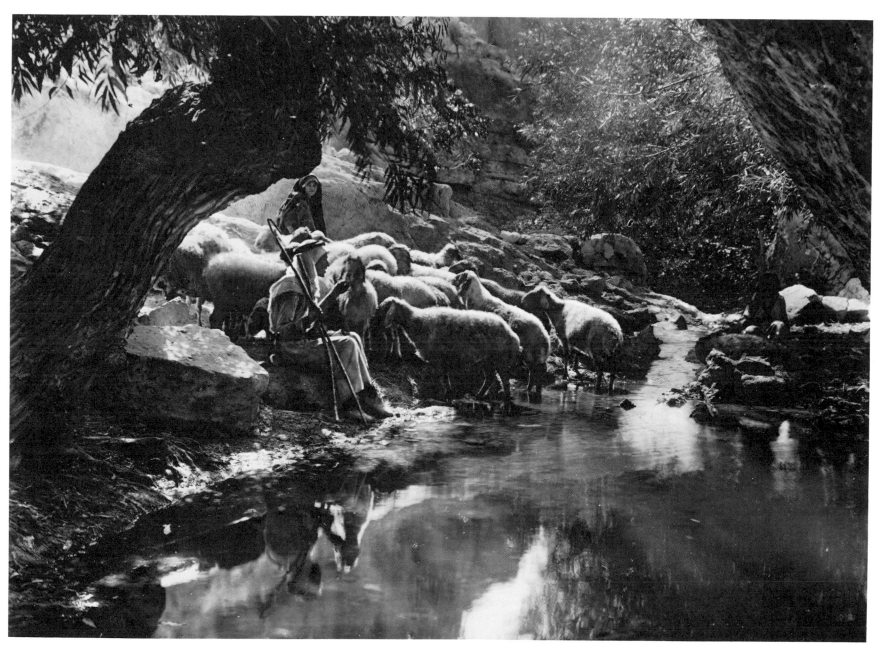

"**The Lord is my shepherd . . .**" The pastoral spring of Ain Farah, about seven miles northeast of Jerusalem, thought to be the inspiration for David's words. Matson photographed this scene as the first picture in his series illustrating the 23d Psalm. LC–M32–B276

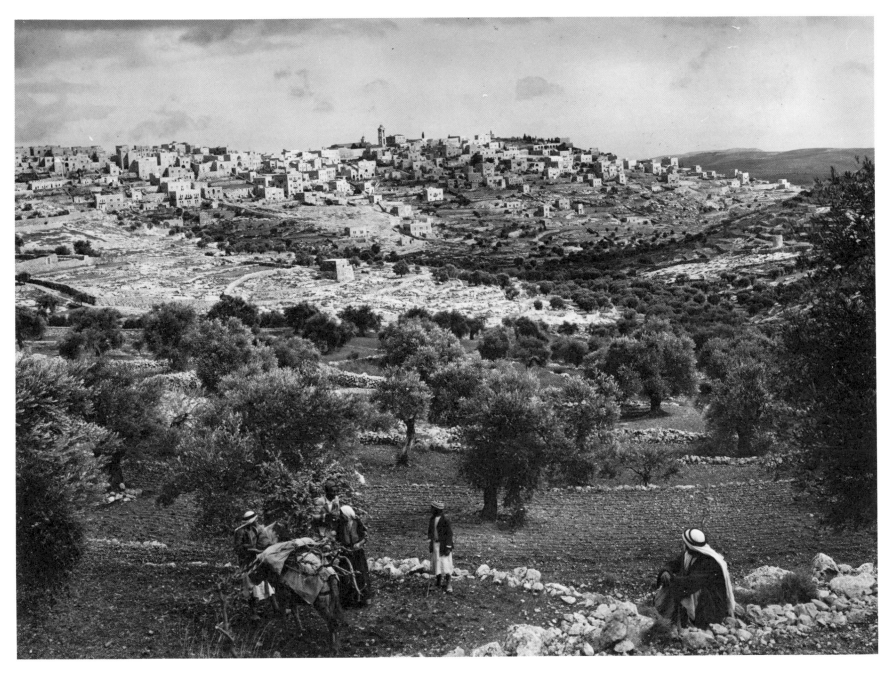

Bethlehem, about 1940, from the southwest, surrounded by vineyards and olive groves. LC–M32–9754

there is a manuscript catalog but no prints. These negatives are almost entirely documentary, showing daily life and newsworthy persons, places, and events between 1934 and 1946. They are at present accessible to readers only through the manuscript catalog.

The remainder of the collection comprises those negatives which had been stored in Jerusalem since 1946. Although many were ruined by water damage or breakage, with many stereoscopic negatives salvaged only because of the dual images, there remain thirteen hundred 24- by 30-cm glass plates of excellent quality, thirty-five hundred smaller glass negatives, and 1,500 film exposures. These negatives and five hundred glass color plates (Finlay positives and Lumière autochromes) span the entire half century from 1896 to 1946 and are roughly sorted by subject. Since there are no corresponding file prints as yet, these negatives have very limited accessibility to readers.

January 1973

NOTES

1. Selma Lagerlöf, *Jerusalem* (London, 1903). See her address, "Christian Love," in *The Stockholm Conference 1925, the Official Report of the Universal Christian Conference on Life and Work Held in Stockholm, 19–30 August 1925* (London, 1926), p. 556.

2. Lagerlöf, "Christian Love," p. 559.

3. Bertha Spafford Vester, *Our Jerusalem* (Garden City, N.Y., 1950), p. 183.

4. Eric Matson, [Petra] "The Rose-red City of Rock," *National Geographic*, 67 (Feb. 1935): 145–160; Eric Matson, "Multi-colored Cones of Cappadocia," *National Geographic*, 76 (Dec. 1939): 769–800.

5. Letter of Eric Matson to Jerald C. Maddox, Prints and Photographs Division, Library of Congress, December 1969.

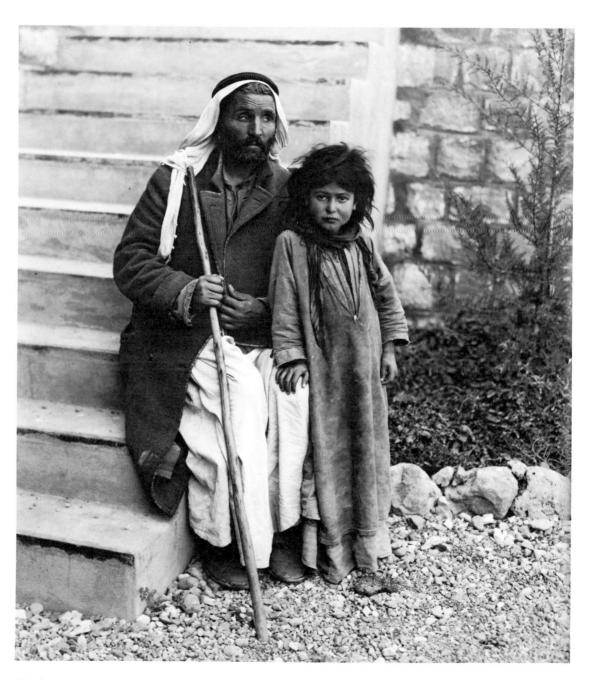

Blind man and daughter waiting outside clinic of Scots Mission Hospital, Tiberias, 1938. LC–M32–7833

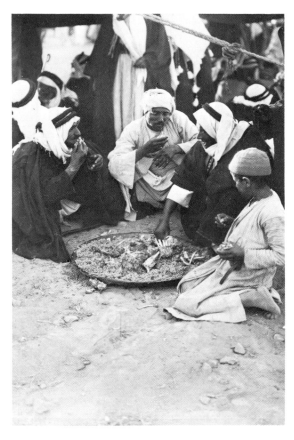

Feasting from a tray of rice and mutton, Bedouins celebrate the close of the 1930 locust campaign, June 30, 1930. LC–M32–3916

These ash heaps—some of which at one time had been 30 to 40 feet high—represent the accumulation of the residue of the daily sacrifices in the Temple in Jerusalem. Gradually the heaps diminished until, not long after this photograph was taken in 1898, they completely disappeared. They had been carried away to make mortar for buildings in the New Jerusalem north of the old city. LC–M31–7023

Camel kissing its Bedouin master. LC–M32–1707

Women's quarters of a Bedouin tent in Moab. LC–M32–663

Druse chief at El Izra, Syria, 1926. LC–M31–3395

Street vendor in Beirut, Lebanon, 192–. LC–M32–1820

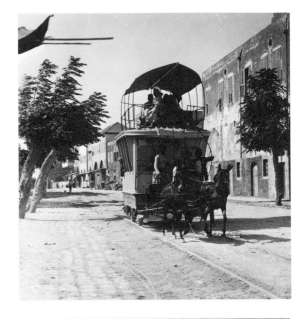

Top: Mule-drawn tramcar in Tripoli, Lebanon, 192–. LC–M32–1725

Bottom: Eric Matson photographing in the ancient rock city of Petra, in southern Jordan, 1934. He is standing high above the Roman amphitheater, looking across to the Nabatean tombs carved into the west facade of El Khubdha. LC–M33–H4

120

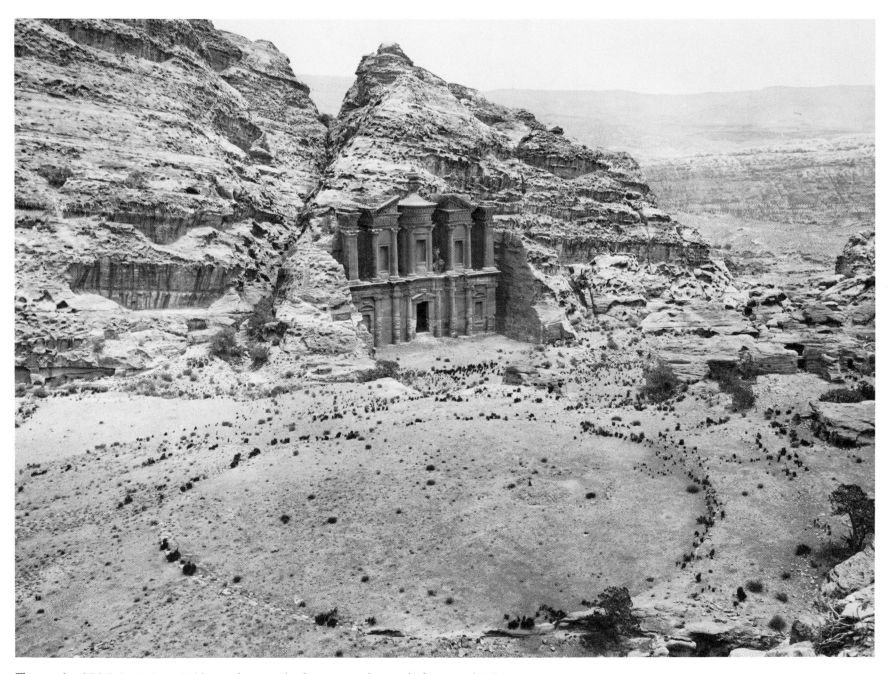

The temple of Ed-Deir, in Petra. Evidence of a great circular court can be seen in foreground. LC–M32–4947

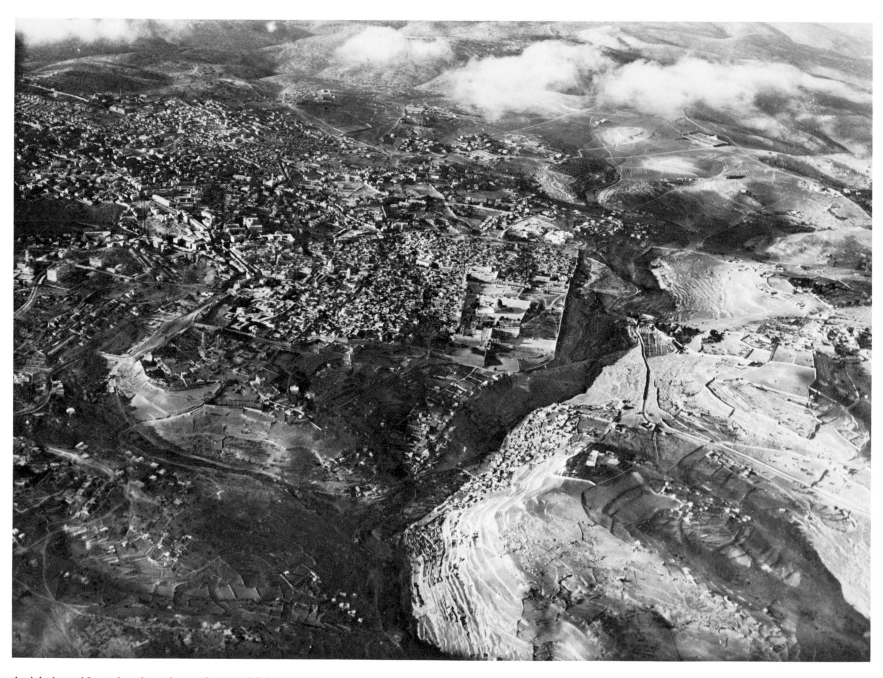

Aerial view of Jerusalem from the south, 1931. LC–M33–4327

Crabs on the beach at Wadi Ghuzzeh near Gaza. LC–M33–3792

Hussein Hashim El-Husseini (with cane), the mayor of Jerusalem, surrendering the city to two British sentinels, December 9, 1917. The mayor walked along the Jaffa Road under a flag of truce until he reached the first British outpost. The white flag is half a hospital bed sheet given him earlier by Mrs. Spafford. This print is from the original stereographic negative taken by Lewis Larson, Matson's longtime friend and chief assistant, and is the only photograph of this historic event, which marked the end of thirteen centuries of Islamic rule of the Holy City. LC–M32–1831

Locusts devouring a thistle during the 1915 plague. LC–M32–1431

Water wheel and Roman aqueduct still used for irrigation, on the Orontes River near Hama, Syria, 190–.
LC–M32–1757

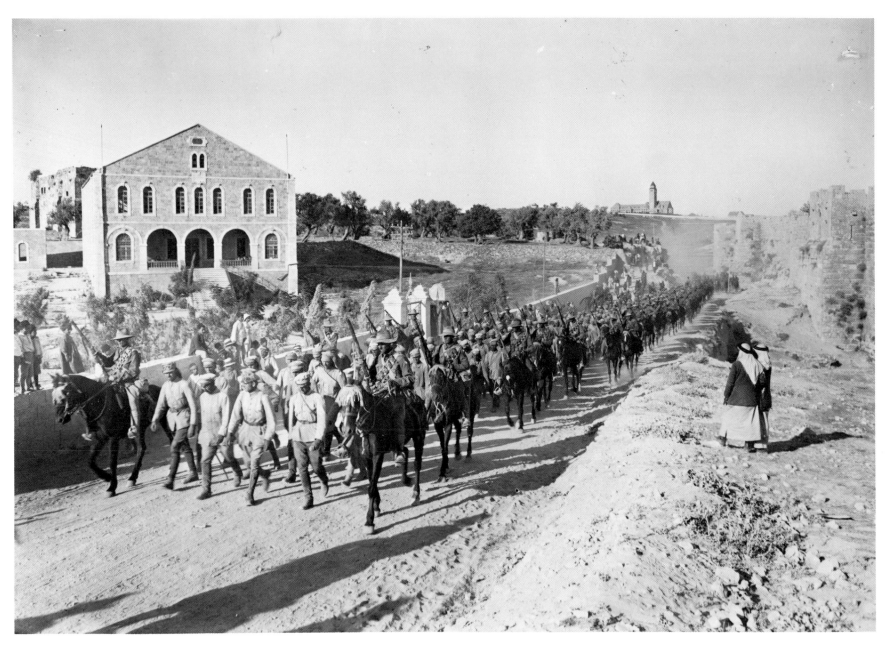

German prisoners of the Australian Light Horse Brigade marching alongside the north wall of Jerusalem, 1918. In the background is the Kaiserin Augusta Victoria Stiftung on Mount Olivet. This hospice and sanitarium, owned by the Kaiserin, was converted by the British into their High Commissioner's residence. LC–M32–1893

Jewish colonists en route to a settlement, 1920. LC–M32–2050

Davora Rushkin, a Jewish immigrant from Poland, at the Borochov Girls' Farm, about 1920. LC–M32–3158

Lord Balfour, whose famous declaration of 1917 prepared the way for Zionist settlement, opens the Hebrew University on Mount Scopus, April 1, 1925. Behind Balfour, to his left, is Chaim Weizmann, first president of the university and destined to be the first **president of the state of Israel. To Weizmann's right are Sir Herbert Samuel and Lord Allenby (in top hat). LC–M32–B434**

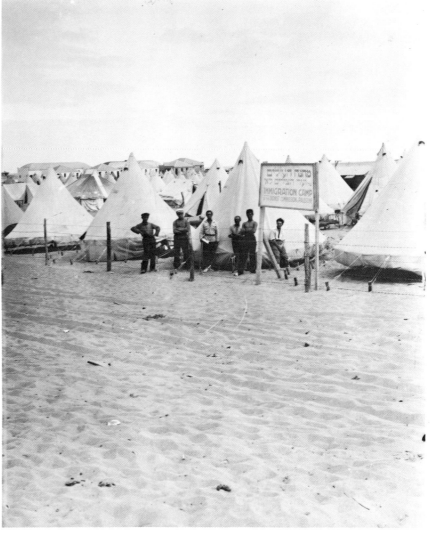

Immigrant camp of the Zionist Commission to Palestine, Tel Aviv, 1920. LC–M32–B441

128

collection: Photographs of refugee camps, refugees leaving the city, ruins of St. Dominick's Church, street kitchens, destruction of Telegraph Hill, bread lines to food stations are included.

Other national disasters such as the Mississippi cyclone in 1908, the tornado at Key West, Florida, in 1909, the Colorado flood in 1921, the tornado at Lorain, Ohio, in 1924, the tornado in Murphysboro, Illinois, in 1925, were also photographed.

The greater part of the collection, however, relates to World War I and to the reconstruction in Europe in the early 1920s. Fifty-seven days after the declaration of war by the United States against Germany, the advance guard of the A. R. C. sailed out of New York harbor. On this first ship went Paul Ramey, a photographer who had taken motion pictures of wild animals in Africa. His job was to take pictures of the American Army in France and of Red Cross Relief Work. Lewis W. Hine, famous for his character studies of children and of Ellis Island immigrants, also went overseas and throughout the collection are many fine examples of his work.

The following photographers represented the American Red Cross in France, Belgium, Germany, Russia, Siberia and the Balkans: Paul Abott, Lawrence G. Arnold, Darius Benham, David C. Bowen, John A. Chamberlain, Henri A. Coles, Joseph A. Collin, Charles A. Darlington, Wm. Henry Derr, Jr., Wm. C. Dorsey, Herbert E. Dubois, Alexander Edouart, Credo Harris, Simon Gartland Horan, Millard S. Huston, Paul Ivanchevitch, Lucian S. Kirtland, Harry B. Lachman, Wm. T. McCulley, Hamish McLaurin, George E. Marshall, John C. Richardson, John M. Steele, Leon B. Strout, Donald C. Thompson, Henry B. Van Steen, John E. Wagner, Agnes Watson, Elliott H. Wendell, Harold M. Wyckoff, Richard E. Taylor and Lewis D. Kornfield.

Top: Books and newspapers for American soldiers, from the American Red Cross Library Committee at 13 Pall Mall, London, about 1920. LC–USZ62–68393

Bottom: Two American soldiers in Hyde Park, London, with the "Bulletin" of the American Red Cross, about 1920. LC–USZ62–68391

An American Red Cross canteen in France, about 1920. LC–USZ62–68387

In France the American Red Cross was actively engaged in helping to make life a little more pleasant for the American doughboy. The serving of coffee, sandwiches, and cigarettes to the soldiers, the providing of recreation and entertainment for them are but a few of the many activities which were "covered" by the photographer. Of special interest also are the photographs on medical rehabilitation. For instance, there is the pictorial record of the various machines, new at the time, which helped men to regain the use of injured limbs.

There are many photographs of the hungry children of France and of the civilian population, bearing the horrors of war even as today. Railway stations are crowded with refugees piling their only possessions into box-cars. Poverty stricken and without homes, these people are shown receiving aid from the American Red Cross.

The work of the American Red Cross in the cities and towns of France—Aisne, Austerlitz, Argonne, Auteuil, Beaune, Blois, Bordeaux, Bourg-en-Bresse, Brest, Château-Thierry, Chaumont, Compiègne, Paris—has also been recorded by the Red Cross photographer.

Paris was photographed in the days following the Armistice: cheering people filling the streets; King George and his two sons, the Prince of Wales and Prince Albert, arriving from England met by the President of France and by Clemenceau; the Avenue du Bois lined with French troops; the Royal Family of Belgium, King Albert with the Queen and the Crown Prince; President and Mrs. Wilson.

There are vivid pictures of the victory celebration in Paris on July 14 and 15, 1919, which show a few of the historic moments of our time. Millions of people in the streets. Victorious allied armies march up the Avenue de la Grande Armée toward the Arc de Triomphe, led by General Pershing at the

Two children receiving American clothing from Queen Marie in a small mountain village in northern Romania, in 1919. LC–USZ62–68271

Top: Mothers and children at the American Red Cross Child Welfare Exposition, observing a doctor and his assistants bathe and weigh babies to show the proper sanitary methods. France, May 1918. LC–USZ62–68386

Bottom: Finnish girls who lost their parents in the war are learning the art of sewing in an orphan home in Viipuri, Finland, about 1920. LC–USZ62–68266

A Belgian boy dressed in American clothing and muffler supplied by the Junior Red Cross, about 1920. LC–USZ62–68268

Children's nursery in France, March 1918. LC–USZ62–68388

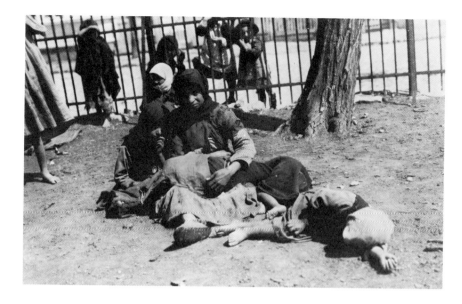

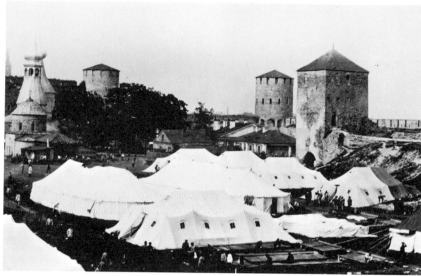

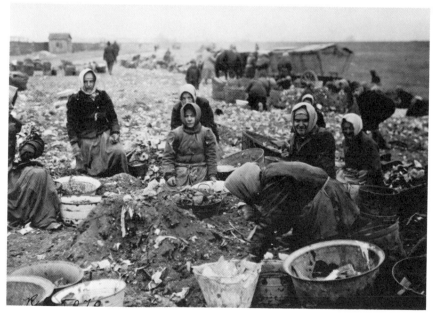

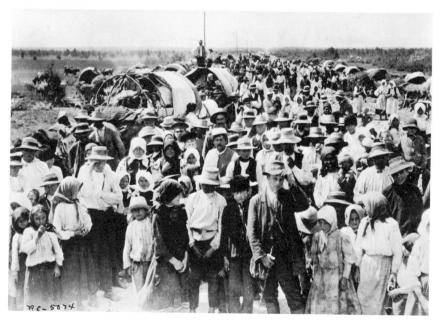

Top: A refugee family consisting of a widowed mother and four children camping out in one of the public parks of a Romanian town, about 1920. LC–USZ62–68261

Bottom: The poor of Vienna, Austria, searching among the garbage piles outside the city for scraps of food, about 1920. LC–USZ62–68390

Top: American Red Cross quarantine camp for Russian refugees at Narva, where Estonia and the U.S.S.R. meet, about 1920. LC–USZ62–68269

Bottom: Hungarian refugees on the road, about 1920. LC–USZ62–68385

head of a picked regiment of American soldiers, followed by troops from South Africa, Algiers, Arabia, Australia, Belgium, Canada, Czechoslovakia, England, France, Greece, India, Italy, Japan, Morocco, Poland, Portugal, Rumania, Siam, Serbia, Scotland, Senegal and New Zealand. Never before in all history had so great a representation of the armies of the world been gathered.

In England many subjects were covered. There is a photograph of King George and Queen Mary receiving American troops in London, and one of a review of the St. John Ambulance Corps by Queen Mary. There is also a photograph of the American ambulance which brought the first patient to the New Dartford hospital near London. American sailors and Red Cross canteen workers are shown inspecting the art treasures in the Great Hall of the Royal Law Courts, and a Red Cross party of wounded servicemen is seen visiting the German submarine Deutschland anchored in the Thames. Of special historical interest are the photographs of the Peace Procession in London taken from the roof of Buckingham Palace. In Liverpool, the Red Cross photographer photographed a review of American troops just arrived from the United States. There is also a remarkable photograph, taken about ten days after the signing of the Armistice, of the first homeward bound troops meeting the last incoming convoy of Americans on the docks, and one of a detachment of American troops receiving the good news to embark on the first boat for home.

To Russia was sent Harold M. Wyckoff. His mission primarily was to photograph American Red Cross relief work being carried on there. However, he became interested in the country itself, and as a result we have a fine collection of photographs of the cities and towns in Russia and of its architecture. Par-

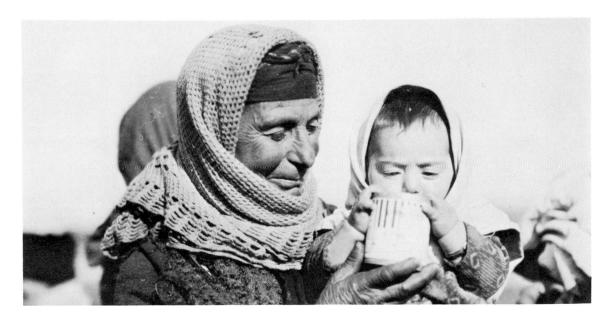

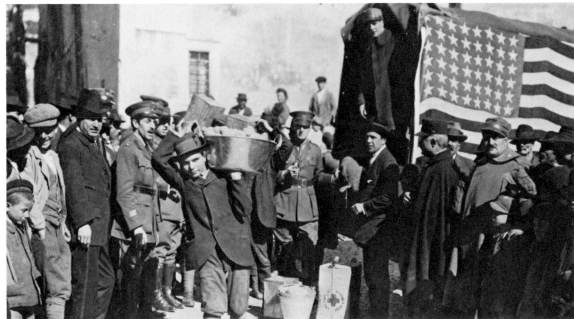

Top: A Greek mother in a camp outside Salonica, Greece, helping her baby to drink from a can of American condensed milk, about 1920. LC–USZ62–68384

Bottom: Unloading food and provisions from American Red Cross truck in Anguillara, Italy, about 1920. LC–USZ62–68265

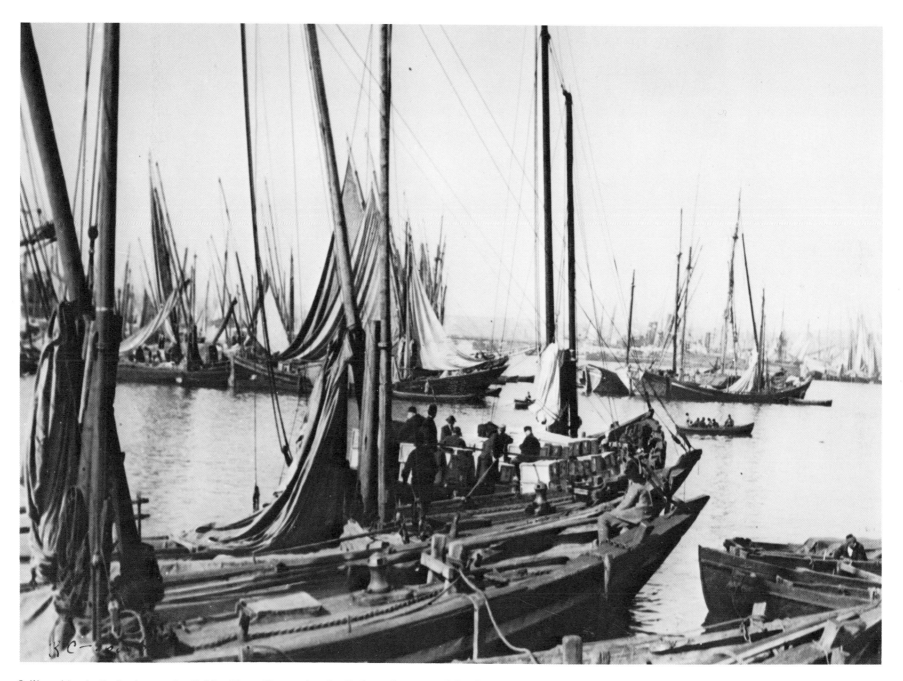

Sailing ships in the harbor on the Golden Horn, Constantinople, Turkey, about 1920. LC–USZ62–68383

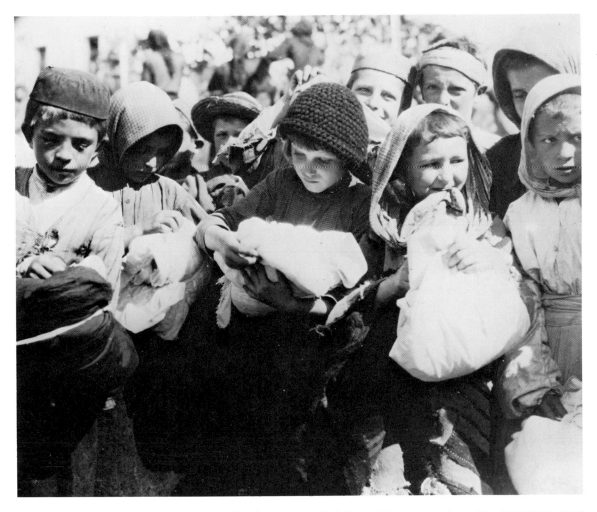

Children with bundles of clothing supplied by the American Red Cross, Montenegro, about 1920. LC–USZ62–68263

ticularly impressive are those of Russian churches. To mention a few: the Lavra Monastery at Kiev; the Russian Orthodox Church in Ekaterinodar, the capital of the Kuban district of South Russia; the Uspenskaia Tserkov', a small but singularly fine piece of Russian church architecture on the waterfront of Archangel. Intrigued by the beauty of rural Russia in wintertime, he photographed many snow-covered villages, one of which was Nizhmozerskaia. One of the rare items is a photographic copy of the only known photograph of the Chief Commissar of Kharkov.

To Albania went Alexander F. Edouart, Paul Ivanchevitch, and David C. Bowen. In this country, as in the majority of countries visited by the Red Cross photographer, anything of interest was photographed. In the capital city of Tirana, the Grand Mosque, a fine example of Near East mosque architecture, was photographed. Its exterior decorations are of fine scroll and hand-carved woods done in many colors. There is a photograph showing the men at evening prayer on the front portico of the Grand Mosque, with rows of shoes lining the edge of the porch. Before entering, the men must remove their shoes and wash their feet. And while they turn to the Mohammedan faith for spiritual help, they are cared for when ill by the American Red Cross which has established body clinics and orphanages throughout the country. There are views of Berat, which changed hands four times during the fighting between the Austrians and the Italians. It was a case of "here they come, there they go" with the townspeople, who went to bed at night with the Austrians in possession of the town and woke up to find the Italians in control. Berat was the center of an epidemic of disease after the Armistice and the inhabitants suffered unbearable hardships. There are photo-

graphs of street life in Scutari, with its irregular buildings, cattle, pigs, and fowl, mixed with people whose dress is strongly Oriental. There are pictures of an ancient water wheel making water flow up hill. A huge home-made wheel is turned by the flow of a small mountain stream. To it are attached boxes which catch the water after its power has been used and lift it into an aqueduct which flows through to an arid plain. The war almost ruined this irrigation project, but with seeds obtained from the American Red Cross the land was again to produce bountiful crops.

Greece is represented by a remarkable series of photographs of ancient architecture found in Athens: the view of the Acropolis with the city of Athens in the foreground; the Acropolis by moonlight and the theatre of Dionysius; the temple Athena Niké, which stands just at the right of the approach to the Acropolis. There are photographs of Salonika and its crowded waterfront. (Salonika was chosen by the American Red Cross as its base for Balkan operations because of its geographic position.) There are also views of the Corinth Canal, which ranks with the Suez as one of the greatest engineering works in the Near East.

Historical events and architectural landmarks make up the most important part of the work of the American Red Cross photographer in Italy. There are photographs of the Palazzo Vecchio in Florence taken during the conferring of honorary citizenship on President Wilson. There is one showing Congressman Fiorello LaGuardia addressing thirty thousand Florentines from the balcony of the Palazzo Vecchio. Venice is represented by views of the famous Rialto; the Doge's Palace from the courtyard, which is rarely photographed; and the magnificant cathedral of Santa Maria della Salute, one of the finest

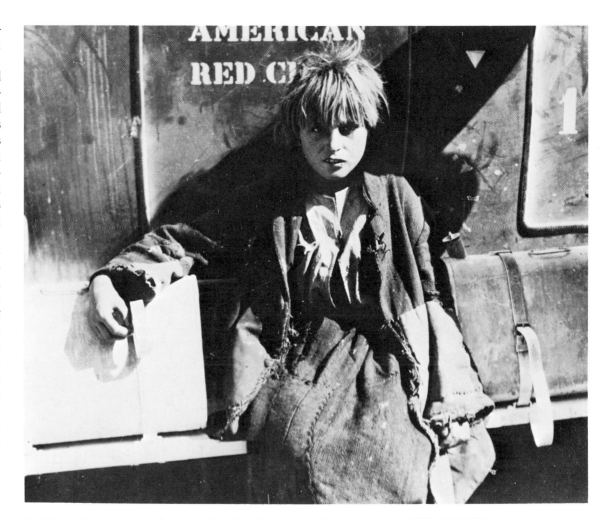

A girl seated on the back of an American Red Cross truck, Montenegro, about 1920. LC–USZ62–68259

Temporary Red Cross hospital for the relief of flood victims in Japan, 1916. LC–USZ62–68264

structures in the city. In 1630 the island city was swept by a terrible plague which threatened to annihilate the entire population. The prayers of the clergy that the plague be checked were apparently answered. Out of thankfulness, the people of the city gave of their money in order to build a cathedral to Saint Mary, who is charged with keeping the health of the surrounding islands. The plague was the last that ever visited Venice and frequent thanks are given to the good Saint Mary whose golden figure surmounts the great dome which can be seen for miles from ships in the Adriatic. Another interesting photograph is that showing the replacing of the "Horses of St. Mark's" in Saint Mark's Square in Venice, after being taken out of hiding in the Venetian Palace at Rome (where they had been put to save them from Austrian bombs). According to legend, when these golden horses travel, empires fall. Since the day when they were removed to Constantinople the truth of the legend has been demonstrated. It was true when Napoleon took the "Horses" to Paris as trophies just before his fall and the latest proof is the fall of empires in World War I.

Across the Mediterranean Sea, in Algeria, the American Red Cross cameramen were also busy photographing relief work, architecture, historical monuments and customs of the people. There are photographs of Carthage's ancient aqueduct, which formerly brought water to Carthage from the springs of Zaghouan and Djouax. This aqueduct, constructed early in the second century by the Roman Emperors Hadrian and Septimus Severus, was approximately eighty-eight miles long. Over three hundred arches of this early irrigation project remain in excellent condition. There are also scenes of Algerian children attending school in the Sahara Desert. The students sit in the broiling sun, smoke

cigarettes, and chant a sing-song drone from the Koran. The colorful life of these people is depicted in photographs of Arab chiefs arriving to cast their votes at the city hall at Biskra, many coming from oases hundreds of miles away in the depths of the Sahara; of market scenes and "Bargain Day Sales" showing crowds of buyers and sellers filling the streets; of Arab chieftains making their annual pilgrimage to the holy city of Kairouan, stopping their camels at sunset preparatory to resting for the night.

Other countries of Europe represented in this collection are Austria, Belgium, Bulgaria, Czechoslovakia, Germany, Lithuania, Holland, Hungary, Ireland, Rumania and Turkey. To these countries, to their starving and destitute people, the American Red Cross brought food and medical relief.

The collection also contains photographs of Alaska, Brazil, Canada, Canal Zone, China, Cuba, Guam, Guatemala, Haiti, Hawaii and Japan. There are views of earthquake and flood victims, child welfare, typhus and cholera epidemics in these lands.

And back here at home, there are photographs of Red Cross conventions, committees, home hygiene, hospital work, life saving instruction and occupational therapy. Last but not least are many portraits of the personnel of the American Red Cross, the people who have made possible the great work of this organization.

February 1945

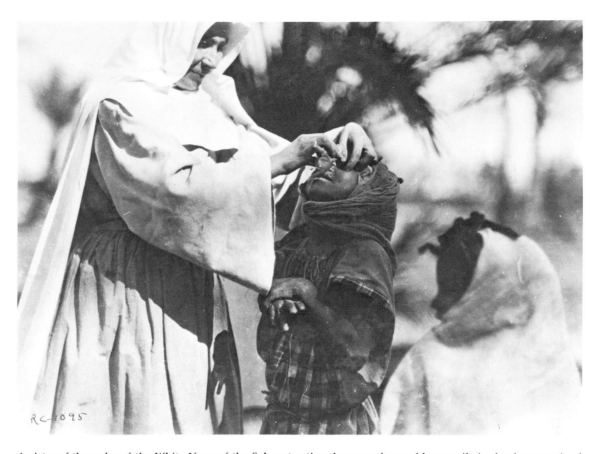

A sister of the order of the White Nuns of the Sahara treating the eyes of one of her pupils in the desert oasis of Biskra, Algeria, about 1920. LC–USZ62–68389

Photographs of Nazi Origin

by Paul Vanderbilt

When Hermann Göring, Reichsmarschall of greater Germany, directed that a staff in his office should collect and organize as a series of super-albums suitable for a superman all the available photographs of himself, he was acting on a well-rooted German proclivity for extensive, detailed documentation, a tendency which has affected German industrial research, special libraries, standards of scholarship, tastes in publication, and even the passion for thoroughness in private affairs. He wanted a complete picture and not a mere summary. His staff assembled photographs submitted by the news agencies (whose men were naturally in attendance at every official act), informal snapshots of family outings and hunting parties, and repetitive series of sequence close-ups of conversational interludes; they selected the significant ones, presumably edited out those which in their eyes were uncomplimentary, and made up two almost parallel chronological series, event by event, covering the years 1933–42. The two series inexplicably end there, though there are several volumes missing from within that span of years, and the main series is preceded by an amazing collection formed by Göring as an aviator in the First World War, showing himself and his associates in the most minute detail. In all there are an estimated 18,500 photographs,

not counting duplicates, in forty-seven albums.

Specialists in recent German history who have inspected the collection in the Library's Prints and Photographs Division indicate that little which was not already known about Göring is revealed; but it cannot be denied that what we already know is reinforced by this intimate record of the meetings he attended, the accolades accorded him on his birthday, the sport cars he tried out, the vacations he enjoyed, the men and women who surrounded him. Other Nazi officials had similar collections of photographs as personal monuments. The exhaustive collection showing the activities of Adolf Wagner, Gauleiter of München-Oberbayern, consisting of seven thousand prints in an incomplete set of twenty-three albums; other albums on building projects in which Göring was interested; a popular little set of souvenir colored postcards of Braunau am Inn, near Linz, the village where Hitler was born; and a set of pictures of Göring's country home in Neuhaus are also among the many German documentary series received in the summer of 1948.

These pictures, in their present form of organization, are unique, and a fairly detailed account of the lots pertaining to the Nazi movement should be available in print in

America. Each lot has been described by a card filed in the analytical catalog of the Prints and Photographs Division, and the details of this remarkable resource may best be studied on the spot.

We do not know all the details concerning the origin of these collections, and such is the inevitable confusion following a war that many may never be traced. Military intelligence teams scoured every likely spot in the occupied territory in their search for documents subject to confiscation as Nazi files, or as the property of Nazi officials, or because of their militaristic or Nazi content. Some of these documents derive from the official party archives in Munich; some from the library of one of the leading training schools for future Nazi leaders at Ordensburg Sonthofen; some from the Arbeitsfront in Berlin, the Nazi labor organization; some from the Rehse-Sammlung, an extraordinary private collection on propaganda, publicity, and the curiosities of contemporary traffic in ideas which was turned over to the Nazis; and some from the Ahnenerbe, the Nazi archeological research organization which was charged with building a foundation for Nazi dogma by surveys of language, folklore, beliefs, music, and the arts, not only in Germany but all over the world. The Göring photograph albums are said to have been

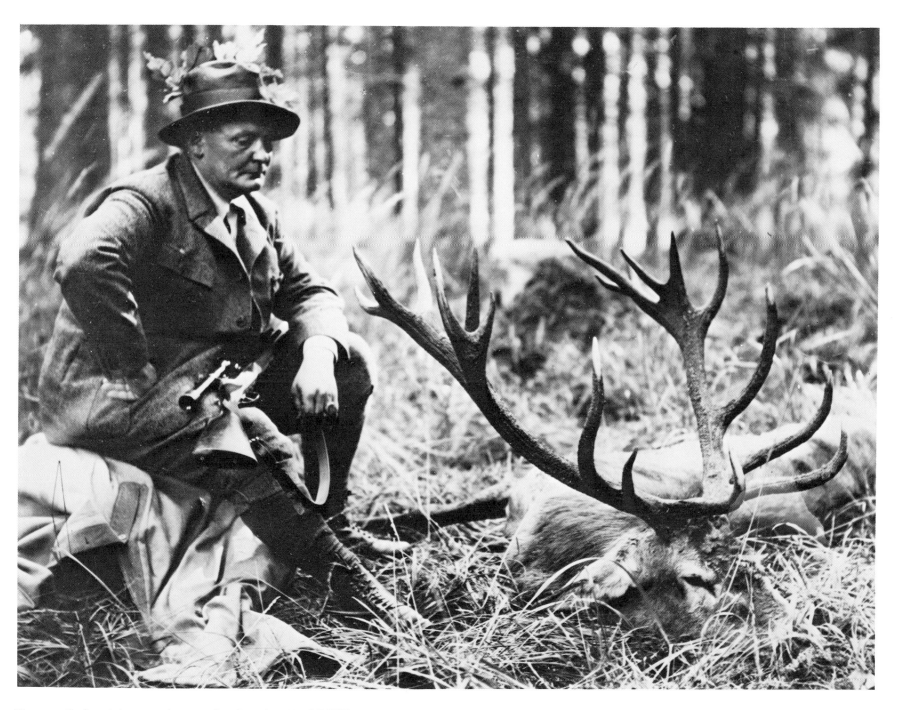

Hermann Göring sitting near deer on a hunting trip, 1934. LC–USZ62–68394

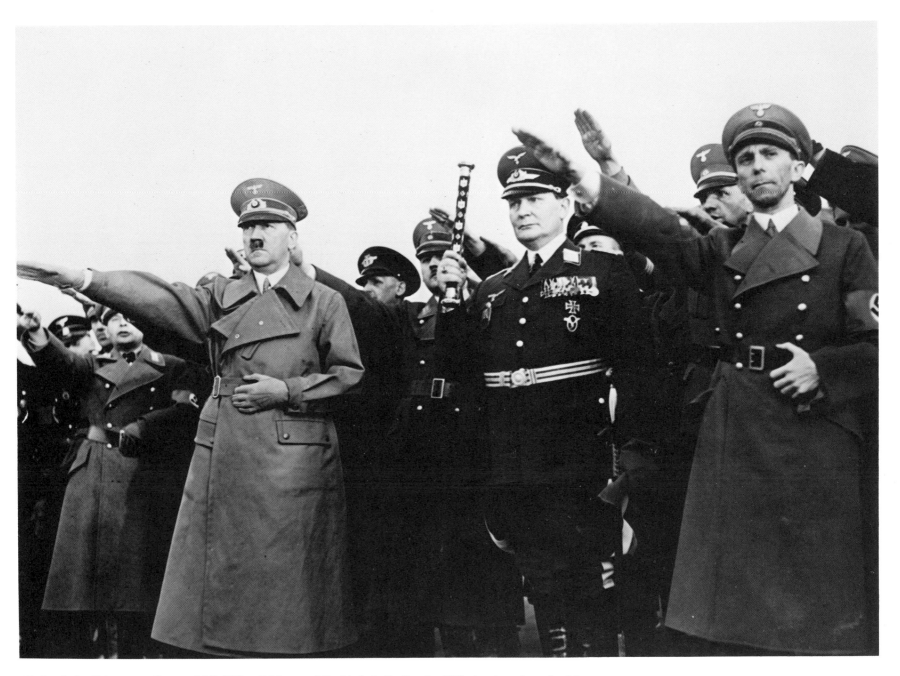

"Ankunft des Führers aus Oesterreich": Hitler, Göring, and Goebbels in Berlin after Hitler's return from Austria, where he signed the unification pact, March 16, 1939. LC–USZ62–68389

found at Berchtesgaden in the Bavarian Alps, where Göring, like Hitler, had a retreat. The materials were gathered as they were found and those not of strategic significance were turned over to the Library of Congress Mission in Europe for transfer to the appropriate collection in this country. Precise identification is often lacking, and in the preliminary descriptions we have had to depend more than we like on internal evidence and surmise. Considered as a whole, however, the collections received through the mission constitute a valuable and extensive resource which it is anticipated historians of the Third Reich will find worthy of attention. All may be reproduced upon application to the Prints and Photographs Division.

Almost all of the titles of these collections are cover-titles applied to custom-bound reports or compilations in album form rather than titles of published works which can be located through bibliographies and union catalogs. *Sieben Jahre Kreis Mühldorf*, for instance, is a typical photographic report in three hundred prints on the first seven years of the rapid growth and entrenchment of Nazism in a small community. It includes views of the party headquarters and "cultural centers," farm community outposts, groups of small children in model nurseries, new sports facilities, construction crews, and model building projects. These are the visible particulars of Nazi local administration.

Typical of a different type of documentation is the special collection devoted to Paul Troost, a leading Nazi architect, which includes his original pencil drawings and unfinished water colors, many portraits of himself, his wife, and their dog, interiors and exteriors of their sumptuous home, views of the buildings which he designed as Nazi commissions, and finally his grave. He won his standing early, for he died in 1934, at the

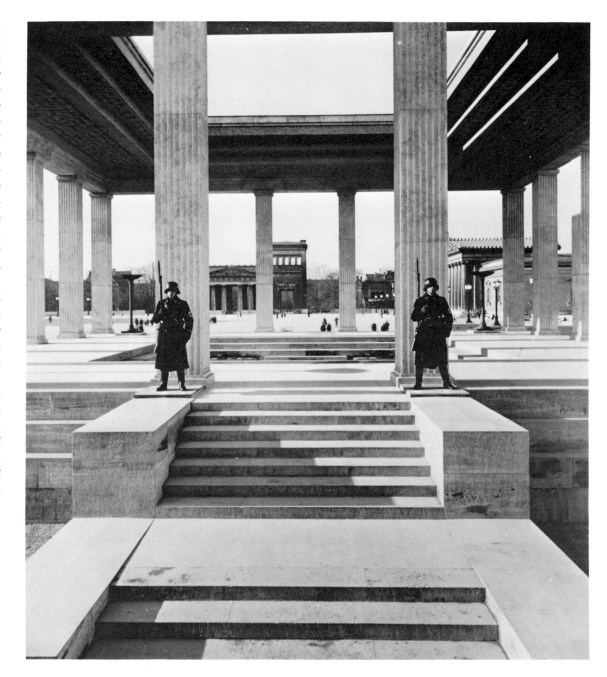

Two Nazi guards at the portico of the Ehrentempel in Munich, designed by Paul Ludwig Troost. LC–USZ62–68243

145

beginning of party power, and was only one of a vast number of party men who were counted upon, as creators, to clothe the new German plan with visible symbols. An album is devoted to the funeral of Richard Arouner, the Oberführer for Goslar, showing the body lying in state with its Nazi guard of honor, the ornamented hearse, the salute as the coffin is lowered. To every man, party honor in proportion to his party service.

Of interest in connection with party origins are reproductions of pencil portraits of the first fifteen party members of Mittenwald, some separate pictures of the then unknown Hitler speaking in a cellar to a dozen initial followers, and sixty photographs with news clippings on the celebration at Stettin of the twelfth anniversary of the formation in 1923 of the Stosstrupp Adolf Hitler. An organization known as the Cigaretten Bilderdienst issued albums of blank captioned rectangles in which were to be pasted pictures of Hitler collected by devotees one at a time as enclosures in packages of cigarettes, just as Americans once formed series, from a similar source, of ball players and actresses. The extensive Hitler series of some 150 cards covers his travels, speeches, and acts as a statesman and as an artist. There are picture calendars which consist entirely of portraits of prominent Nazi officials, one for every week, with biographical notices.

The Nazi fondness for political party meetings and their practical effect, reviews of marching delegations, torchlight parades, dances executed by girls in peasant dresses, and similar accompaniments, is quite fully documented both on the large national scale like the *Reichsparteitag der Arbeit* at Nuremberg and on the local level like the harvest festival at Bückeberg, the *Kreistag der NSDAP* at Erfurt, or an excursion of officials into the mountains of Saxony, where, upon leaving

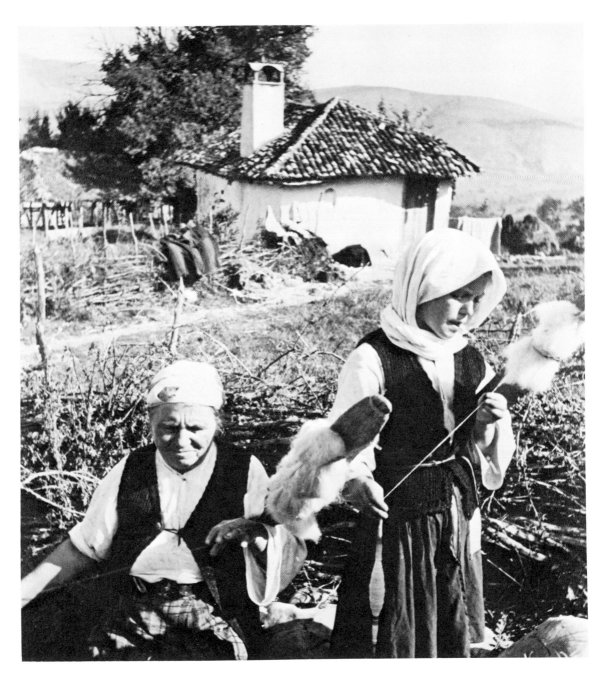

Peasant women hand-spinning thread by the ancient Roman method. Photographed during a motor trip through Yugoslavia and Bulgaria by officials of the National Socialist Motor Corps, 1937. LC–USZ62–68247

146

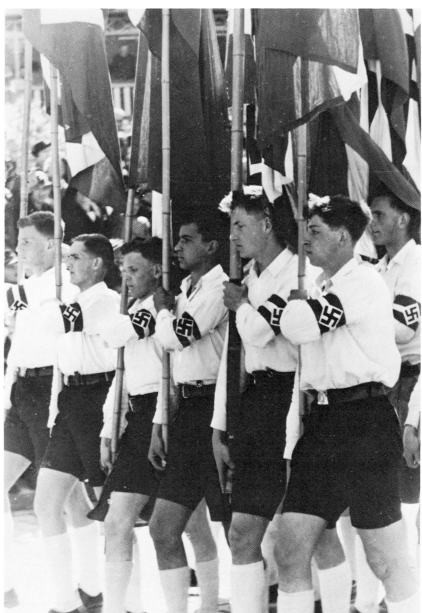

Boys marching with flags, (from the period 1936–38). LC–USZ62–68240

Top: Germans participating in the "Kraft durch Freude" movement. Photo by Wolf Strache. LC–USZ62–68248

Bottom: Girls in brown uniforms on parade route, (from the period 1936–38). LC–USZ62–68242

their busses, the Nazis inspect local handicrafts, are entertained by folk singers, and are waved farewell by the cheering villagers. An unusual item is an album of fifty photocopies of framed commissions of local Nazi party units and original color drawings of pistol holsters, complete with insignia, for the political hierarchy, designs for the uniforms of railroad personnel, special Nazi arm bands, and the like. Hitler's visits to children's camps and work camps, with his personal guards; a convocation of Gauleiters at the impressive Ordensburg Sonthofen; propaganda activities in the Saar in 1934, including the use of sound trucks, selected motion pictures, and parades of flag-bearing children; a volume issued by the Deutsche Lichtbild-und-Filmgemeinschaft a. d. Saar; and progress photographs of the construction of the Haus der Deutschen Erziehung in Bayreuth, with the dedication ceremonies of this "cultural center," are typical of this class of material. The activities of the German educators' organization, the Nationalsozialistischer Lehrerbund, in Vienna, are demonstrated in an album showing feting of the prize-winners in a "German peoples' destiny" competition, the opening of a puppet theater, and sightseeing tours.

The Deutsche Akademie was an agency whose function it was to send propaganda teams into foreign countries to acquire a building as headquarters, initiate a program of classes in German, exhibitions, and outings, and generally to develop a nucleus of prepared sympathizers. The outposts followed a uniform pattern and were apparently required to illustrate their reports to headquarters by sending in photographs of their local quarters, classes, and so forth. This entire documentation of a propaganda network is now in the Library of Congress in the form of several thousand photographs, usually rather dull, it is true, from the Balkans and Scandinavia, from China, India, and the Argentine, arranged by city: Agram, Athens, Baghdad, Brusa, Candia, Changsha, etc. The Roman set and the Munich headquarters set are the most revealing, the former elaborating on the ceremonial presentation of copies of German books as prizes to Fascist youth.

The repatriation and agrarian population programs are represented by the pictorial charts used in one of the Volksdeutsche Mittelstelle exhibitions; by another exhibition designed to exhort farm families to maintain the standards of purity of German blood and raise large families in return for promises of rehabilitation; and by shows which deal with the increase in quantity of farm produce and with the relation of organized management to food supply, the latter organized by the Reichsnährstand, a semi-official corporate food organization. A large collection of original photographic negatives is apparently the national German survey of farm houses and rural living conditions, considered from both the folklore and sociological points of view, made by the Forschungsstelle Deutscher Bauernhöfe. Related is an extensive collection of original water colors and drawings of furniture, painted chests, and decorative objects in the folk-art tradition, not unlike our Index of American Design in plan but inferior in execution and extent.

The emphasis which the Nazis placed on the organization and indoctrination of youth is well known and is represented among these collections by photographs of boys gardening, marking corners with luminescent paint for guidance during blackouts, tending wounded soldiers, serving as firefighters and telegram delivery boys, and otherwise helping the war effort, as well as by views of the buildings and activities at the Adolf Hitler Schule, Vogelsang, Krössinsee, a marine school, and records of visits of Nazi officials to youth camps where the children are loading hay and making sandwiches for the entertainment. The last item is a presentation album to Reichsbauernführer Darre. Another presentation album, given to officials in gratitude for bicycles furnished to the group, comes from a Hitler youth school in Bilbao, Spain, in 1941. A limited survey of inadequate, often dilapidated village schoolhouses was undertaken in 1940–41 by the Nationalsozialistischer Lehrerbund, and these photographs with caustic comments on existing conditions and recommendations for improvements are among the pictures received. There is also material on the school for kindergarten staffs at Steinatal, children in kindergartens playing and resting under sunlamps, and city children's visits to idyllic country vacation spots, organized by the Jugenderholungspflege, a branch of the Nationalsozialistische Volkswohlfahrt, or welfare agency. The "maternity convalescent homes" or breeding centers for the illegitimate children which German girls were encouraged to bear to soldier fathers are well covered in pictures. Another special set on women covers their wartime activities in industry, the arts, and the professions. One small folder concerns a concert given by the national symphony orchestra for a Nazi workers' group in a railroad station.

The patriotic propaganda program included promotion of every device for emphasizing to Germans the beauty of their picturesque country and the values of local traditions. *So sehen wir Deutschland*, a series issued by the Kulturamt der Reichsjugendführung; *Deutschland ist schön*, again enclosures for packages of cigarettes; the old town hall, winding streets, and canal of Esslingen; innumerable picture calendars; reproductions of genre and portrait paintings of

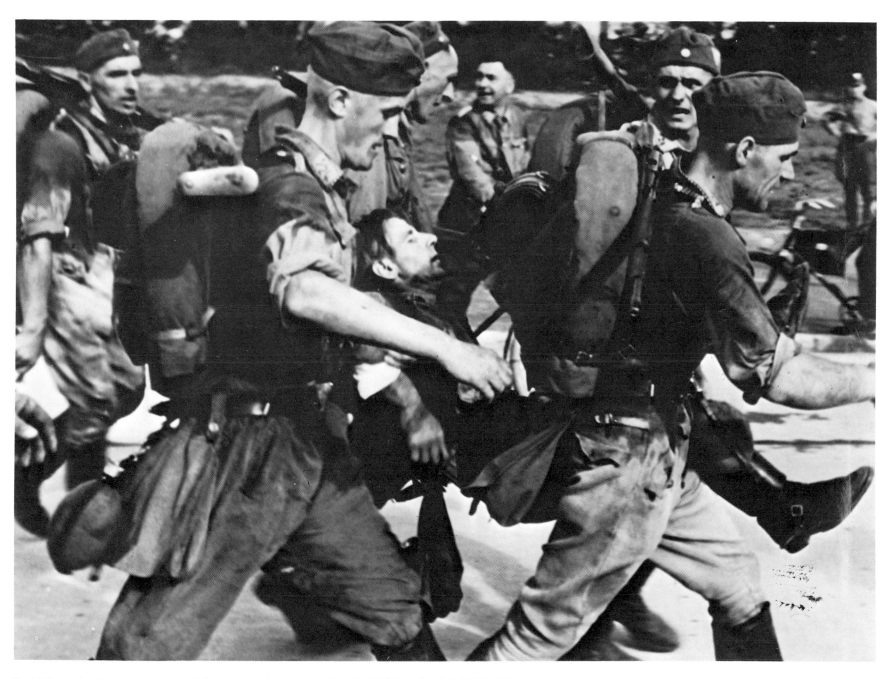

Nazi "Sturmabteilung" on a fifteen-kilometer training march. Photy by Wolf Strache. LC–USZ62–68241

"Heldengedenktag." Göring reviewing military parade in honor of World War I heroes, Berlin, March 13, 1939. LC–USZ62–68397

the Schwalm valley; scenic educational posters for use in schools; a crowded stadium decorated with sheaves of wheat for the 1937 *Erntedanktag,* or German version of Thanksgiving, celebrated early in October, are examples of this type, while similar groups of pictures glorify the industrial activity of Upper Silesia, with its open-hearth furnaces and chimneys pouring smoke.

There is among these collections only a limited amount of concentrated anti-Semitic material, though implications are everywhere. A collection of "early" (1892–97) cartoons is remarkable for its virulent representations, and a group of photographs intended for publication in *Der Stürmer* shows extreme examples of anthropological "undesirables" among Orientals, Negroes, Polish Jews, and feebleminded and criminal types. On the other hand, the collected portraits and records, apparently from an album concerning the wealthy and prominent von Speyer family over the period 1650–1930, illustrate the type of documentation eagerly assembled by the Nazis. A set of caricatures of leading political figures of the Weimar Republic, Neurath, Landauer, Toller, Radek, and others is captioned in this 1933 issue with derogatory rhymes. Caricatures of different categories include an extraordinary item said to have been found in the Gestapo headquarters in Paris (presented by Harold J. Jonas rather than received through the Library of Congress Mission) consisting of anti-British cartoons culled from French periodicals of the period 1845–1903 and pasted up as a dummy for publication under the title *John Bull auf der Anklagebank,* and a propaganda cartoon series in English, apparently issued to demoralize British troops by emphasizing loss of British food imports.

Among items of war documentation, which are numerous, the Italian campaign in Ethio-

pia in 1935–36 is represented by an album of some 300 photographs of combat action, camel caravans, tribal chiefs, etc., captioned by official Italian communiques. A smaller series covers German annexation of the Burgenland, the easternmost province of Austria, showing destruction of illegal printing shops, speeches at outdoor torchlight meetings, and local Nazis greeting the newcomers. General compendia of news photographs were issued under the titles *Grossdeutschland im Weltgeschehen, Das Heer im grossdeutschen Freiheitskampf,* and *Bilddokumente von Kampf und Sieg,* while there are also unique sets of more or less obvious material, published booklets like *Panzergrenadiere,* consisting of color reproductions of staff artists' drawings of tank warfare, and an album of some 250 photographs of the Atlantic Wall fortifications, assembled in February of 1944. The prisoner-of-war camp at Mannheim is shown in its most favorable light in a book issued with captions in English, French, and Russian as well as German. But a completely direct album of photographs of corpses lying in a railroad train, under the title *Bildbericht über von den Bolschewisten ermordete und geschändete Deutsche in Metgethen,* and bearing the stamp of the Königsberg Sicherheitspolizei, was probably not intended for distribution.

Wall newspapers issued by the OKW, General-Gouvernement, and other offices under titles like *Aktualne ilustracje* and *Novi visti* for use in occupied Poland and Russia are of some interest, as they consist principally of photographs of developments in Germany, enemy atrocities, peaceful rural scenes, and crowds cheering invading German troops.

Foreign relations are further represented by a large historical collection from the Japan-Bücherei consisting of copies of exhibition material concerning Philipp Franz von Siebold, a nineteenth-century German physician

Two technicians working on an enormous fan used to generate wind for aviation experiments in the "Hermann Göring" wind tunnel in Braunschweig, Germany, 1940. LC–USZ62–68396

Swimmer at the start of a race at the 1936 Olympic games. Photograph by Leni Riefenstahl. LC–USZ62–68246

and scientific explorer, who worked in Japan for the Netherlands Government; photographs of the visit of German marine cadets to a cadet school in Japan in 1938; and the visit of a German university mission to an unidentified Italian university in 1939. An album stamped "secret" shows German army engineers sinking wells in Turkey and Albania; large composite air photographs show the topography of parts of Yugoslavia; and a series of 1939 concerns the efforts of the Rumanian Government to raise the cultural and productive level of small villages. Poland is featured in one album on Zamosc, in another concerning repatriation and deportation shifts in population, and in a series of large composite aerial photographs. Interpretive studies of the people of Riga and its vicinity attempt to demonstrate that they are largely Germans and therefore within the German sphere. An earlier lot of photographs issued by the Latvian War-Destroyed Areas Congress concerns displaced farmers of the 1920s in makeshift log shelters among that country's ruins. Some Russian lots are included, among them chromolithographs of historical events in Nizni-Novgorod over the centuries from 1171 to 1612 and romantic Russian postcards sold in Leipzig in 1914 just before the outbreak of war.

A number of construction projects and series on buildings in Germany are shown, but in view of the ambitious plans for reconstruction and the enormous amount of work actually completed, the material is incidental. The construction battalion known as the Organization Todt is represented by hangars, a snow tunnel in Norway, submarine bunkers, the Westwall, and other works. A good historical series of 1889–92 shows the Nord-Ostsee Canal, now known as the Kiel Canal, under construction. From wartime Kiel, Münster, and Rangsdorf are the photographs

Karl Hein, German gold-medalist, throwing the hammer at the 1936 Olympic games in Berlin. Photograph by Leni Riefenstahl. LC–USZ62–68244

153

of models and drawings as well as the completed buildings of the German air command, and there is a special portfolio on the Hermann Göring wind tunnel. Plans for the proposed bridge over the Elbe at Hamburg involved as well the reconstruction of the neighboring waterfront and a fantastic series of buildings, shown as models. Other sets cover in considerable detail the new buildings of the University of Berlin's medical clinic for women, the Ministry of the Interior, the Haus der Deutschen Kunst (the Nazi art gallery in Munich), shown in various stages of construction, and the North Westphalia district office building of the party.

From the immense field of German technology, only a few items have been received, but notable is the exhaustive photo report on the Daimler-Benz automobile complex of manufacturing plants, retail outlets, racing interests, and varied promotional activities. This report, an estimated five thousand photographs in forty-three albums, is primarily of automobile interest for the sake of the Mercedes models shown, and it has already proved to be of use to American automobile historians. Special timing and photo-recording mechanisms were designed by Zeiss-Ikon in 1936 for the Berlin Olympic games, and the detailed pictures of this equipment and its accessories are available. The Schoeller-Bleckmann Stahlwerke at Ternitz in Austria are represented by a set of record photographs and the Junkers Flugzeug- und Motorenwerke at Dessau by another, which includes the historical development of Junkers airplanes from 1909 to 1937. There are also some photographs of mothproofing and waterproofing textile techniques developed by I. G. Farbenindustrie about 1938.

The style of painting and sculpture in official favor is represented not only by sets of color reproductions from the successive exhibitions at the Haus der Deutschen Kunst at Munich, but by a "lot" of about twenty-five hundred excellent prints from the original negatives, probably the official record set of all the works of art entered in the 1942 Nazi art competition. Art historians may also be interested in an Ahnenerbe compilation called *Altreligiöse Ausdrucksformen des Schwabenlandes,* an attempt to document Germanic religious mythology by photographs of archeological fragments and architectural iconographic details of the sixth to the eighteenth centuries. A series of lithographic copies of the medieval frieze of the town hall at Breslau; a collection of representations through several centuries of the Bamberger Reiter, showing several different restorations and comparative material; and a similar retrospective collection of reproductions of the Externsteine at Detmold are likewise in the art history group. Of original artists' prints issued in limited edition portfolios during the 1920s, a somewhat overplayed vogue during the period of expressionism, the Library has received several examples by Archipenko, Erich Waske, Theo Scharf, and others. An official collection of pictures for the study of prehistory was developed at the Institut für Kulturmorphologie at Frankfurt a. M., and the elaborate installation, "visual" catalogs of material, and service are shown in an album of interest to museologists and librarians.

The typographical materials received at this same time through the Library of Congress Mission are so extensive and of such particular interest to the Library that they deserve a separate descriptive article and can only be mentioned very briefly here. Not positively identified as yet is an immense lot of over one hundred thousand pieces, mainly job printing and principally German, but including material from all over the world and covering the period 1840 to 1925, with some of earlier date. In addition to a large quantity of catalogs, posters, entries for design competitions, and the like, there is a collection of over one hundred postcards issued in 1900 on the occasion of the five hundredth anniversary of the birth of Gutenberg, material on the great international book and graphic arts exposition of 1914, several exhibitions of samples of fine printing and enlarged photographs of technical processes, an exhibition of 1928–30 entitled *Gute Bücher sind Kämpfer der Wahrheit,* and several sets on technical schools and the modern headquarters building of the Verband der Deutschen Buchdrucker in Berlin. Of calligraphic rather than typographic interest are several collections of examples of hand-lettered placards, usually quotations from Nazi leaders, executed as exercises in competitions or printed as decorative propaganda. There are also the original entries in several national competitions for cover designs or symbols, among them those for the Gutenberg Reichsausstellung of 1940 and for the Reichsbetriebsgemeinschaft held in 1934. Altogether it is an extraordinary and often very amusing resource for the study of the history of advertising and of graphic arts organizations.

The miscellaneous collections of routine news photographs are interesting but not significant in view of the immense quantity of this type of documentation in existence. The Orbis, Weltbild, Scherl, and other agencies were prolific in their output, and perhaps the only specialities worth noting are the coverages of the Olympic games and a set on the disastrous collapse of the Berlin subway tunnel, which includes pictures of the Nazi burial ceremonies for the workers who were killed. From Wolf Strache, an individual photographer in Stuttgart who has retained all his negatives, the Mission obtained an extensive lot

dealing chiefly with the Strength through Joy movement.

Material relating to the First World War was found, quite naturally, throughout Germany in considerable quantities. A set of battlefront terrain photographs; a published set of albums under the title *Oesterreich-Ungarn in Waffen*, edited by the K. u. K. Kriegsarchiv; color reproductions of paintings glorifying submarine warfare, *Deutsche U-Boot-Taten in Bild und Wort;* an interesting collection of sample issues of newspapers published by various German army units and by business houses for military consumption; postcards and playing cards relating to the war; and about one hundred issues of *Kriegszeit Künstlerflugblätter,* a weekly cartoon publication, are among the German picture materials added to our already extensive Allied documentation of 1914–18.

August 1949

Rathaus in Neckartailfingen. Facade of a sixteenth-century building in German Swabian town, showing sun signs and other pagan religious symbols. Photograph by SS-Obersturmführer Ruppmann, 1938. LC–USZ62–68395

155

Erwin Evans Smith
Cowboy Photographer

by Ona Lee McKeen

The late Erwin Evans Smith built up a documentary photographic record of particular interest to historians of the American West. Concerned with the rapidly changing life on the large ranches of the Southwest around the turn of the century, he sought to capture through his lens, action and models typical of the cattle country before they completely disappeared from the scene. The resulting collection of more than eighteen hundred negatives, given to the Library of Congress by his sister, Mrs. L. McCullough Pettis, is one of the most complete and, from the standpoint of quality, probably the best of its kind in existence today.

Born on August 22, 1886, in Honey Grove, Texas, Smith had his first real experience of the open-range country at the age of eight, when he went to visit an uncle, John Sanders, owner of the old JCS Ranch, located near Quanah, in the center of the great northward cattle drives. There he received a valuable introduction to the industry from cattlemen of the old school, and during subsequent summer vacations they trained him to the leather. Trailing Edwin Sanders, a cousin some twelve years older whom he greatly admired, the boy listened with delight to the sounds of the cattle country—the bawling of vast numbers

Erwin Evans Smith. Photographed in 1909. LC–S6–10

of mottled longhorns in round-up herds and at the watering tanks, the staccato of pounding bronco hoofs across the prairie, the jingle of spurs, and the squeak of saddle leather. Back home in school, he penciled sketches of cowboys, horses, and Indians in the margins of his books. He saw harmony and rhythm in the agile grace of these Western figures and was excited by their beauty. He aspired to be a cowboy; and, as he grew older, he became filled with the desire to record the life of the range for posterity.

While still in his teens, Smith began experimenting with a cheap Buckeye camera and development fluids, and he took some remarkably clear and well-composed ranch pictures. A number of these early efforts, which are in the Library's collection, show Edwin Sanders riding the range, butchering a steer, or drinking at a water hole. One remarkable series of photographs, featuring Sanders and his horse "Puddin' Foot," was made during a summer vacation when Smith was working as a regular cowhand at the Three Circles Ranch, and it is captioned "The Usual Morning Fight." The eight exposures in the series, taken only minutes apart, present Sanders trying to saddle his skittish animal and mount it. The determination of man

The chuck wagon on the move. LC–S59–104

and the cautious maneuvers of beast are clearly evident, and there is action in every line.

Encouraged by these results, Smith set out for the larger ranches of the Southwest, equipped with camera, chemicals, and plenty of courage. Would they hire him to work for a small salary, he inquired, and permit him to take pictures of everyday scenes on the ranch? They would; and during summers from 1905 to 1915 he ate sourdough, blistered his hands on rawhide rope, wrangled, rounded, and branded. Traveling over the larger ranches of Texas, New Mexico, and Arizona, and even taking pictures as far south as the OR, in Sonora, Old Mexico, he patiently and painstakingly recorded the life of the American cowboy in all its aspects.

In the course of time Smith's photographs came to attract national attention. In 1912 the Eastman Kodak Company of Rochester, New York, bought a group of them and gave them world-wide publicity as examples of expert work that could be done with a simple box camera. All of the negatives are in the Library's collection. They include three outstanding pictures of individuals. One is a pose of Smith himself, sitting slightly sideways in the saddle on his pony; relaxed, facing the camera as if instructing an assistant to "snap it now," he could easily be the prototype of the American cowboy. Another, one of Smith's particular favorites, shows a mounted Matador Ranch cowboy with knotted bandanna about his throat and hat resting on the back of his head; he, too, is unmistakably typical. A third portrays Tom King, also of the Matadors, drinking from the rolled brim of his hat while his horse stands beside the buffalo wallow in the hot midday sun. The bright sunlight glazes a triangular sheen down the left shoulder of the animal and the reflection of both horse and rider in the placid pool is remarkably clear. Patches of gravel and water intermingle to form a distinct and pleasing pattern.

Typical scenes of ranch life are portrayed in other pictures in the Eastman group. In one, taken on the famous JA Ranch in 1907, cowboys are shown working with a herd in an early-morning round-up. A lone rider is in the foreground and there is a touch of skyline in the background. The dust rising like white smoke picks up the light and outlines the cattle distinctly, making little stick-fences of their slender, delicate legs. Another classic composition, made in 1906 on the LS Ranch in Texas and later reproduced on the cover page of the February 1928 issue of *The Cattleman*, depicts the foreman tracing in the dust a map indicating work to be done for the day. The cowboys sit about looking on, their horses standing behind them "tied to the ground." The arrival of the mail-man—an important semiweekly occasion on the ranch—is shown in a photograph of two cowboys squatting in the noonday sun beside a mail box, absorbed in examining what appears to be a mail-order catalog. Tufts of grass with individually outlined blades appear in the foreground, and the flattened top of a butte in the distance shows up so distinctly that the rocks can be distinguished against the hard-packed sand.

The chuck wagon on the move is the central theme of another photograph of classic beauty testifying to Smith's infinite patience and expert timing. In it he has caught his subjects just as the crest of a rise is topped and the mules have started downward. Bear-grass spears are sharply outlined against the sky, and the tracery of the design is a tribute to Smith's eye for beauty. The whole composition is fluid with movement as the wagon seems to roll down the steep incline, yet the action of the mules is frozen in midstep with no blurring of detail.

A picture of an encampment of "nesters"—squatters who were the bane of the cattlemen—is an ethereal early-morning scene with watery foreground in which bunches of grass and water weeds are sharply reflected, creating double-edged patterns of artistic beauty. The covered wagon, a decrepit affair, and a pioneer woman with arms akimbo are also reflected in the pond. The contour of the water's edge prevents the reflection of several horses on the left and adds an interesting balance to the photograph. The horizon fades into the morning mist to form a charming arrangement of light and shadow.

Finally, among the outstanding photographs in the Eastman selection, is a picture of five men riding up a curved trail of almost solid rock, a masterpiece of composition and detail. The detachment of riders picks its way along the slope, skirting boulders and making a figure "S" that matches the line of the escarpment. Light and shadow fall in with the design. Clear in the afternoon sunlight are shaded ridges of rock, the grain and rain-pockets distinctly discernible. This was another of Smith's favorite studies; according to his younger sister, he kept a velvety-toned enlargement in his house for years and presented copies of it to many friends.

Many of Smith's best photographs stem from his association with his friend George Pattullo, who in 1908 left his post as a newspaper reporter on the *Boston Herald* to accompany him on a series of cowpunching jaunts in the Southwest. Working in collaboration, Pattullo writing Western stories and Smith photographing the illustrations, they traversed the XIT, LS, and LIT Ranches in the upper Panhandle and Tascosa country; the

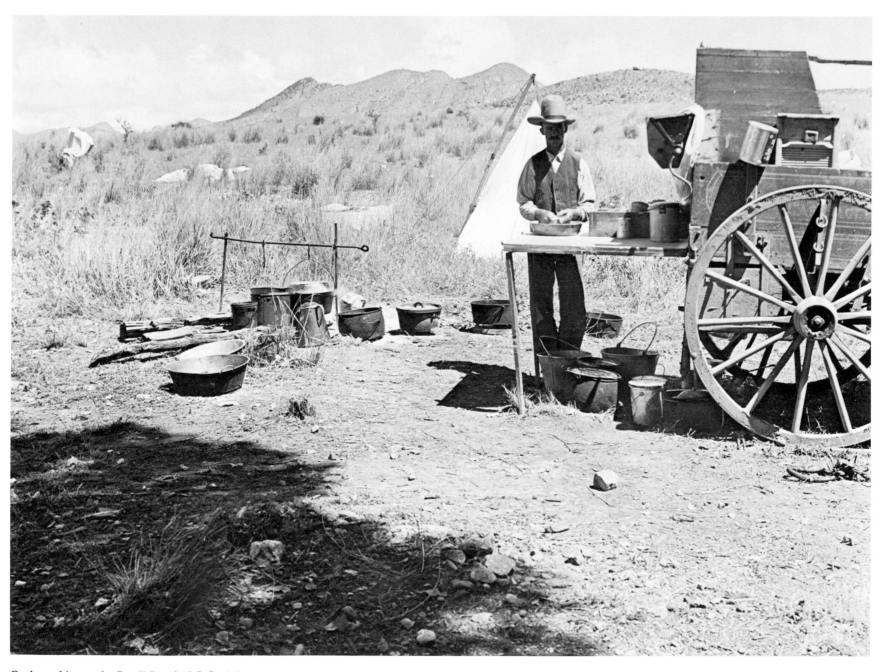

Cook working at the Box T Ranch. LC–S6–312

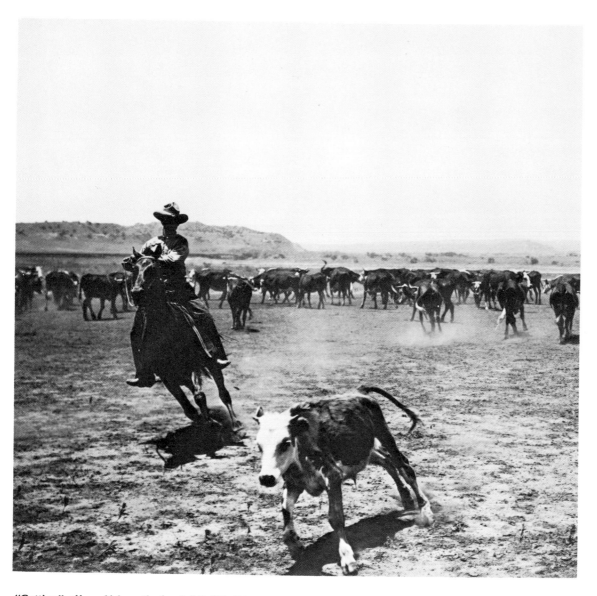

"Cutting" off a calf from the herd. LC–S59–420

Matadors, SMS, and Spurs farther south; the Shoe Bar, JA, and Quarter Circle T of the lower Panhandle; and many others.

One group of striking pictures resulting from their partnership illustrates how men and animals performed the difficult task of "cutting" a calf out from a herd. They tell a graphic story of a duel between animals, the calf doubling and twisting away from the horse, trying to get back to the herd; the horse cutting her off at every turn, dipping and sweeping at a furious gallop, as if made of quicksilver. Only the best riders and ropers with alert "cutting" horses were capable of doing this intricate feat well, and Smith photographed them at every move.

Other series of unusual photographs taken on various ranches deal with roping out—or, as it was called, "catching up"—mounts from a *remuda* held within a rope corral; bringing in strays to join the herd; day herding; tallying the herd; early-morning broncobusting; and killing a steer during a round-up. Waterhole scenes, which were favorite subjects with Smith, show cattle coming in to drink, *remudas* crossing a stream, or camp grounds with the water beyond. A group of chuckwagon photographs includes pictures of cowhands thundering across the prairie to "come and get it"; and there are others showing the cowboys loading up the "hoodlum wagon" with bedrolls; dragging firewood into camp; and lending a hand, using their lariats tied to saddle horns, to pull the wagon out of rough ground. One scene, with all the beauty of a drypoint etching, portrays a cook bending over the fire as streaks of dawn lighten the gloom. The pot rack hung with iron kettles is outlined above the glowing logs as he pokes up his fire to stew the day's breakfast.

Memorable individual photographs offer sharp vignettes of cowboy life and ranching scenes—a lone cowboy branding a maverick

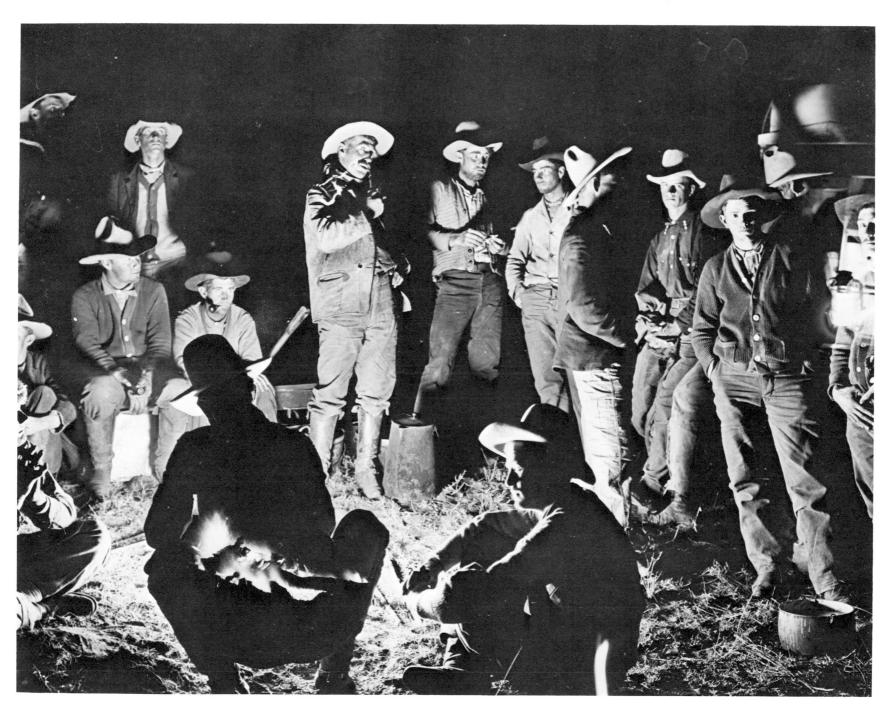

Storytelling in Matador, Texas. LC–S6–240

or replacing a horseshoe on the prairie without benefit of a blacksmith shop; two cowboys sharing the "makin's" for a cigarette; cowboys shaving one another; a day herder lazily watching a cut of cattle or having a midmorning snack of canned tomatoes in camp; and broncobusting and branding scenes in which alkali dust overhanging the corral is depicted with vivid clarity. A spectacular print, showing fun around a campfire, graphically registers the startled expressions of a group when Smith unexpectedly threw a pinch of flashlight powder into the flame.

Although Smith spent much of his time in his later years in farming activities on the "Bermuda," near Bonham, the life of a cowboy still held its fascination for him, and he was a regular visitor to rodeos and livestock shows throughout the country. Taking his photographic equipment with him, he made excellent pictures of the best rodeo performers of the nation. After photographing many of them on their first appearances in obscure Texas towns, he followed them as they climbed to fame through the Southwestern Exposition and Fat Stock Show in Fort Worth and on to the Denver, Pendleton, Cheyenne, and finally the Madison Square Garden shows. Among those whom he documented with his camera in this fashion were Fern Sawyer of Cross Roads, New Mexico, who won the Pecos "cutting" contest for four consecutive years (1942–45), and Cuatro de Julio, winner of the registered Quarter Horse "cutting" contest in Brownfield, Texas. Of more importance to Smith, however, were his photographs of "cutting" by the most expert cowboys of the largest ranches: Mat Walker (Matador), Emory Sager (Shoe Bar), Julie Moody (R2), Billy Pardloe (the "Pitchfork Kid" of the Matadors), Ed Bomar (Turkey Tracks), Henry Lyman (LS), and Frank Moson (OR).

Smith was still a relatively young man at the time of his death on September 4, 1947. His pre-eminence as a photographer of cattle-ranching activities had long been recognized. In donating his collection of negatives to the Library of Congress his sister, Mrs. Pettis, stated: "I know he would want them to be where they would serve the greatest good; he wanted to share them with people who appreciate the life and ways of the West." As a record of one man's dreams, the pictures are inspiring; as documentation of the West in their particular field, they are unsurpassed; and in the matter of artistic composition and beauty, they speak for themselves.

May 1952

Alexander Graham Bell: A Photograph Album

by Beverly W. Brannan, with Patricia T. Thompson

From early manhood, Alexander Graham Bell was often so totally absorbed in his work that his wife, Mabel, had to visit his study to persuade him to eat, sleep, or see his family and friends. The tone of their relationship was already established during their engagement, when he pursued his ideas with little regard for his health, while she worried about it constantly. Their lifetime struggle to balance his immersion in the world of thought and hers in the world of feeling is reflected in the many letters they exchanged. On December 3, 1889, Mabel, who was accompanying her father on a business trip through the Northwest, wrote to Alec at their summer home in Beinn Bhreagh, Nova Scotia: "I wonder will you take the trouble to read all this trash. I wonder do you ever think of me in the midst of that work of yours of which I am so proud and yet so jealous, for I know it has stolen from me part of my husband's heart, for where his thoughts and interests lie there too must his heart be."[1] From Halifax, Nova Scotia, Alec wrote to Mabel, who was at their Washington, D.C., home:

Oh! Mabel dear—I love you more than you can ever know . . . My dear little wife—I feel I have neglected you. Deaf-mutes—gravitation or any other hobby has been too apt to take the first place in my thoughts—and yet all the time my heart was yours alone. I will throw

Still pursuing new theories at sixty-six, Bell is shown in this photo, taken by I. D. Boyce, working comfortably late into the night in his dressing gown and slippers. LC–G9–Z1–137,733–A

everything on one side now—and this summer shall be devoted to you and my children. I have neglected them, too—I want to show you that I really can be a good husband and a good father—as well as a solitary selfish thinker.[2]

Words describe this conflict in Bell's life; photographs depict it. In a typical photograph of a nineteenth-century personage prepared by a professional studio, the subject is formally posed and often surrounded by symbols of his financial, social, or academic status. An occasional snapshot may provide a glimpse of the subject's family life or avocation, but such intimate views are not usually available. When I. D. Boyce captured Bell lost in thought in July 1913, he preserved a part of that world which the nineteenth-century studio photographer rarely portrayed: the intellect at work, the tender gesture, the flash of anger. The unobtrusive eye—the camera wielded by family and friends—captures such unguarded moments.

The Gilbert J. Grosvenor Collection, recently donated to the Library by Bell's descendants presents both the professional and personal facets of the life of Alexander Graham Bell. The collection includes early daguerreotypes and later portraits by Bachrach, Harris and Ewing, Frances Benjamin Johnston, and C. M. Bell. But since Bell's family

These prints from glass-plate negatives of the 1850s are either Alexander or his older brother, Melville, but all three brothers could be both comedians and tragedians. Encouraged by their father, an amateur photographer and professional elocutionist, the boys indulged in pantomimes and charades, often in front of the camera. After their performances, the boys and their father would retire to the darkroom to develop the negatives. The fact that photography was still in its infancy and a hobby for those who liked to experiment with developing solutions may account for the deterioration now evident on the plates the Bells developed. LC–G9–Z3–106–AB; LC–G9–Z3–124–AB

and friends were shutterbugs, the collection also contains albums, scrapbooks, and glass negatives rich in the more intimate details of Bell's life in his laboratory, with his family, and during his travels.

Alexander Melville Bell and Eliza Grace Symonds had three children: Melville, Alexander, and Edward. Alexander was acquainted with the world of silence very early in his life. His mother was nearly deaf, and young Alec served as her interpreter. Despite this handicap, she seems to have led a full life. The Bell family relaxed on weekends at Milton Cottage in Trinity, away from the confines of their home in town. Bell later commented that Edinburgh was where he resided, but Milton Cottage was where he lived. The happy moments the family shared at their country home were tragically interrupted in 1867 when Ted died at the the age of eighteen and in 1870 when Melly died at twenty-four, both from tuberculosis. When Alec showed signs of the same disease in 1870, his mother and father decided to emigrate from the Scottish climate. After much persuasion, Alec agreed to accompany his parents to Canada.

The Bell family thrived in Canada, and Alec was absorbed by his work with the deaf. His knowledge of his father's work in elocution and the mechanical production of speech, his musician's ear for tone, his experience as interpreter for his mother, and his great desire to enable the deaf to communicate apparently combined to make him an excellent instructor. As a result of his effectiveness as a teacher, he shared a great rapport with his pupils.[3] He translated his concern for the deaf children's exclusion from the world of sound into innovative teaching methods.

While teaching at the Pemberton School for the Deaf in Boston, Bell became acquainted with Mabel Hubbard, who was later to become his wife. Although totally deaf by the

Acting was a family tradition. Grandfather Alexander Bell had been an actor before he became an elocutionist, and Alexander Melville Bell passed that tradition on to his sons. The use of emotive gestures as well as precise elocution later aided Bell in his work with the deaf. In this very deteriorated glass negative, which probably dates from the 1850s, Alexander Melville is dressed in his usual natty style, as he is in many other photos in which he wears tassled caps, velvet jackets, and plaid vests and pants. LC–G9–Z3–68–AB

age of five, Mabel was encouraged by her parents Gertrude McCurdy and Gardiner Greene Hubbard to continue speaking, despite the pessimism of experts. Their efforts led her to her first meeting with the young instructor. Her description of that meeting follows:

It was in Vienna . . . that I first heard of Mr. A. Graham Bell . . . It was therefore with some interest not unmixed with prejudice that I first went with Miss True soon after our return to America to see the teacher of whom I had heard so much but whom I privately considered a quack doctor. I both did not and did like him—he was so interesting that I was forced to like to listen to him, but he himself I disliked. He dressed carelessly and in a horrible shiny broadcloth—expensive but not fashionable—and which made his jet black hair look shiny. Altogether I did not think him exactly a gentleman

But Mabel's first impression was not permanent, as she recalled in her diary: "One afternoon . . . in October Alec came out to see me, and was invited to stay for tea. Happening to speak of his telegraph ideas Papa became so much interested that he offered to take out patents for him and from that day began the friendship that ended in our marriage."[4]

The years 1875–76 were difficult ones for Bell, who wrote to his parents on February 12, 1876: "I rush from one thing to another and before I know it the day has gone! University [where he taught vocal physiology]—V. S. [Visible Speech]—Telegraphy—Mabel—visiting—etc. & etc. usurp every minute of my time . . . I think that May and I are both very happy—almost too happy. I am sometimes afraid—for great happiness cannot last long."[5]

The financial and moral support of the Bells and the Hubbards and Mabel's enthusiasm enabled Bell to realize his dream: the electrical transmission of speech via the telephone. On July 7, 1876, Bell wrote: "Mabel's voice has been the first human voice to traverse a real

Alexander's mother poses for her husband in the family garden at Milton Cottage with Ted and Alec, with a double exposure of Melville as a ghost creating the transparent apparition. Melville's appearance here is prophetic, for he tried to communicate with the spirit world and made a pact with Alec to attempt contact should he die first. Alec seen shielding himself against his mother, was the only son to live beyond early adulthood. LC–G9–Z3–140–AB

Appearing to have adopted the North American culture in this 1876 photo, Bell poses in a costume borrowed from a friend of the family, Mohawk Chief Johnson. He is accompanied by Frances Symonds, his Australian cousin, who is wrapped in a blanket and armed with a peace pipe. Despite the subjects' restrained expressions, the photo was of much interest to Frances's relatives back home. In her August 11, 1878, letter to Alexander's mother, she commented: ''So the poor old Chief Johnson has been nearly murdered, poor fellow. I am very sorry. I am afraid he will meet with an untimely end some day. Whenever any of you see him, remember me most kindly to him. I have his photo in his official dress on the mantle piece of the drawing room, and show it to everyone. I am proud of it. You remember the large signed photo Alec had taken in the Chief's dress and me with him as his squaw, well I have that also in a conspicuous place'' (Alexander Graham Bell Papers). LC–G9–Z3–156,500–AB

166

With Bell (top row, far right) in this frequently published photograph of the Pemberton Avenue School for the Deaf in Boston is Mary True (fourth row, far right), who recommended to Mabel Hubbard, a former pupil of hers, that she take private lessons with Bell. LC–G9–130,726–A

telegraph wire. She spoke into my telephone and the vibrations of her voice had to travel to Rye Beach and back (a distance of 120 miles) before reaching my ear. The experiment was successful and I *heard her* although I could not understand what she said."[6]

After Bell had persuaded the Hubbards that he would be a good husband and provider, he and Mabel were married in July 1877 at the Hubbard's stately home in Cambridge, Massachusetts. Alec gave up teaching Mabel because, as she wrote in her journal a few weeks before her death, "he considered that husband and wife stood on a position of

Mabel Hubbard as a young girl. On January 6, 1879, she recalled in her diary: "Became deaf at the house of my grandfather in New York when nearly five years old. Have no recollection of hearing except of a soft low sound I always called the singing of the frogs" (Alexander Grahm Bell Papers). LC–G9–Z3–156,502–AB

In a photo taken toward the end of World War I by their son-in-law Gilbert Grosvenor, Mabel and Alec are shown enjoying a few peaceful moments together near their home in Beinn Bhreagh. LC–G9–Z1–116,844–A

equality and the position of teacher and pupil is not such."[7] Although no longer her teacher, Bell continued to translate the world of sound for Mabel. She in turn translated the world of emotions and daily events for her absent-minded inventor husband. The happiness that Bell had feared to be fleeting endured, for they remained devoted partners throughout their lives.

Elsie May Bell was born to Alec and Mabel in 1878, and Marian, always called Daisy, was born in 1880. Two other children, boys, died shortly after birth. Upon Elsie's birth, Mabel wrote to her mother-in-law on May 22, 1878: "He is much interested to see that all organs of speech and sight and hearing are perfect and in verifying Darwin's observations [that acquired characteristics, such as Mabel's deafness, were not hereditary] on his own children. Alec's next choice of a name for baby is Darwinia."[8] As the girls grew they remained close to their parents and enjoyed the circle of inventors, scientists, and pilots with whom their parents surrounded themselves.

Bell delighted in anything aural. Two of his favorite activities were observing the development of speech in children and playing the piano. On December 5, 1889, Alec, an agnostic, wrote to Mabel, who was traveling with her father:

Elsie, the other day, caused a great sensation at the dinner table during my absence—by her description of how we spent our evenings at Beinn Bhreagh. Among other things she said that "Papa would pray for them while they danced!" "What?" "Yes—sometimes we would dance and sometimes we would sing and *pray* with Papa." She was quite unconscious of the *lapsus linguae* that led her to substitute an R for an L—until the laughter that went round the table recalled her to herself.[9]

Bell's wealth enabled him to acquire the materials and hire the personnel necessary to carry out his experiments. He responded to events which affected his life by trying to im-

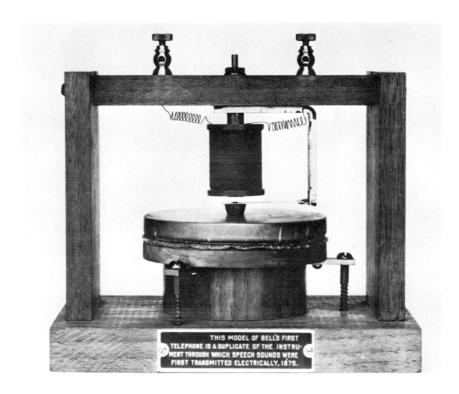

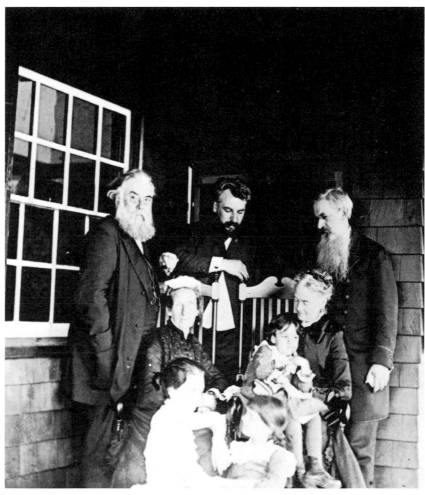

The Hubbards and the Bells at the summer home in Manchester-by-the-Sea. Under August 3, 1884, Mabel noted in her journal: "Mr. and Mrs. Bell went yesterday to our great regret. We enjoyed their visit so much and the children especially enjoyed their grandfather. He is so good to them, always telling them stories and playing with them. We spent yesterday morning photographing ourselves . . . then we all stood in a very ugly group and were photographed for our heights. I thought the children would afterwards like to know how tall they were and how they compared with others this 2nd day of Aug., 1884. Mamma and Papa came in to say goodbye and stayed to be photographed. . . . I finished developing just as the carriage drove up to take Mr. and Mrs. Bell to the station" (Alexander Graham Bell Papers). LC–G9–Z3–156,504–AB

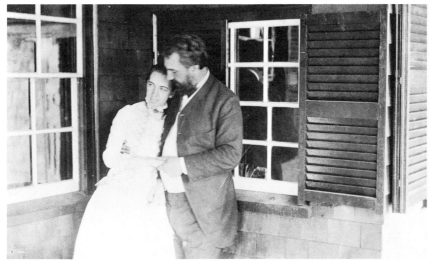

Top: The first telephones used telegraph wires to send messages. LC–G9–Z4–68812–T

Bottom: Mabel and Alec in 1884 at their Manchester-by-the-Sea summer home. LC–G9–Z3–156,503–AB

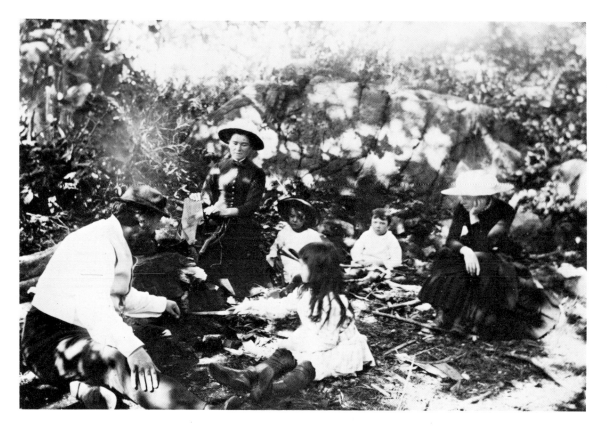

The income from the telephone patents ensured a comfortable life for the Bell family. While their letters indicate that their life style was costly, photographs show that they enjoyed such simple activities as picnics, swimming, camping, and walks through the woods. Here, on a sun-dappled afternoon, puffing on a cigar by a campfire and with a hole in his shoe, Bell is surrounded by his wife, his children, and their nurse. LC–G9–Z3–155,764–AB

prove conditions in the world around him. His grief caused by the death of his first son, a premature baby who had died from breathing difficulties, found expression in an invention he called the vacuum jacket. This respiratory device was the forerunner of the iron lung, which saved the lives of many polio victims.

When President Garfield was shot in the summer of 1881, Bell worked against time to perfect his induction balance, which he designed to locate the bullet lodged in the president's body. Unfortunately, Garfield died one month before the machine was perfected. The telephonic bullet probe, based on this machine, was widely used before the X ray was developed. Photographs in the collection also document Bell's successful attempt in using X rays to locate a needle embedded in a neighbor's foot.

At his summer home in the Nova Scotia fishing village of Beinn Bhreagh, Bell shared his neighbors' concern for the plight of fishermen who died in dories of dehydration after becoming separated from their boats. He set to work to find a way of producing fresh water for survivors. He first considered collecting condensation from fog or sea air, but the inadequate yield led him to the more productive system of reclaiming fresh water from exhaled human breath.

The high incidence of twin offspring produced by the multinippled sheep in Bell's flock induced him to determine whether they did indeed give birth to more offspring than the more common two-nippled sheep. For twenty-four years he carefully observed his flock, conducting experiments and maintaining detailed records. At one time or another, the entire Bell family was involved in these activities. There are tiny photographs in the photo collection of the grandchildren playing with the sheep and helping their grandfather

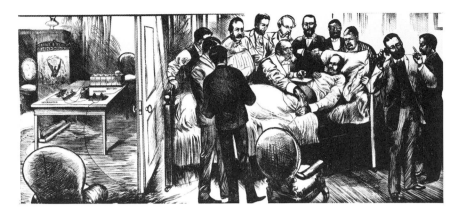

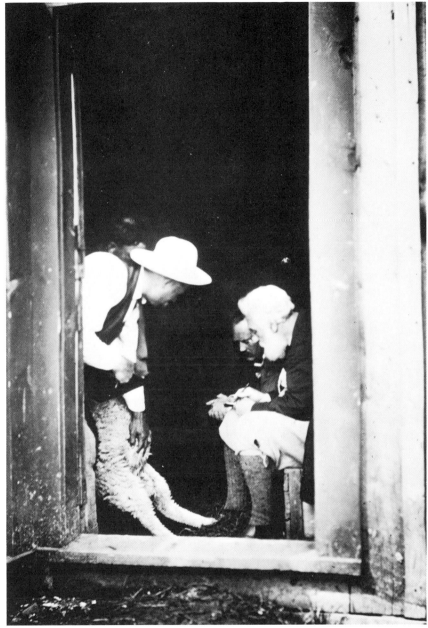

Top: Bell's description of the process of reclaiming fresh water from exhaled breath appeared in an article entitled "Water Water Everywhere," in the July 31, 1909, issue of his in-house newspaper, the *Beinn Bhreagh Recorder*. In the article Bell noted that the "apparatus could be operated for any length of time without fatigue. The process proved to be as easy as smoking a pipe. . . . I read a book for more than an hour while making an experiment with it." LC–G9–Z3–138,106–AB

Bottom: Bell, sitting outside the lab, observes his kite-flying experiments, while his grandson Melville Grosvenor naps. LC–G9–Z3–116,774–AB

Top: Lab workers and some members of the Bell family in front of one of Bell's tetrahedral kites. LC–G9–Z1–139,160–A

Bottom: Bell (left) and his assistants observing the progress of one of his tetrahedral kites. LC–G9–Z1–116,451–A

care for them. In a discouraged mood in 1914, Bell auctioned off the last of his flock, only to learn the next day that Mabel had bought the sheep by proxy because she suspected that her husband would miss his hobby. After Bell's initial displeasure with his wife's action was dispelled, he vigorously renewed his experiments. Others continued Bell's work after his death in 1922. The Department of Agriculture, which owned his flock by then, concluded in 1941 that Bell's multinippled sheep were of no practical value in increasing the size of his flock and, therefore, the production of wool.[10]

In flight, another of his lifelong interests, Bell saw opportunities for improving people's lives. The four-sided tetrahedron, strong for its weight and size, was a constant preoccupation. Bell hoped eventually to invent an airplane by equipping his tetrahedral kites with motors. Between 1898 and 1908 he designed and built many different tetrahedral kites with the help of lab workers at Beinn Bhreagh. Mabel was always an interested participant in her husband's experiments. In January 1895, Mabel wrote to Bell, who was then just a few yards away from her but was closeted in his Beinn Bhreagh laboratory:

Since I must leave Beinn Bhreagh I wish I were going to the bright colors of Mexico. Let's you and I go there together someday—in your flying machine perhaps. . . . I think I understand your experiments even if I don't know the higher mathematics and even if I am not sure whether : : means "is to" or "as." I am sure though that L is to L^1 as V^1 is to V^{12}—and I think I could explain how you worked out that curve if you let me alone long enough to digest it my own way. At least I believe thoroughly in you Alec dear.[11]

Mabel was interested in ground applications of the tetrahedron as well, and one application later came to be known as spaceframe construction. In a letter of May 15, 1906, she informed a patent lawyer that "a young civil engineer who has seen the system

Top: From what more appropriate position could Bell mark the flight of his tetrahedral kites than from his own tetrahedral observation post? LC–G9–Z3–156,505–AB

Bottom: On May 15, 1906, Bell described his tetrahedral tower in a patent application: "Perched up on top of a hill . . . it looks like a huge camera tripod, but in reality is a Lookout Tower about 70 feet in height, made to demonstrate the tetrahedral principles applied to large structures" (Alexander Graham Bell Papers). LC–G9–Z1–116,448–A

The Bell grandchildren participated in the kite-flying experiments as did Mabel, who helped finance her husband's endeavors. LC–G9–Z3–156,506–AB

Mabel, credited with this photograph, occasionally functioned as the photographer for the Aerial Experiment Association, documenting the group's work. From left to right are Glenn H. Curtiss, F. W. "Casey" Baldwin, Bell, Lt. Thomas E. Selfridge, and John A. D. McCurdy. LC–G9–Z1–38715–A

From left to right in this photograph, bundled in blankets in a tetrahedral hut, are Bell, his secretary, and his father.
LC–G9–Z1–137,983–A

Bell outside the lab sharing a moment with his grandchildren. LC–G9–Z1–139,034–A

believes that it would be better than the 'unit' system of reinforced concrete and has written for cells with which to experiment."[12]

After Bell learned that a Quebec observation tower had collapsed under the weight of sightseers, he proposed building a tetrahedral tower which, though lightweight and simple to construct from standard equipment, was capable of supporting great weight. A unique feature of the tower was its capacity to be constructed entirely on the ground, thereby risking no lives. Bell was enormously proud of this factor. He commissioned F. W. "Casey" Baldwin to construct a tower, which was opened with great ceremony in 1907 but which failed to attract the attention Bell had anticipated. Ironically, this design principle was reinvented in the 1920s with the towers of the George Washington Bridge in New York.

Mabel Bell ardently supported the application of the tetrahedral form to aviation as well as to construction. She financed the Aerial Experiment Association and paid the salaries of the experts hired to implement Bell's ideas. The association was formed to design a working model of Bell's idea for a motorized tetrahedral kite and to collaborate on the production of airplanes designed by each member. Among the members of the association were Glenn H. Curtiss, who made his first gasoline motors for airplanes at Bell's request; Casey Baldwin, chief engineer of the association; Lt. Thomas E. Selfridge, a West Point assistant instructor on assignment with Bell; and John A. D. McCurdy, a local boy who trained to be an engineer to work with Bell.

The Bells became very close to this group of experts, and, as members of the group realized some of their goals, the bond became stronger. These young men of the AEA provided Bell with fresh ideas, and Bell encouraged them with their own experiments. When

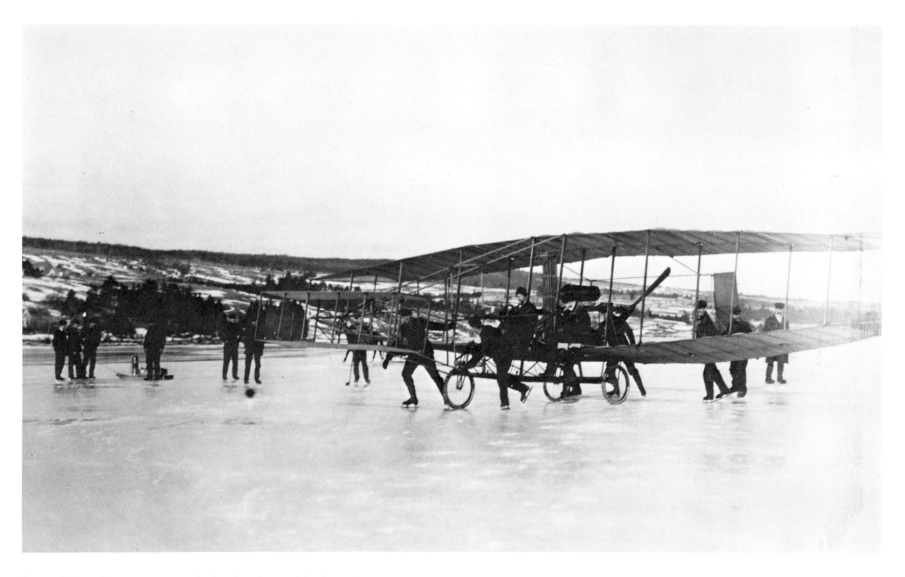

Some of the early AEA flights took place in winter, with a horse drawing the craft and men on skates guiding it across the iced-over Bras d'Or Lake on Cape Breton Island. Mabel described a flight of the Silver Dart on February 24, 1909, in a letter to her daughter Daisy: "It was a really wonderful flight Douglas [McCurdy] made this morning. He started from about 100 yards from the boat house out on the bay, flew across towards the Kennan's boathouse and thence toward the light house making a glorious sweep and came back past B.[einn] B.[hreagh] shore passing close by me purposely as I said I hadn't really seen yesterday's flight. . . . In the air six minutes. . . . The drome [short for hydrodrome out of deference to Samuel P, Langley's terminology] is such a beautiful sight it goes to Daddysans [family name for Bell] heart. He sits by himself while the tests are going on absolutely still. He was almost as pleased this A.M. as if the Silver Dart was absolutely his own machine and so proud of Douglas" (Alexander Graham Bell Papers). LC–G9–Z1–138,197–A

Bell designed and oversaw the production of this hydrofoil that broke speed records, but he never consented to ride in it. A lab photo of September 1919, captioned "Experiment 3," shows him waiting on the dock, notebook in hand, while the HD–4 speeds across the water. LC–G9–Z1–118,625–A

Top: Bell's assistants working on one of Bell's hydrofoil designs. LC–G9–Z1–138,074–A

Bottom: With the men away at war, Bell hired women to build dories he designed for the Canadian government. LC–C9–Z3–1494–AB

Tom Selfridge became the first aviation fatality on a flight with Orville Wright, the association sorely felt the loss. Years earlier, the Bells had tried to adopt John McCurdy after his mother died when he was two years old. Mabel wrote to McCurdy regularly when he was away at college. The Bells provided for Casey Baldwin, who later married and raised his family at Baddeck, Nova Scotia. They also took the Baldwins on their 1910 round-the-world tour, while McCurdy went barnstorming with Curtiss. Curtiss kept in touch with Bell and in 1914 presented him an album of the association and a photographic record of his own contributions to the advancement of aviation and navigation.

Alexander Melville Bell, in his tassled cap and with his pipe, enjoying a reflective moment while Elsie talks to her grandmother Eliza Grace Symonds Bell through the trumpet or speaking tube. LC–G9–Z3–156,501–AB

There is scarcely a picture in the collection of Bell and Keller in which they are not communicating with each other. LC–G9–Z1–155,718–A

In 1901 at Baddeck, Helen Keller is shown with Bell testing the pull of the kite to sense its soaring flight. LC–G9–Z1–137, 735–A

When the AEA disbanded in 1909, Mc-Curdy and Baldwin stayed on to work with Bell on other projects, particularly the design of hydrofoils and catamarans. With the onset of World War I, Bell, a naturalized citizen, decided to practice the neutrality of his country by manufacturing small boats for private citizens. A German submarine attack on Nova Scotia confirmed his need for caution. When the United States entered the war in 1917, Bell began to produce boats for the Canadian navy. Lack of money and powerful engines during the war impeded his work on the hydrofoils. However in 1919, once those obstacles were overcome, Bell and Baldwin built a hydrofoil which established and held speed records for ten years.

As boats, kites and planes held Bell's attention until he reached old age, so did his concern for the problems of the deaf. He was generous to his students and protégés, giving some a start in business, lending them funds, and encouraging them to function in a broader world than the isolated community of deaf-mutes. He visited students and schools for the deaf all over the world. His devotion to this cause led him to form one of his more famous friendships. Helen Keller's father brought her to Bell for instruction when she was six years old. Bell helped him locate Annie Sullivan, who became Helen's miracle worker.

The happiness that Bell feared to be fleeting endured for forty-five years, ending with Bell's death in August 1922. Mabel died five months later. Both were buried in Beinn Bhreagh, near the sea.

April 1977

NOTES

1. Alexander Graham Bell Papers, LC.
2. June 24, 1889, Bell Papers.
3. Robert V. Bruce, *Bell: Alexander Graham Bell and the Conquest of Solitude* (Boston: Little, Brown and Company), pp. 80–89.
4. January 6, 1879, Bell Papers.
5. Bell Papers.
6. Ibid.
7. Ibid.
8. Ibid.
9. Ibid.
10. Bruce, *Bell,* pp. 416–17.
11. Bell Papers.
12. Ibid.

Mabel and Alec, looking toward the sea from Sable Island. On the back of this photo Bell wrote: "Mabel and I think ourselves alone, but photographer McCurdy steals up behind us, and secures a snapshot." LC–G9–Z1–149,066–A

Discovering Theodor Horydczak's Washington

by Beverly W. Brannan

In 1957, Theodor Horydczak offered to sell his print and negative collection to the Library of Congress, but the Library did not react. Although it is not possible now to determine why, an unpublished history of the collecting trends of the Prints and Photographs Division indicates that, except for a few collections like Mathew Brady's, photographs held little interest for the Library. This was true for most museums, libraries, and archives until fairly recently, when photographs began to be collector's items and to fetch high prices.[1]

Unlike many institutions, however, the Library was acquiring photographs through other sources. Photographs came into its collections in abundance as copyright deposits and by gift. Horydczak's own work was already fairly well represented in the holdings of the Prints and Photographs Division through deposits for copyright purposes and a compilation of photographs of the Library of Congress during the 1930s put together by the Harris and Ewing photography studio.[2] Fortunately Horydczak's work was still in one place in 1973 and Norma Horydczak Reeves, his daughter, and her husband, Francis Reeves, gave his photographs to the Library free of family restrictions.[3] I have been unable to locate the donors since I began work on the collection.

Photograph labeled "Own Self." Theodor Horydczak wearing plus fours and argyle socks, about 1930. LC–H8–893

The Theodor Horydczak collection now in the holdings of the Prints and Photographs Division of the Library of Congress numbers more than 30,000 items and includes approximately 17,450 black-and-white photographs, 14,000 negatives, and 1,500 color transparencies. At present, the color transparencies are arranged and indexed by subject and await production of protective Mylar jackets to make them available for use by the public. Pending complete processing, a selection of photos pertaining to various topics of interest to readers using the photograph collections were processed. The selections are now available for use and more photographs will be added to them as staff time permits.

In any field, some practitioners achieve fame in their own times while others go about their work unnoticed. In photography, works by many of the well-known practitioners now command high prices and the study of their photographs is prestigious. Works by the lesser-knowns are taken for granted except for their documentary value. The works of Theodor Horydczak could fall into the latter category. People like his photos because they show how specific buildings looked on certain dates, for instance.

The works of a competent commercial photographer serve at least three research needs.[4]

Collectively, they document historic trends during the photographer's career. Individual items record the photographer's immediate environment. Finally, even though the photographs may be done on commission, they reveal how an average person felt about issues of the day.

The Horydczak collection is especially significant because it documents the period between the two world wars, a time of rapid change. The collection is especially significant in that it first pictures Washington, D.C., as the national capital and then traces the city's gradual development into a world capital since the mid-1930s. This record is therefore of both local and national significance. Finally, for the student of human nature, it is interesting to compare events of the period

Horydczak's daughter, Norma, seems totally at ease in front of her father's camera, about 1928. LC–H8–277

Street vendor with balloons, about 1933. LC–H8–1683

The boys in the fountain react to the photographer as if he were an intruder. They stare at him from waiting faces, protecting themselves with taunting, defiant expressions. About 1931. LC–H8–1282–6–Z

with biographical data about Horydczak to study how the photographer may have felt about the rapid changes of his day. In Horydczak's case, such a study is made more difficult by the dearth of information about his life.

Andrew "Buck" May, a Washington photographer who knew Horydczak, provided valuable assistance in tracing Horydczak's career in Washington, a career which spanned the period from the 1920s until his retirement in 1959, when he left town. May recalls that Horydczak took up photography during World War I. A photograph probably taken in 1928, the last year Horydczak's occupation was listed in the city directory as "Army," shows him in a sergeant's uniform with Signal Corps insignia on his collar. This was the corps to which Army photographers were assigned.

The city directory shows no other Horydczak entry between 1880 and 1960, so it is safe to conclude that Horydczak had no close relatives in the area. May thinks that he was probably born in Europe. A 1973 fire destroyed Horydczak's standard military records at the Military Personnel Records Center in St. Louis, making it impossible to find additional information there.

Information in the collection itself is interesting but meager. One unidentified negative shows a young man in uniform wearing a gunnery pin. An index entry under "O" for "Own Self" in another part of the collection shows the same person several years later at a Canadian logging camp on a 1939 picture-taking trip, verifying that Horydczak was the subject on the earlier negative.

According to the city directories, Horydczak began living in Washington in 1921, at 1818 G Street NW, and was employed by the U.S. Army. In 1922 he was listed as a photographer, living at 1223 Twelfth Street NW. His occupation was listed as "Army" again

in 1926. In 1927 he was an army sergeant and lived at 1321 Fern Street NW.

A notation for his wife, Frederica (listed as Frederica St. G—— in later years), is added in the city directory entry for 1928, but the marriage is not recorded in the marriage records of the District of Columbia. Horydczak was listed in 1929 as a War Department army employee and in 1930 as a commercial photographer. By 1938 he had moved to 4820 W Street NW, where he continued to live until he left the city in 1959.

A group of a hundred or so undated negatives, most of them of a snapshot nature, appear from internal evidence such as clothing and decorating styles to be from the early 1920s, probably 1920 or 1921. Horydczak's logbook begins with a picture of cherry blossoms along the Tidal Basin taken in 1921. This photo was copyrighted, possibly representing his first professional work.

These facts are virtually all that is known about the photographer who left this sizable collection. As for Horydczak's times, they include the uncertain and rebellious 1920s, the economic and psychological depression of the 1930s, and World War II and a short period after its end. Most of Horydczak's work was done between the wars. Those fascinating years have prompted myriads of books, movies, and television surveys. Horydczak's photographs will provide valuable new data for future studies.

Horydczak took relatively few portraits or even candid shots of people. May reports that Horydczak disliked photographing people to the extent that he refused to maintain a studio, working out of his home instead. And he was sufficiently successful that he did not have to scout around for jobs—instead, people came to him. His early photos show family and friends smiling directly into the camera, involved in the photographic process. But

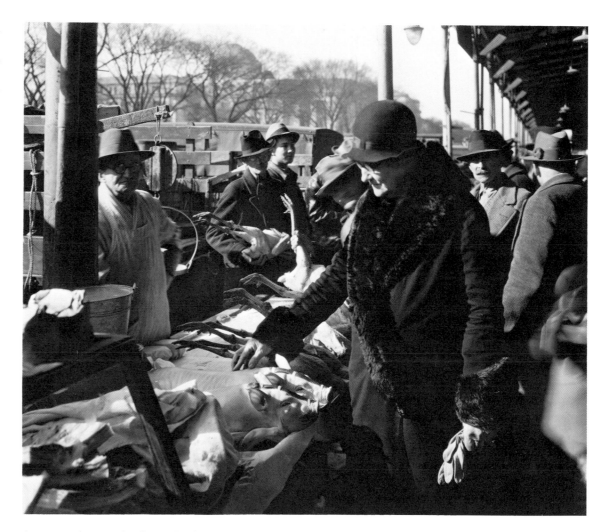

A woman shops at the Center Market, Washington, D.C., wearing layers of heavy clothing. About 1930. LC–H8–1030

over the thirty-six years his work covers, his photographs of people indicate an increasing distance between the photographer and his subject, few photos showing any relationship between Horydczak and the people he photographed, whether they were individuals or groups, children or adults.

Many of Horydczak's photographs show a society with a greater degree of formality than is exhibited today. Street vendors wore suits, women wore hats, and only laborers wore the equivalent of jeans. With the exception of young children, the people in Horydczak's photos stood well apart from each other, even in crowds. They wore layer upon layer of clothing, regardless of the season, in sharp contrast with the present custom of dressing scantily in hot weather and informally as a rule. It is difficult to tell how much restraint and decorum can be attributed to Horydczak's careful selection of subjects and how much of it is merely characteristic of the time in which he lived.

Horydczak may have had good reason to feel uncomfortable with people. The twenties and thirties were times of isolationist foreign policy and fervent nationalism, when the Ku Klux Klan reigned virtually undisturbed. Immigrant laborers were discouraged from continuing ethnic life-styles and encouraged to Americanize. As a recent immigrant, Horydczak may have felt sensitive to such pressures. As a person of Eastern European extraction, he may have felt singled out by the 1917 alien labor law that excluded immigrants from Southern and Eastern Europe. But whether Horydczak's alienation was conscious or not, it colored the whole of his work.

A 1930 view of the meat counter in Fred Grover's grocery store at 117 Hare Street, Baltimore, Maryland, shows a way of life unknown to most Americans today. The store appears to have on hand a little bit of every-

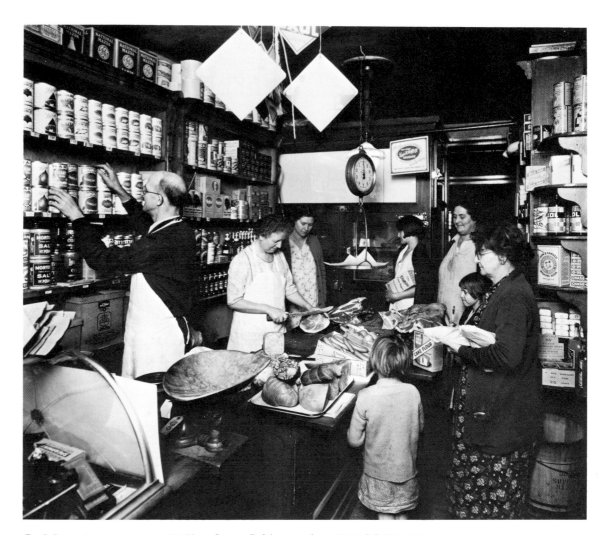

Fred Grover's grocery store, 117 Hare Street, Baltimore, about 1930. LC–H8–1006

186

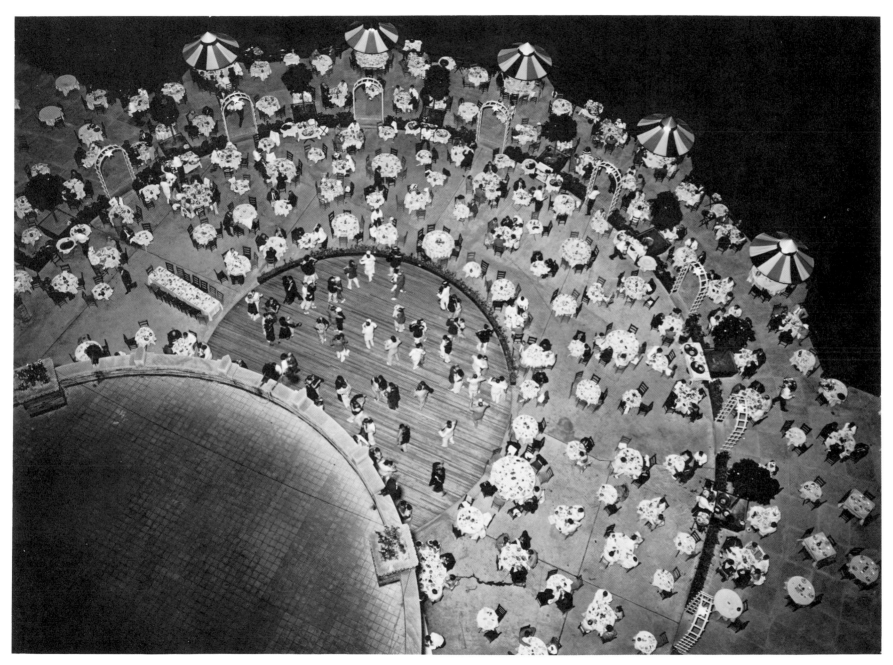

Dance floor scene, lit in such a way that no shadows appear. Shoreham Hotel garden room, Washington, D.C., 1934. LC–H8–1881–11

thing—beans, corn, pancake mix, tomatoes, ketchup, noodles, salt, shortening, sardines, coffee, crackers, cake flour, and sugar, with candy, coughdrops, and chewing gum in the foreground. Many of the brand names displayed are still in use.

In this photo, taken some seven years into Horydczak's free-lance career, the people maintain careful ignorance of the photographer's presence. Mr. Grover's hands are too long in place to be reaching for a can whose location he knows in his sleep. The apron of the woman slicing meat is too crisp and clean for her to have worked on the quantity of meat laid out around her. The saleswoman is too intent on the simple act of slicing ham, the concentration of the shoppers on the slicing activity too complete, their avoidance of chatter too effective not to be conscious, and the smile of the lollipop-holding child too constrained not to be instructed. How much constraint is convention and how much the photographer's instructions to his subjects?

Horydczak was a technically competent photographer. Note the lighting and focus, revealing crimped-edged candy papers in the foreground, globules of fat on the cutting board in the middle of the picture, and folded ends in the metal loaf pan in the glass-faced refrigerator toward the rear of the store. Note the composition; the group of people on the right balances the mass of cans on the left. Horydczak's approach seems to have been to give the impression that business is going on as usual, despite the self-conscious smirks on averted faces that belie that assumption. The photographer seems no more involved with his human subjects than he is with the displays of groceries.

True, one picture may not tell a person's whole story, but this photograph is representative of the bulk of Theodor Horydczak's work. Throughout the collection, his work is

Boston Bonus Marchers seem to welcome Horydczak's documenting their encampment on Anacostia Flats, 1932. LC–H8–1456

188

well controlled, tightly composed, carefully lighted, optimally focused, and studiedly remote. Informed ignorance of the photographer's presence, remote perspective, and physical distance are doggedly maintained after Horydczak's first few years in business. He kept himself at a physical and psychological distance from the people he was photographing. The complexities of Horydczak's personality are reflected in his calm pictures of life in a time that appears simpler than ours today.

Best conveying the photographer's distance from his subject is his photograph of dancers on the outdoor dance floor of the Shoreham Hotel. It was taken from a derrick high above the floor, recalling Busby Berkeley movie scenes. Lights must have been placed at that height and at various intervals below it, so that no shadows form anywhere in the area. It is curious to note that no one on the floor is looking up. The contrast of dancing, a close-contact activity, with the distance from which the photographer took the picture heightens the sense of alienation pervading Horydczak's work. Here he is so far removed from his subject that the dancers look unreal.

One group of pictures of people, however, stands out from the rest because of the obvious involvement of the photographer with his subject. Horydczak's subject here was the 1932 Bonus Expeditionary Force, jobless veterans of World War I who tried to persuade Congress and President Hoover to grant them their Veterans Bonus ten years early. From all over the country they congregated in vacant barracks and in empty office buildings in Washington, D.C., until those were filled to capacity. Then they built temporary shelters on Anacostia Flats, where Horydczak's pictures were taken.

As a World War I veteran, Horydczak may have empathized with the marchers' frustrations, reflecting on his own good fortune at having found relatively stable employment. Although the army had been almost entirely demobilized one year after the armistice, Horydczak had continued his army career for nine years until his photography business was well established. The decision to become self-employed turned out to be a good one for his time. Potential for advancement in the peacetime army was negligible and the 1917 alien labor law made it difficult for Southern and Eastern Europeans to find employment in industry. Although Horydczak might have been an army intelligence agent documenting the seriousness of the threat the Bonus Expeditionary Force posed, examination of his work and comparison of it with that credited to the Army Signal Corps indicates that he wasn't.

Horydczak's images of the Bonus Army are closeups, showing the dejected men, their living conditions, and the sense of humor in some of the protests displayed. His photographs stand in sharp contrast to those taken by various other D.C. commercial photographers and by the Army Signal Corps. Horydczak's photos show none of the tense moments. He did not record the California contingent parading on the Capitol grounds; evictions from sewerless buildings; MacArthur, Eisenhower, and Patton commanding the troops that gassed and burned buildings where veterans had encamped; or the use of "four companies of infantry, a mounted machine gun squadron and six whippet tanks" against straggling Bonus Expeditionary Force members and their wives and children.[5] Even though Horydczak's usual custom was to try to negate any interaction between the photographer and the subject, when he felt strongly enough his feelings and opinions asserted themselves.

As a result, a few of his pictures of people, like those of the Bonus Army, betray personal interest.

His photographs depicting the technological changes of his day also reveal a dichotomy. He seems to have been fascinated by the objects people made with machines. His shots of engine parts and of people using machines are beautiful and inspiring. But other photos are nostalgic, as though he regretted the shift in the way people lived.

Two changes which influenced Horydczak's life were the extremely fast mechanization of processes that for ages had been done by hand and the styling of machine-made products to boost consumption. During the 1800s, the speed of mechanization accelerated, with science and technology prodding each other on to further and further advancements. Constantly improving technology and more efficient factory management tremendously increased industrial production. Manufacturers soon saw that production had surpassed consumption. Products were comparable mechanically, and the more attractive items sold more readily than the purely functional. Desire for profit forced industry to recognize the necessity of beauty. Industrial design came into existence as a profession in the mid-1920s, with the express purpose of making useful commodities beautiful.

The best of the designs had similar features, resulting in part from the common aim of simplifying an object's design to bring out its inherent beauty rather than applying previously conceived characteristics of beauty. This style of simplification became known as *streamlining* and was seen by some as a reunion of "art and life which science and industrialization had wrenched apart"[6] centuries earlier. Optimists hoped that a reunion of reason and aesthetics would simplify every as-

Like many other 1930s photographers, Horydczak focused on the symmetrical beauty found in industry. Pattern made with cast gasoline-engine blocks, Maytag Washing Machine Company, Newton, Iowa, about 1930. LC–H8–477

pect of people's lives, through increased efficiency and economy of production, relieving men and women of tedious tasks, allowing them creative leisure in place of drudgery.

America, unburdened by Western Europe's legacy of guilds and outmoded equipment, became the world center for innovative industrialization. Foreign businessmen and manufacturers came to study American machinery, the assembly line, scientific management, and efficiency techniques. They were amazed at the production capacity they encountered.

Many of Horydczak's photographs show the beauty of engine parts, machines, and factory workers. Note the symmetrical pattern repetition of washing machine engine blocks and the magnificence of the human form in the pouring of ingots. As attractive as these studies are, photographs of the automobile assembly line may have had more impact. In terms of product value, automobile manufacturing emerged by the mid-1920s as America's largest industry. Horydczak's photos show changes in design, reflecting both progress in mechanization and streamlining.

As technical advances occurred in automobile production, design changes included rounded front-end lines and tapering rear-end lines; less conspicuous radiators; absorption of fenders, running boards, and lights into the body of the car; and consolidation of body and frame units. Interior changes brought increased usable space with movable furniture and sealed, air-conditioned, soundproof interiors. New materials, such as shatterproof glass and plastic moldings, as well as new methods of working the body metals, resulted in more adaptable and aesthetic forms. Most popular automobiles took on an ovoid form, designers citing reduced air resistance and increased interior legroom as functional justification for an aesthetic improvement.

Horydczak's photos reflect many improvements in transportation now so commonplace that it is easy to overlook the fact that they were innovations at the time he photographed them. A 1930 photograph shows mail still being picked up by horse and wagon, and a photo taken in 1933 records men working in Rock Creek Park using a mule-drawn wagon. An amazing variety of service vehicles for Washington businesses depicted in the collection includes the rows of panel and flatbed trucks used by the Starett Operating Service, photographed by Horydczak in 1932. The photographs take us from public transportation—the streetcar, bus, and heated taxi—to the family car. Service station scenes present a view of the world opening up to car owners, who relied on technology to extend human capabilities and to compensate for human failings as well. A sign on many of the gasoline pumps reads, "Glass must be full before and after filling [car tanks]," to ensure that no greedy merchant could give short measure. Technology gradually transformed man's relationship to his environment, a change about which Horydczak seemed to feel ambivalent.

His pictures show the replacement of man by machine, a change that speeded up the pace of life. Throughout the time that Horydczak worked in Washington, the District of Columbia highway department built more and more roads from the city to the suburbs. He photographed highway construction that enabled people to go farther and get there faster in their automobiles. He photographed construction of the bridges between the District and Northern Virginia, as well as construction of the George Washington Memorial Parkway, which enabled people to get quickly to another vehicle that changed transportation habits all over the world, the airplane.

The airplane not only embodied outright

the idea of getting people farther faster, it lent its style to nearly all mass-produced items of the day. Its long, hard lines, and sheer surfaces showed up everywhere. A 1930 photo of Hoover Air Strip, located near the present Washington National Airport, shows the airplane in streamlined contrast to the automobiles around it. The freshly dragged earth runway and the cars with their square lines look rustic beside the sleek airship. A photo of National Airport in 1941 shows a techni-

Pouring ingots, Martin Fireworks Factory, Fort Dodge, Iowa, about 1930. LC–H8–574–11

191

Workmen use a horse-drawn wagon to clear fords, probably in Rock Creek Park, Washington, D.C., about 1930. LC–H8–1723

Top: Square shapes characterize 1920s vehicles. Flat windshield, square body lines, and flattened hubcaps date this tour bus as an early 1920s model. LC–H8–2700–Z

Bottom: This President model Studebaker shows the streamlined design of the 1930s. Note inset headlights, rounded radiator grill and hood line, wrap-around fenders, and curved bumpers. Ornamentation is suggestive of flight and speed. LC–H8–2280–6

Gas station, Colesville Road, Silver Spring, Maryland, about 1932. LC–H8–1504–1

cally advanced environment in keeping with the tone set by the plane. The later photograph looks devoid of humanity.

Streamlining affected interior as well as exterior products. Three photographs of kitchens show how technological advances changed the lives of ordinary people. The first photo shows a 1938 kitchen in which a sleek 1920s model gas range, with oven and broiler beside the range top, sits on elongated cabriole legs next to a nineteenth-century style wood-burning stove with oven and broiler overhead to accommodate the firebox. The flue is still connected for occasional use and the covered burners serve as practical workspace, that area and the table top being the only work surfaces available. The presence of a work-table instead of built-in cabinets indicates that this kitchen is only partially modernized. Scientifically run kitchens have cabinets with work surfaces. The icebox-style refrigerator predates both the overhead-motor of the mid-1920s and the introduction of the freezing compartment in 1932. Electrical gadgets, such as the toaster, were gradually making their way into households at this time.

The second photo, taken in about 1950, shows a kitchen in the process of being remodeled. A steam radiator stands next to a box-shaped gas range which has its heat source in burners and ovens instead of a firebox. The range could have been integrated into the system of continuous working surfaces that was the ideal of the efficiently organized kitchen. An electric toaster stands on a window ledge above a sink with drainboards. Under the sink are enclosed base cabinets, and glass-front cabinets are built into the wall. The room looks old-fashioned to viewers in the 1970s because each item is treated as an isolated piece of kitchen furniture. Each piece does not fit into the sur-

193

Mount Vernon Boulevard, now George Washington Memorial Parkway, about 1935. LC–H8–2245–1.

rounding units, nor does the furniture reflect the work process, although this kitchen is closer to an ideal of efficiency than the kitchen in the preceding picture.

When compared to the fully organized kitchen of about 1950 in the third photograph, however, it looks ancient. A dishwasher and disposal unit, prefabricated cabinets with stainless steel tops and a "Hide-a-can" disappearing trash can represent a reliance on technology that offered something for the common woman as well as for the common man. During the 1920s electrical power became the major source of energy for industry, and the manufacturing of electrical machinery, light bulbs, and appliances such as vacuum cleaners, mixers, and toasters grew to rival automobile manufacturing. Horydczak took photographs of kitchen modernization financed by utility companies. These renovations called for more innovative equipment to improve upon earlier innovations and, incidentally, increased energy consumption. Labor-saving devices radically changed the pace of life in Horydczak's world.

Another major cause of change in his day was the development of communication devices. Talking movies were introduced in 1926. The telephone, in existence since 1876, evolved during the 1920s from the wall phone to the "candlestick" model to the cradle model that had the advantage of freeing one hand. This streamlining effect simplified the telephone to a basic functional form suited to the human hand. The radio developed technologically between 1920 and 1929, bringing mass culture to isolated regions and ultimately provoking a shift from a regional to a national culture.

Streamlining principles operated in architecture and community planning, too. Efficient design was expected to give machine-age people freedom by widening their control

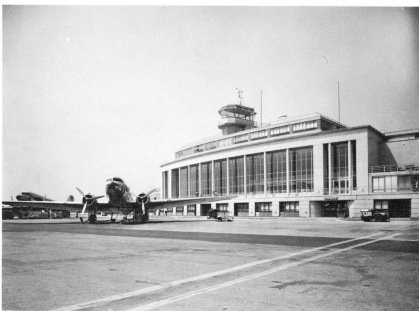

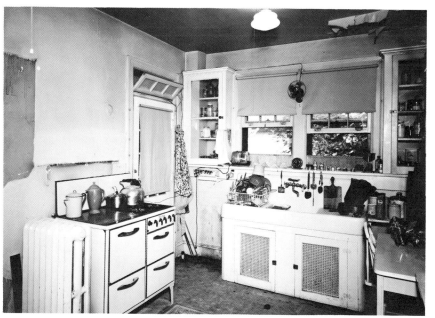

Top: The Washington, D.C., airport and its dirt field, about 1931. LC–H8–1235–4.

Bottom: Washington National Airport with a concrete runway, about 1941. LC–H8–A2–15.

Top: Kitchen about to be remodeled, about 1938. LC–H8–2474–46

Bottom: Kitchen being remodeled, about 1950. LC–H8–2641–2

over the minutiae of daily routines. The principles that guided scientific industrial management, efficient kitchen planning, and optimization of form and function found expression in planned communities where each dwelling could be set well apart from its neighbors for privacy.

This trend, along with improvements in roads and increased automobile ownership in the 1920s, was followed in the 1930s by demands for increased housing for the growing numbers of federal workers who arrived in Washington to implement the New Deal. Suburban growth in such areas as Greenbelt, Maryland, and Clarendon, Fairlington, and Parkfairfax, Virginia, providing low-cost housing for incoming bureaucrats, is documented in Horydczak's work. Although construction of residential and commercial buildings slowed during World War II, the pace increased later to provide housing and services for the still larger postwar work force. Community characteristics of streamlined organic planning included free spaces around each dwelling, each home becoming what Sheldon and Martha Cheney called "an orderly unit in a larger design organism."[7]

Model kitchen with all the latest equipment, about 1950. LC–H8–2641–5

"Park and Shop" at Connecticut Avenue and Porter Street NW, Washington, D.C., about 1930. LC–H8–1049

196

Arlington Hotel, one of Washington's wide selection of hotels and residential hotels, 1931 or 1932. LC–H8–1272–1

Top: The Shoreham Hotel's popular cocktail room, 1934. LC–H8–1881–2

Bottom: Bolgiano Seed Company, probably Washington, D.C., about 1938. LC–H8–2465–2

197

The collection depicts a wealth of domestic interiors, general commercial buildings, and renovation views of all types. It is curious that there are few examples of modernism in domestic architecture in Horydczak's work. His own house, built in 1938, is a traditional brick home, freestanding but located in the city.

A trend noticeable in Horydczak's work is the demographic shift from urban to suburban. Many residential hotels, popular during the business boom years before the 1929 stock market crash, are featured. These photographs may have been made during the 1930s for advertisement purposes. They show comfortable lobbies, impersonal suites, and friendly gatherings in tea and dining rooms. Jobs were scarce, money was hard to come by, and young people tended to live at home with their parents after they began working full-time. Visual inducements were needed to persuade them to get places of their own.

Horydczak next depicted the housing wave that resulted when people from all over the nation came to Washington to take jobs in the new, big government under Franklin Roosevelt. There were so many people arriving that there were not enough hotels and apartments to hold them, and they searched for rooming houses. Many people supplemented their incomes by renting rooms to boarders. Without individual entertainment areas, boarders met at hotel dining rooms and tea rooms for socializing, continuing the earlier pattern of urban life.

After World War II, many of those hired to do war work stayed on in Washington, and the city grew to accommodate them. Services expanded and roads, offices, churches, and apartments were built in Maryland and Virginia. New buildings continued to replace old ones. Modern commercial buildings of the 1940s are well documented by Horydczak.

Washington Gas Light Company building, Eleventh Street NW, Washington, D.C., November 1950. LC–H8–2483–33

Building model for the never completed Great Plaza on Thirteenth Street between Pennsylvania Avenue and B Street NW, Washington, D.C., about 1930. LC–H8–535–Z

After the war, many of the new commercial buildings were built in the modern style.

Architectural characteristics of modernism include long unbroken lines, sheer walls, broad areas of shiny glass, and slim bands of gleaming metal, extending and multiplying the resources of light, air, and sunshine. Architecture of the thirties blends Bauhaus sheer-wall and hard-edged simplicity with the softer effects of rounded corners, bits of neobaroque ornament, and sherbetlike coloring that characterized Parisian architecture of the era. A typical exterior motif was a gently fluted panel set into an otherwise blank functional wall. Interior traits were zigzags, mirror glass, textiles, etched glass, and asymmetrical patterning.

These characteristics show up in many of the commercial buildings featured in the Horydczak photographs. The 1948 Washington Gas Light Company at 11th and H Streets NW, for example, shows the sleek design and construction associated with streamlining. The Bolgiano Seed Company building, photographed in about 1938, shows a transition between streamlining and the softer styles. The design is linear, with columns rising on the outer sides of the building and windows spanning its width in three bands. Alternating bands of concrete and glass bricks expand the amount of light available indoors. The lines of the building are modern, but the brick construction material is too textured to conform with the slick aura of the streamlined style.

Horydczak was fortunate to have worked in Washington during a period of dramatic architectural change. The early 1920s were years when Washington was gaining what has been described as a "new outward grandeur," a time when people across the nation were concerned with the beauty of their capital.[8] Until the mid-twentieth century, pe-

Detail of a government building, 1934. LC–H8–A8–8

200

Jefferson Memorial from the Tidal Basin, about 1941. LC–H8–J2–17

riods of federal building construction counterpointed booms in public, commercial, and domestic architecture. Federal buildings of the twenties are primarily neoclassical in style.

A chronological list of some federal projects photographed by Horydczak includes the Lincoln Memorial, the Reflecting Pool on the Mall, the planting of cherry trees that culminated in the first annual Cherry Blossom Festival, and the Department of Agriculture South Building in the 1920s. The 1930s saw construction of the British and Belgian embassies, the christening of Constitution Avenue, and the building of the Bureau of Printing and Engraving, the Supreme Court, the Library of Congress annex (now called the Thomas Jefferson Building), and the Police Court on Judiciary Square. The enormous Federal Triangle project began in the thirties as well, but construction was slowed by the war. Four major projects begun the decade before were completed in the 1940s, however—the Jefferson Memorial, the War Department building, National Airport, and the National Gallery of Art.

An excellent feature of Horydczak's work is his documentation of several phases of construction for the Federal Triangle redevelopment. The project, which dated from 1928 to 1938, involved razing a motley assortment of structures along three-quarter-mile stretches up Pennsylvania and Constitution Avenues, to replace them with the official houses of big government. All a sort of neoclassical design, the buildings are visually tied together by uniform cornice and belt lines and identical construction materials. Buildings in the Triangle area are the Federal Trade Commission, National Archives, Department of Justice, Internal Revenue Service, Interstate Commerce Commission, Department of Labor, Post Office Department, and Department of Com-

Stephen Decatur House, Jackson Place on Lafayette Square NW, Washington, D.C., about 1928. LC–H8–280–Z

merce, all dating from the 1928 redevelopment plan, and the Old District Building and Old Post Office Building, which survived from an earlier period.

Horydczak photographed the construction of all the new edifices in the Triangle. Documentation of construction of the Labor Department, for example, includes photos of the clay building model that, when compared with views of the finished facade, show the changes that took place during the building process. The entrance changed from three rounded arches with keystone trim flanked by two rectangular doorways without trim, as shown in the model, to three rectangular entrances with figureheads above the openings, flanking carriage lights, and ornamental grille gates that block passage to the completed building. Detailed close-ups of interior views and construction scenes at various stages are available for most of the buildings.

Other federal structures that Horydczak documented include traditional Washington sites symbolic of the national heritage and patriotic tradition, such as the White House and the Capitol, the Washington Monument, the Lincoln and Jefferson Memorials, Arlington Cemetery and the Tomb of the Unknown Soldier, and the cherry trees along the Tidal Basin. These pictures were probably made for sale as postcards or calendars or for other commercial purposes. A brochure for Horydczak's commercial work, probably prepared in the late 1940s or early 1950s, lists six photographic services, including glossy prints for commercial use, enlargements up to forty-by-seventy-two-inch murals, lantern slides, color transparencies in several sizes, mounted 35mm color slides, and custom assignments.

Horydczak's work is valuable not only as a record of what still stands but also of what once existed, before renovation or removal. The Decatur House on Lafayette Square is a

case in point. In Horydczak's 1928 photo, the house is decorated in Victorian style. The building visible behind it no longer exists today. This photo shows the way the house looked in the interval between construction and its present restoration. The streetcar tracks in the foreground call to mind an efficient form of urban transportation that has also passed from the scene. Other examples of photos showing prerenovation conditions are the Horydczak photos of the Capitol and the White House featured in the Dunlap Society's survey of the architecture of Washington, D.C.[9] Still other buildings featured in the collection have been demolished to make way for newer buildings.

Throughout his career, Horydczak consistently took competent pictures of buildings. He used the field camera, then standard for the commercial and technical photographer, a bellows device on a tripod behind which the photographer stood under a black drape. Most of the photographs are taken using natural light. The rig was heavy to carry and difficult to operate, yet Horydczak painstakingly set it up in awkward places and under unusual conditions, enjoying the challenge of photographing fireworks at night, snow-clad buildings before a single footprint had marred the fluffy blanket, and reflections from rain-wet streets.

Most architectural photography is technically exacting—optical distortion can make buildings appear to lean backward or curve toward the horizon. To avoid this problem, Horydczak usually employed a large-format camera, a Gold Ansco, using tilts and swings to move both the lens and the film to correct visual perspective when he photographed buildings. The Gold Ansco's eight-by-ten-format also allowed him to capture such details as building material, textures, carvings, and cornices with great gradation in tone.

Fireworks, July 1934. LC–H8–F4–6

Corrugating metal sheets at Central Alloy Steel Corp., Massillon, Ohio, about 1930.
LC–H8–3000

Supreme Court spiral staircase. LC–H8–C11–103

After World War II, it appears from Horydczak's logbook that most of his efforts went into organizing his archive into a picture service to which he added few new subjects. He classified a wide selection of his work and assigned new negative numbers. Although the collection contains no records to indicate the volume of picture sales, his logbook shows progressively fewer custom assignments in black and white. [10] One reason for this decline may have been his desire for a slower pace of life or semiretirement. Another factor may have been that the market had shifted to color photographs.

Horydczak was one of the first photographers in the Washington area to use color film, according to Buck May. From internal evidence, the color transparencies in the collection appear to date from the late 1930s. Horydczak's color techniques appear to have been quite different from those he used in the black-and-white medium, although the subjects are the same. Both his color and black-and-white photographs show tourist attractions in Washington, frequently picturing the same location. But there the similarity ends. In the black-and-white photos, there is one shot of each scene and on any single assignment Horydczak might have attempted several different scenes. He used a large-format camera, producing eight-by-ten-inch negatives. There were no particular people in the scenes. Lighting varied considerably—the photographs are taken not only under normal daylight conditions but at dawn, in the rain, at night, in bright artificial light, and under other extremes.

In his color work, however, Horydczak took many shots of the same scene, attempting to learn what effects he could get with color film. For some photos he varied only the exposure, using a technique called bracketing, so that the same scene appears to have been photographed under lighting conditions ranging from dusk to noonday sun. Bracketing allowed the photographer to get the best exposure on the color transparency itself, since he could not later adjust the tonality as he could when making prints from black-and-white negatives. Although some of Horydczak's color transparencies are eight by ten, most of them are the less expensive five by seven or four by five. He sometimes took the same shot over and over, varying both the exposure and the color of the filter—yellow, blue, or green. One compositional element distinguished his color work from his black-and-white photographs—a ubiquitous woman in a red coat.

The quality of Horydczak's color work is equal to that of his black-and-white photos. The character of the medium, however, is quite different. Color photos begin to fade as soon as they are processed. Color film is made of three separate dye layers, one for each of the three primary colors—red, yellow, and blue. Yellow, the least stable of the three dyes, fades first, leaving red and blue to give an unearthly bluish-purple shade to the transparency. Fading is especially noticeable in the flesh tones of Caucasian subjects. Since the Horydczak photos were taken as early as the 1930s, many in the collection evidence this type of fading, which is noticeable in a fairly short period of time. The items are still usable, and the color shifts are noted in the guide to the color material. The Dunlap Society, for example, in producing sets of instructional materials in American architecture for college levels, obtained reasonably satisfactory restoration to original tonal values when duplicate transparencies were made through filters to replace the colors of the dyes lost from the originals.

Primary emphasis in the color series is on Washington, D.C. Scenes are reminiscent of picture postcards of the 1940s and 1950s. They show the White House, monuments, and more cherry blossoms than the mind can cope with and perennially feature the woman in the red coat. Interior views of the Pan American Union, the House and Senate, the White House, and the Library of Congress are unsurpassed. Arlington National Cemetery is beautifully documented, with wisteria decking the arbors, Marines guarding the Tomb of the Unknown Soldier, and sad hills of stone and crosses marking graves of the country's defenders.

A Washington, D.C., guidebook in the collection was published for General Motors in 1956 and uses Horydczak color work entirely, indicating that he was still active at that time. Three years later, however, he stored his work at the Davis and Dunlap studio and left the area. According to the files of District of Columbia wills probated, he died in 1971, location not given. No obituary appeared in the Washington, D.C., newspapers. It seems somehow appropriate that his record is visual rather than verbal.

To draw some conclusions about this man, let us look back at his technique. How well did he control his medium? To judge this we must ask whether the picture is sharp or whether any lack of clarity is deliberate; whether the exposure was varied to fit the subject and its environment or whether some photos are too dark while others are too light; whether the development process reveals startling whites, velvety blacks, and a wide range of grays in between; and whether the photographer selected images that are interesting to others and discarded his near misses. By these criteria, Horydczak was a skilled craftsman. In 1937, for example, he won a prize in photography for a shot of the Washington, D.C., skyline that required expert skill at handling the variables of focus, ex-

Preparing lanterns to warn of street construction between the Supreme Court and the Library of Congress, about 1935. LC–H8–2321

posure, and development. A contemporary newspaper account described it as "exceptionally fine in composition and the employment of lights—night light—as a factor therein."[11]

Horydczak's work shows that he was aware of contemporary trends in photography as well as some earlier developments. When he began photographing for himself around 1920, he took tender, intimate pictures of his wife and daughter, using the "straight" style, which called for sharp brilliant details, as opposed to the then recently out-of-vogue "soft" style, which called for deliberate blurring of detail. His selection of style is revealing, since such subjects had been considered most appropriate for the impressionistic style. Horydczak's choice of the straight style may reflect the influence of his training in the Signal Corps, where he might have been an aerial photographer or at least have been taught to photograph machines, buildings, and landscapes.

It would seem from his experiments with lensless photographs and solarization and from his work with color film soon after its introduction to the commercial market that Horydczak kept up with developments in the field. A note in his logbook refers to various lenses and a camera publication. Constraints on his style must therefore have come from internally imposed limitations, not from a lack of awareness of alternatives.

One of Horydczak's colleagues remembers him as having a proclivity toward things technical. He also remembers Horydczak as a man who loved people, related well to them, and conversed easily. Horydczak must have felt some conflict between the two attractions, one human and the other technological, because whenever he put his camera between himself and other people, any sign of emotional involvement vanished. Perhaps

Boat loaded with watermelons, southwest Washington wharf, about 1933. LC–H8–1743–1–Z

Horydczak maintained an uneasy balance between two poles. He left not only outstanding products of that precise technological device, the camera, but also friends who remember him with fondness, respect, and admiration.

Horydczak's strength lay in his choice to concentrate on a wide range of subjects, emphasizing his exploration of the world beyond his lens rather than the person behind it. In choosing to do so, he preserved for us a record of some of the trends of his day, of individual artifacts and events, and, finally, of his own ambivalence to the rapid changes around him. Careful analysis of Horydczak's work reveals some of his philosophical framework as surely as would his diary, his correspondence, a discussion with him, or an interview with his family.

John Dos Passos once wrote that "a sense of continuity with generations gone before can stretch like a lifeline across the scary present." [12] A sense of continuous identity can provide for individuals as well as groups the courage to tackle the future, maintaining a balance between continuity and change. [13] Currently, change occurs so fast that to keep pace with the present people sometimes deemphasize their pasts. In doing so, they risk losing their sense of continuity. Today, when visual media as well as printed documents are being used to recreate and preserve the past, Horydczak's work provides us a visual lifeline stretching "across the scary present."

Winter 1979

Capitol on a rainy night, about 1930. LC–USZ62–30917

208

NOTES

The author wishes to thank Robert Shanks and Sally Stein for their expert advice and sustained moral support and Bernard Mergen for his insightful suggestions. Ellyn Sudow prepared the black-and-white albums of Horyd-czak material for public use, and Atlee Valentine arranged the color photographs and drafted a guide for them.

1. This fact is widely recognized and perhaps best outlined in a recent interview with John Szarkowski, director of the Museum of Modern Art's photography department. John Gruen, "The Risky Life of John Szarkowski," ART news 77, no. 4 (April 1978):66.

2. Harris and Ewing, photographers, lot 5760, Prints and Photographs Division, Library of Congress. Horydczak's photographs of the Library of Congress Thomas Jefferson Building are contained in this group of 300 photographs dated approximately 1930–40 in six albums transferred from the Information Office in 1952. The albums also include views of the main Library of Congress Building, reading rooms, bookstacks, and permanent and temporary exhibits, as well as photocopies of manuscripts.

3. Publication of the photographer's personal photographs is unrestricted, but publication of commissioned photographs could entail liability for infringement of copyright as certain rights to the use of these items may still reside with the people who commissioned the work. The photographer's logbook (which may be viewed on microfilm in the Prints and Photographs Division) should be consulted to ascertain if a photograph was personal property or the result of a commission. If commissioned (or if such a distinction is not clearly made), the reader should make every attempt to find the commissioning agent and determine if any copyright restrictions exist. The Library has no record of the rights which the photographer assigned to his commissioning agents or the names and addresses of any such agents. Users are responsible for making a reasonable attempt to determine what rights, if any, may still encumber commissioned works and in whom such rights are vested. Failure to honor existing restrictions on use could result in grounds for copyright infringement proceedings.

4. Historians are just beginning to consider photographs as historical documents. Few historians see them as primary source materials which can be read and interpreted along with written manuscripts. Instead, most picture users come to the Library of Congress seeking illustrations to tack onto their already completed works, but there is some indication that this way of thinking may change. In his presidential address delivered to the Society of American Archivists in October 1978, Walter Rundell, Jr., discussed methodological problems historians face when using photographs as documents. His slide presentation was entitled "Photographs as Historical Evidence: Early Texas Oil."

5. Irving Bernstein, *The Lean Years* (Boston: Houghton Mifflin Company, 1960), p. 453.

6. Sheldon Cheney and Martha Candler Cheney, *Art and the Machine* (New York: McGraw-Hill Book Company, 1936), p. 6.

7. Cheney and Cheney, p. 18.

8. Constance M. Green, *Washington: Capital City, 1879–1950* (Princeton, N.J.: Princeton University Press, 1963), 2:292, 286.

9. Bates Lowry, ed., *The Architecture of Washington, D.C.* (Washington: Dunlap Society, 1976). This text-microfiche publication is the initial step in a program sponsored by the Dunlap Society to document visually all aspects of American art.

10. The logbook is arranged chronologically by assignment number. Entries are generally single words or abbreviated phrases, usually undated. The information is useful in identifying subjects or commissioning agents and, because of the chronological arrangement and occasional reference to date, helps date jobs by approximation.

11. Clippings file for the 1930s, Washingtoniana Room, Martin Luther King Memorial Library.

12. Quoted in Richard Hofstadter, *The American Political Tradition* (New York: Vintage Books, 1959), p. v.

13. William Kilpatrick, *Identity and Intimacy* (New York: Delacorte Press, 1975).

About the Authors

Beverly W. Brannan, curator of photographic collections in the Prints and Photographs Division, is responsible for large documentary collections. These include the Toni Frissell, *Look* Magazine, and Theodor Horydczak collections, as well as the Gilbert H. Grosvenor Collection of Alexander Graham Bell photographs. In 1974 Ms. Brannan transferred to the division from the Library's Manuscript Division. She holds B.A. and M.L.S. degrees from the University of Maryland.

Alan Fern, director for special collections in the Library of Congress since 1978, joined the Library staff in 1961. He served in the Prints and Photographs Division as assistant curator of fine prints, curator of fine prints, assistant chief, and chief, until his appointment as director of the Library's Research Department. Dr. Fern received his A.B. degree in 1950 from the University of Chicago. He continued his studies in the history of art at the same university, receiving an M.A. in 1954 and a Ph.D. in 1960. Before coming to the Library, Dr. Fern taught at the University of Chicago, the Art Institute of Chicago, and the Institute of Design. He has also taught at the University of Maryland and Pratt Institute and has published extensively in the fields of art and printmaking.

George S. Hobart, curator of documentary photography, received undergraduate and graduate training in history and museology at the University of Massachusetts and the College of William and Mary, after which he served as curator of the U. S. Army Historical Collection. Since joining the staff of the Library of Congress in 1968, he has served as picture cataloging specialist and curator of documentary photography.

Milton Kaplan, retired curator of historical prints, came to the Library of Congress in 1941 after graduating from the College of William and Mary and joined the staff of the Fine Arts Division (now the Prints and Photographs Division) in 1942. He organized several major exhibits, among them "Hair," "Advertising in Nineteenth-Century America," and "The Performing Arts in Nineteenth-Century America." He compiled *Pictorial Americana* and co-authored *Charles Fenderich, Lithographer of American Statesmen,* and *Viewpoints,* all Library of Congress publications. Mr. Kaplan is also the coauthor of a number of illustrated books in American history, including *Presidents on Parade* (1948), *Divided We Fought* (1952), *The Story of the Declaration of Independence* (1954, 1975), and *The Ungentlemanly Art* (1968, 1975).

Ona Lee McKeen served on the staff of the Library of Congress from 1949 until 1962, working twelve years in the Prints and Photographs Division. Her other assignments included the reference and public information desks in the Main Reading Room before her retirement from the Copyright Office. Mrs. McKeen studied at the University of Oklahoma, Texas Tech University, American University, and the Department of Agriculture Graduate School in Washington. An occasional free-lance writer, she has published articles in *American Heritage* and *National Republic* magazines. Her Oklahoma background and her interest in the history of the Southwest equip her to interpret the life of early American cowboys as they appear in the documentary photographs of the Erwin E. Smith collection.

Jerald C. Maddox, curator of photography, joined the Library of Congress staff in 1966, after serving for three years as assistant to the director of the University of Nebraska Art Galleries. Mr. Maddox holds A.B. (1955) and M.A. (1960) degrees from Indiana University and has studied at Harvard University. Interested in photography since he was an undergraduate, Mr. Maddox has published articles and given lectures on the history of photography, has been involved in the organization of major photographic exhibitions, and has published and exhibited his own photographs nationally.

Hirst D. Milhollen (1906–1970) was specialist in photography in the Prints and Photographs Division for over forty years. He studied at the George Washington University

and the National School of Fine and Applied Arts in Washington, D.C. Mr. Milhollen helped secure for the Library the Brady-Handy photographs as well as several additional collections of importance in the field of documentary photography. He was also instrumental in generating renewed interest in Currier & Ives lithographs and other historical prints of the nineteenth century. Mr. Milhollen served as picture editor for *Presidents on Parade, They Who Fought There, Divided We Fought, Horsemen Blue and Grey, Best Photos of the Civil War, Civil War Photographs, 1861–1865, Embattled Confederates*, and *The Story of the Declaration of Independence*.

Renata V. Shaw, bibliographic specialist in the Prints and Photographs Division, joined the Library staff in 1962. A native of Finland, she completed the M.A. in art history at the University of Chicago (1949) and the Magister Philosophiae at the University of Helsinki (1951) and received a diploma in museology from the Ecole de Louvre in Paris (1952). After two additional years of postgraduate work at the Sorbonne and the Ecole de Chartes, Mrs. Shaw taught French in Washington, D. C., and worked at the National Gallery of Art. Upon graduating from Catholic University in 1962 with an M.S. in library science, she came to the Library of Congress as reference librarian for fine arts. Mrs. Shaw has written several articles in the fields of graphic arts and visual librarianship. In 1973 she published a bibliography entitled *Picture Searching* and in 1977 she compiled *Graphic Sampler*, a selection of articles from the *Quarterly Journal of the Library of Congress*.

Paul Vanderbilt, now retired, was chief of the Prints and Photographs Division from 1947 until 1950 and consultant in iconography from 1950 until 1954. He received a B.A. at Harvard in 1927. From 1929 until 1941 he was associated with the Philadelphia Museum of Art as librarian, editor, and research assistant. He then joined Roy Stryker in the Office of War Information, where he developed a scheme of picture retrieval for the photographic collections. When the Farm Security Administration/Office of War Information picture files were transferred to the Library of Congress, Mr. Vanderbilt joined the Library staff. In 1955 he published the *Guide to the Collections of Prints and Photographs in the Library of Congress*. From 1954 until his retirement in 1972 Mr. Vanderbilt served as curator of the iconographic collections of the State Historical Society of Wisconsin. Mr. Vanderbilt's photographs have been exhibited in one-man shows as well as in group exhibitions throughout the country. Examples of his photographic work are in the permanent collections of the Museum of Modern Art, The Art Institute of Chicago, and many other museums.

☆ U.S. GOVERNMENT PRINTING OFFICE : 1981 O - 348-346 : QL 2

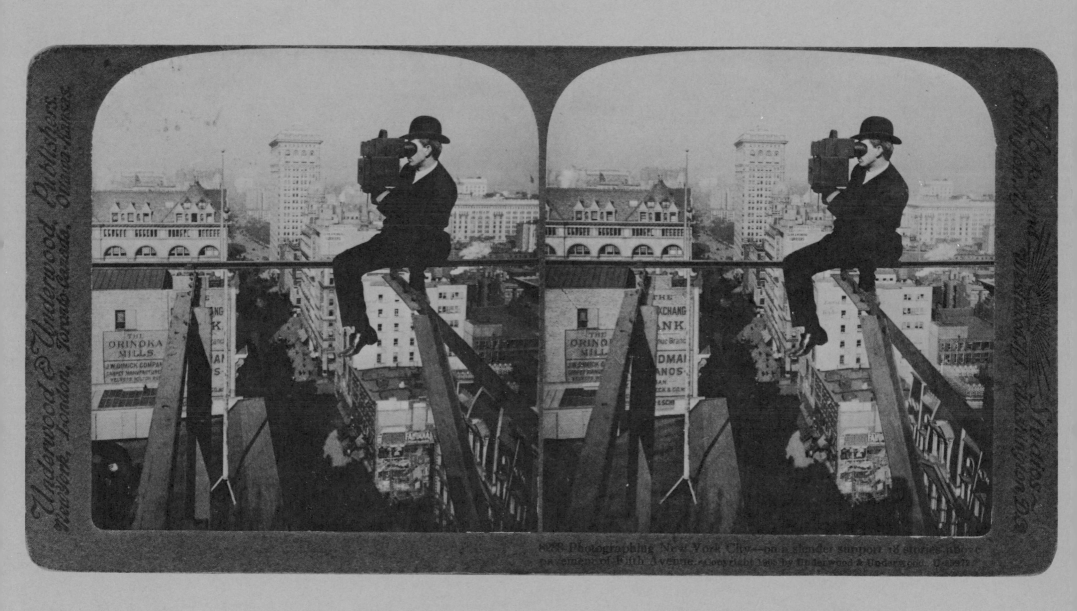

8268 Photographing New York City—on a slender support 18 stories above pavement of Fifth Avenue. Copyright 1905 by Underwood & Underwood.